THESE RARE LANDS

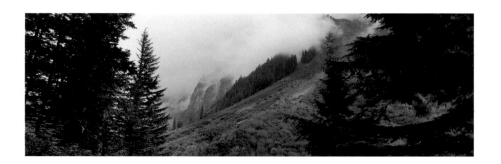

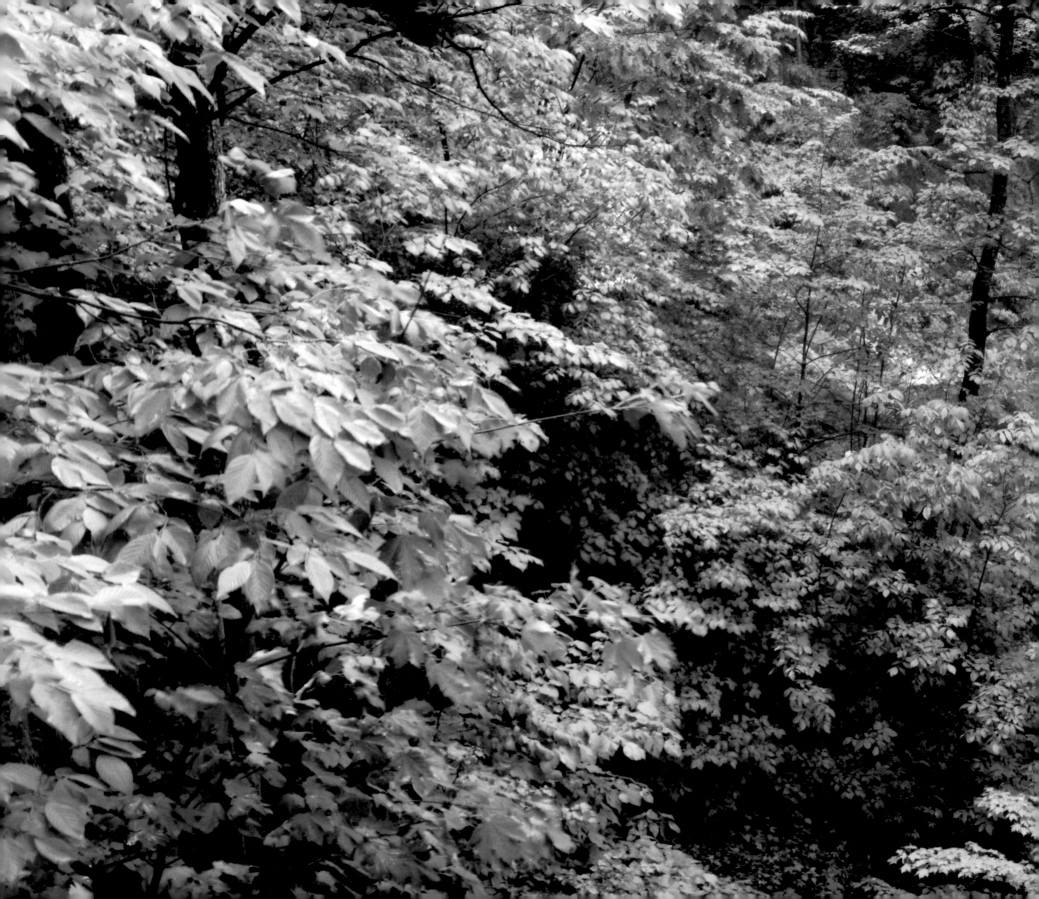

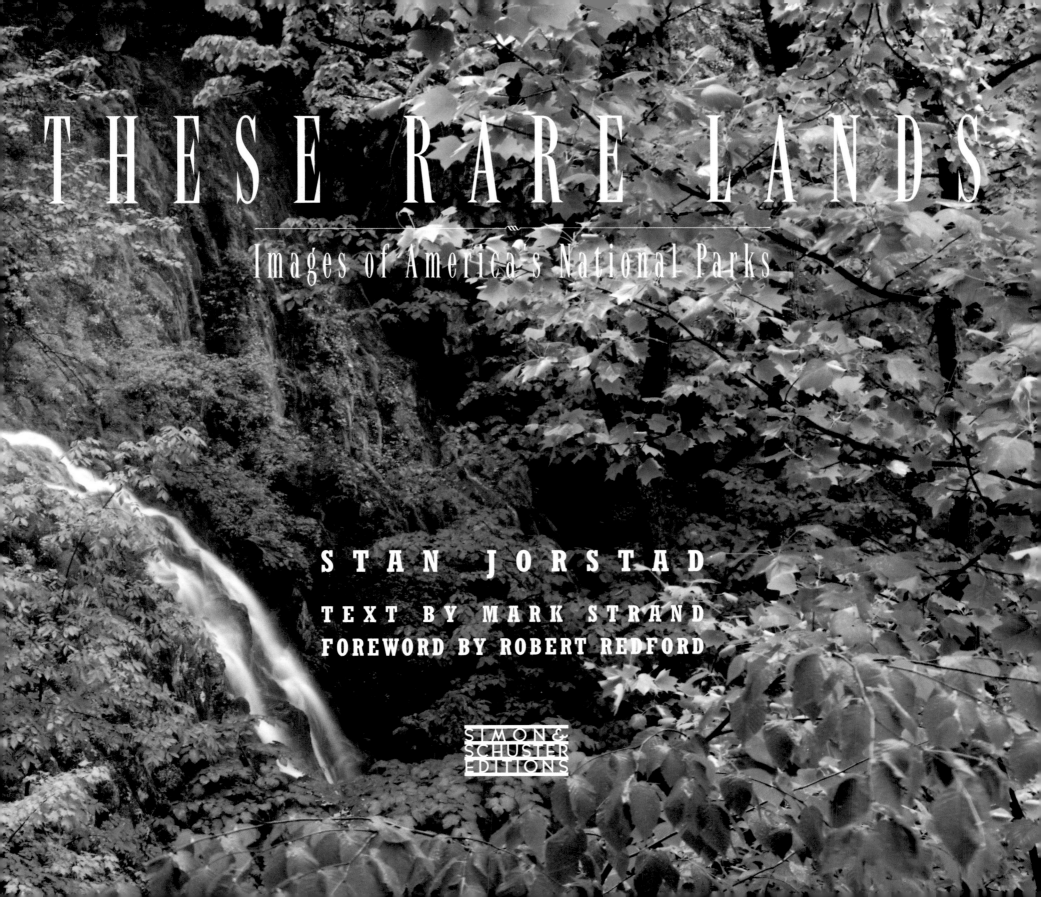

THESE RARE LANDS

Images of America's National Parks

STAN JORSTAD

TEXT BY MARK STRAND
FOREWORD BY ROBERT REDFORD

SIMON &
SCHUSTER
EDITIONS

Dedicated to my late wife, Wanda,
who provided everlasting support and love.

— STAN JORSTAD

All of the photos in this book were taken using nondigital cameras and film,
and reflect the conditions that nature presented.
 Inquiries regarding the photographs may be directed to PhotoMark,
Post Office Box 701, St. Charles, Illinois, 60174-0701, (630) 690-9222.

Page i: View from Cascade River Road, North Cascades National Park.
Pages ii–iii: Spring in White Oak Canyon, Shenandoah National Park.
Page v (top to bottom): Sequoia National Park, Mesa Verde National Park,
Rocky Mountain National Park, Haleakala National Park.
Page vi (top to bottom): Zion National Park, Virgin Islands National Park,
Redwood National Park, Kings Canyon National Park, Shenandoah National Park.
Page vii (top to bottom): Channel Islands National Park, Joshua Tree National
Park, Gates of the Arctic National Park, Guadelupe Mountains National Park,
Glacier Bay National Park.
Page 1: Goose Island in St. Mary Lake, Glacier National Park.

Simon & Schuster Editions
Rockefeller Center
1230 Avenue of the Americas
New York, NY 10020

DESIGNED BY JOEL AVIROM AND JASON SNYDER
DESIGN ASSISTANT: MEGHAN DAY HEALEY

Manufactured in Italy
10 9 8 7 6 5 4 3 2 1

Jorstad, Stan.
 These rare lands : images of America's national parks / Stan
Jorstad ; text by Mark Strand ; foreword by Robert Redford.
 p. cm.
 Includes index.
 1. National parks and reserves — United States — Pictorial Works.
2. United States — Pictorial Works. I. Strand, Mark, 1934– .
II. Title.
E160.J65 1997
363.6'8'0973022 — dc21 97-16156
 CIP
ISBN 0-684-84112-6

CONTENTS

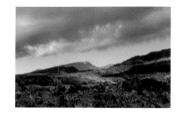

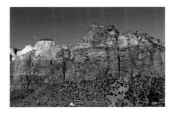

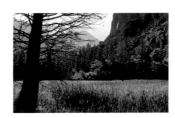

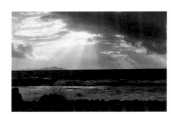

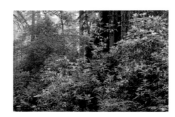

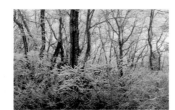

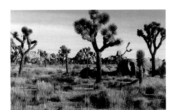

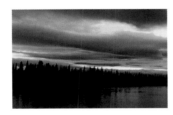

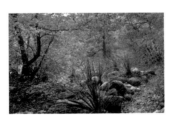

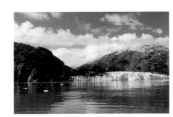

FOREWORD

America's national parks were born of a vision of unspoiled wilderness as a shared national heritage, one placed in trust long ago by our country's leaders for all of us to own. The first time I truly felt the power of nature was on a visit to one of the parks as a child. I'll never forget passing through a tunnel carved into a mountain and suddenly before me was the stunning magnificence of Yosemite. It changed me forever. I remember thinking, I want to be a part of this—I want to be *in* it somehow.

Stan Jorstad has spent years in the parks—walking through them, studying their light, photographing them—and in this book he shares with us his life's work. His exquisite panoramic photographs made at all fifty-four of America's national parks are not only a unique accomplishment but a profound gift to us all. At once we are inspired by Stan's own deep feelings about his subject and awed by the grand perfection of our untouched natural world. Just as these places are national treasures, so too are Stan Jorstad's images.

Words as well as pictures—writers as well as visual artists—have helped Americans understand the tremendous importance of our land. Back in 1862, Henry David Thoreau declared, "In wildness is the preservation of the world." And when poet and essayist Ralph Waldo Emerson visited Yosemite in 1871, his host was John Muir, the man who, with all the thunder of an Old Testament prophet, fathered the American conservation move-

ment. So it's fitting that Stan Jorstad's photos are coupled here with the elegant words of Mark Strand, a poet and writer who was designated America's poet laureate by the Librarian of Congress in 1990.

To many of us, the preservation of these last wild places is linked to our soul as a nation. How we treat them says much to the rest of the world about America as a society. Today, this natural heritage, which we borrow from our children and theirs, faces an uncertain future. But it is certain that these photographs by Stan Jorstad will never let us forget the rare beauty of our American wilderness and the reason we must protect it.

—*Robert Redford*

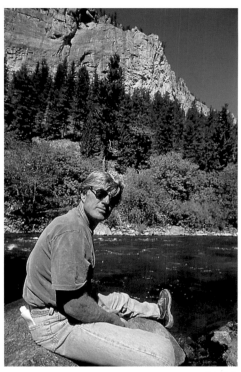

John Kelly

PREFACE

For over forty years I have had an intimate relationship with the most beautiful, wildly exquisite, and rugged landscapes in this land. I first experienced the American wilderness during World War II when I trained in the spectacular Rocky Mountains with the Tenth Mountain Division ski troops. When the war was over, I returned from the fighting in Italy with a deeply felt need to get back to the wilderness. Since then I've made multiple photographic forays into every one of our fifty-four national parks. Avoiding the height of the season, I would visit the same park at different times of the year and explore its lands, searching for new and different panoramas, seeking and waiting for that special elusive light.

You might say that a photograph is captured light. But there's light, and then there's light. In the National Park of American Samoa in the South Pacific, the light brings out the brilliance of color, but in the Kenai Fjords of Alaska the light is soft, like an eternal twilight. In landscape photography, light is virtually everything.

I've been in Death Valley National Park many, many times, and the quality of the light there is astounding. If it rains—and it's rare when it does—the raindrops usually evaporate even before they hit the ground. I have visited Death Valley in August, when the park is nearly deserted because of the 130 degree heat, but if I climb to the high desert where many of the wildflowers are, I may need a jacket.

America's national parks are probably the most popular attraction in the world—the entire world. I've been in parks where it seems that every other person is a visitor from Germany or Japan. The official annual count for visitors to our national parks is over 63 million, more than the population of most of the world's nations.

With this level of attendance, the pressures on the parks and on their staffs are tremendous. Throughout the years, I've come to hold in high regard those dedicated men and women who work for the National Park Service. Loving their work, most go beyond the call of duty in the preservation of the wilderness. But they are going through difficult times, as is our whole national park system. Some of the parks are literally being "loved to

death." Many are in need of additional staffing and funds for repair and maintenance. In the future, with the increase in population and industry, it will be necessary to set aside more wilderness areas and to increase our support for them to ensure that our national treasures are not lost.

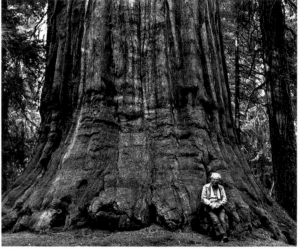

Steve Jorstad

Stan Jorstad and a giant sequoia.

To me, America's national parks are the nation's greatest resource. They may not provide us with food for our bellies or raw materials for our industries, but they inspire the soul and nurture the whole human being. I know, because they have nurtured and inspired me.

Less than two years ago I walked into the offices of Questar in Chicago and told Albert Nadar and Steve Furman of my dream to create a book of photos on all of our national parks. With their assistance they helped turn my dream into reality and to them I express my appreciation.

Heartfelt thanks also go to Mark Strand and Robert Redford, who, from their own artistic perspectives, impart a new level of meaning and depth to my photographs.

I am grateful to the wonderful people at Simon & Schuster, particularly Constance Herndon, Gillian Casey Sowell, Joyce Andes, and Peter McCulloch. Thanks as well to our book designers, Joel Avirom, Jason Snyder, and Meghan Day Healey.

I would also like to express my deepest thanks to my daughters, Jan and Mary Ann, my sons, Steve and Tom, and my son-in-law, Byron Burk. All are very much a part of this book. This dream would not have come true had you not believed in your dad and stood with me through all of the difficult times. You are truly beloved.

I wish to express a sincere debt of gratitude to the many national park personnel who assisted me in this endeavor and to the many utterly amazing pilots, boat navigators, and guides who safely got me, my assistants, and our film and equipment in and out of very challenging locations.

Lastly, I'd like to share a special message of gratitude to those unknown, caring folks who really both appreciate and try to do their best to preserve and protect places like these rare lands.

—Stan Jorstad

INTRODUCTION

To go to one of America's national parks is to put oneself on the threshold of the wilderness. It is also to experience nature unspoiled by the expansionist character of civilization. This could be the reason many of us are willing to travel thousands of miles to see them—they offer the extraordinary. But perhaps more immediately, to visit the parks is to look upon nature at its most impressive. Each one features an unforgettable aspect of our topography—sometimes formidable as at the Grand Canyon, sometimes otherworldly as at Death Valley. Each harbors flora and fauna that can be encountered only with difficulty elsewhere, if at all. To our endangered species, the national parks offer protection, and often in subtle ways they offer a form of protection to our own species as well.

Unlike many of our state or city parks, which are commemorative, the national parks provide spectacular veiws of a narative begun long before the advent of man. One will not see a bronze statue of Brigham Young in Zion or one of John Muir in Yosemite. Whatever the considerable achievements of such men, they must be weighed on a different scale, one that is calibrated to the relatively recent events of history. The perspective that our national parks provides us with is so vast that it diminishes the ultimate importance of even the most cataclysmic episodes in our recorded past. Our victories and losses seem frail and forgettable against the backdrop of geologic change. It becomes clear just how short a time is allotted to us and how inescapably our point of view is largely generational. If nothing else, the presence of our national parks offers a corrective to our short-sightedness and a warning about our easy and perhaps ill-considered absorption in the whims of the current day. In all but

words they ask us to locate ourselves in a context that is far greater than the one we are used to, and they remind us that we have obligations that are as important as the conventional ones to self, home, and nation. We live by the planet's sufferance. And since many of us know only a little about the planet—though we have designated ourselves its guardians—our national parks may be the best places to begin learning more.

The experience that each of us has in the parks will, of course, differ. Though their age, their seeming permanence may put our social duties and personal obsessions in perspective, they are an unending source of visual delight as well. They overwhelm and inspire. They force us into an exultant consideration of what is around us.

Ralph Waldo Emerson saw in nature a healthy, normalizing corrective to our more or less restricted lives in the city. He felt its enchantments were "medicinal," that is, its influences were in fact "ministrations to the imagination and the soul." When he found "nature to be the circumstance which dwarfs every other circumstance," he was not even thinking of the overpowering scale of its existence in our national parks, he was thinking of more modest manifestations of the miraculous—the fall of snow, the woods at evening, a field, a moonlit lake.

Henry David Thoreau also found nature restorative. Toward the end of *Walden,* in the chapter entitled "Spring," he tells us:

Ruby Beach, Olympic National Park.

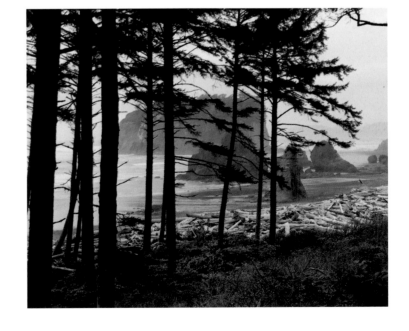

We need the tonic of wilderness—to wade sometimes in marshes where the bittern and the meadow-hen lurk, and hear the booming of the snipe; to smell the whispering sedge where only some wilder and more solitary fowl builds her nest, and the mink crawls with its belly close to the ground.

But he also suggests something else, a kind of thought that seems appropriate to the sublimity of our national parks, their enhanced ruggedness, their unconditional largeness. He continues:

At the same time that we are earnest to explore and learn all things, we require that all things be mysterious and unexplorable, that land and sea be infinitely

wild, unsurveyed and unfathomed by us because unfathomable. We can never have enough of Nature. We must be refreshed by the sight of inexhaustible vigor, vast and Titanic features, the seacoast with its wrecks, the wilderness with its living and its decaying trees, the thundercloud, and the rain which lasts three weeks and produces freshets. We need to witness our own limits transgressed, and some life pasturing freely where we never wander.

It is perhaps this appetite for the mysterious that draws us to our national parks. Each of us needs to experience a world beyond ourselves, but one in which we can nevertheless rediscover ourselves, have our own limits transgressed so that our relationship with the world might be revitalized. The parks offer us change and at the same time they ground us. To take in what they offer, we must refigure our previous connections to the natural world, step out of our ordinary lives, and be willing to experience the extraordinary. But this is easier said than done, for though we are attracted to the mystery and remoteness of our national monuments, we find soon enough that they are unassailable, that their grandeur is precisely what keeps them from becoming normalized and is what enlarges our capacity for visionary experience. No matter how close we feel our connection with the American wilderness to be or how intimate we believe our knowledge, its power finally resides in its remoteness. The panoramas the parks offer should be engaged with sparingly, and their views should never, through over-familiarity, lose their capacity to astonish.

Walking is necessary if a visitor to the parks wants to experience what is out there. Indeed as you move through the park, it dawns on you that you are made of the same stuff as the earth. Instead of being possessed by the sublime, we begin to feel that it is possessed by us as well. A balance has been struck: we contain the world in our smallness just as forcefully as the world makes room for us. But the excitement of this shared increase of presence does not last long. That is, it is not a feeling we carry with us after we have left one of the parks, nor is it a feeling that can be regenerated in the absence of wilderness. The remembered experience does not bear much resemblance to the original.

**Avalanche Gorge,
Glacier National Park.**

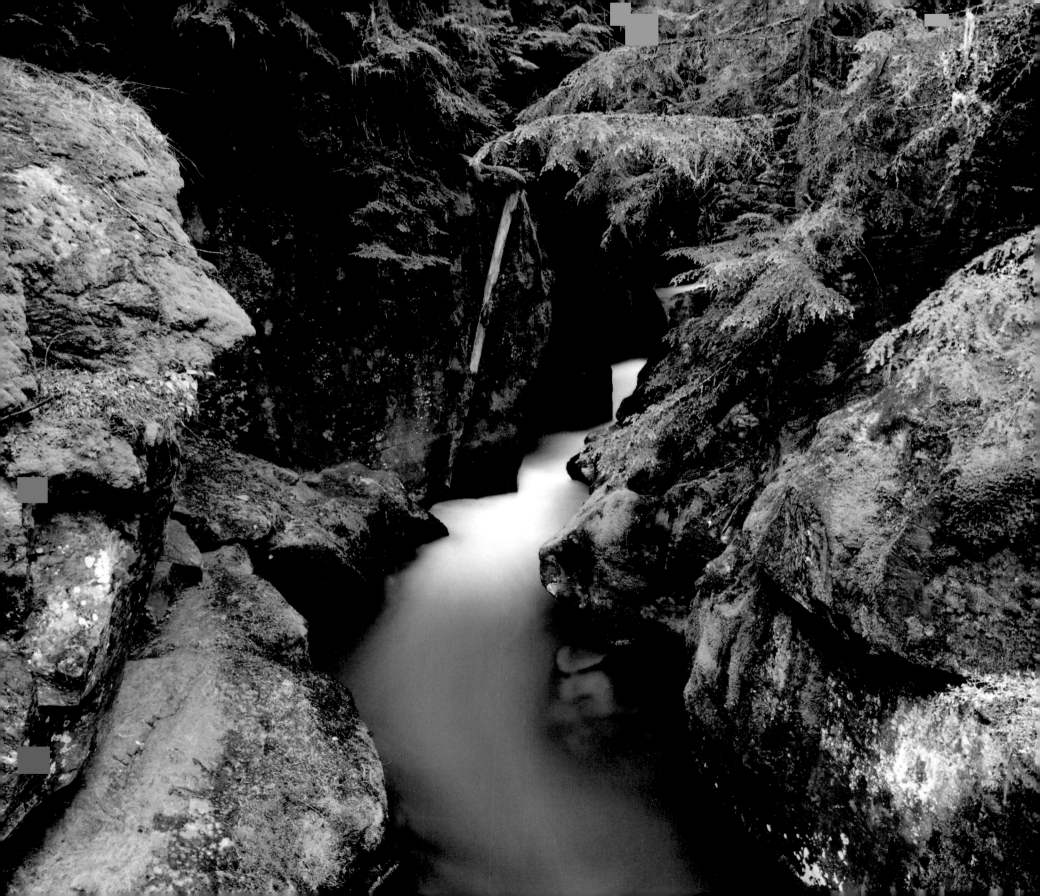

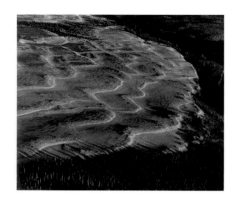

**Great Kobuk Sand Dunes,
Kobuk National Park.**

Stan Jorstad knows this, which means that the photographs he has taken of all the national parks serve a purpose beyond reproducing the experience of being in them. Clearly, holding a book on one's lap, even a big book filled with brilliant and unusual photographs, is not like actually being in the place that was photographed. Even if one could imagine oneself very, very small and imagine the photo much larger than it is—still, it does not work. Parks are one thing; they offer the sublime, but photographs of the parks are something else.

Jorstad's photographs are informed by a deep knowledge of the parks and the light that inhabits them. He is on the lookout for the unusual, the telltale. He lives in the parks until he finds what he is looking for—that revelatory instant when he believes the essential character of the place is not only disclosed but joined inexplicably with its esthetic potential. At this moment the park's identity is held in virtual balance as it shifts from being part of the natural world to becoming an image of the natural world, its sublimity transformed into a work of art. Jorstad's patience points toward that moment when the raw matter of the parks suggests the possibility of another life for itself.

When nature turns into image—a painting or a photograph—it loses some of the authority of self-embodiment. It becomes part of an idea of the beautiful, a particular artist's idea of the beautiful. Its true character is compromised by its imagined character, oftentimes for the better, and instead of astonishing with its grand and inexplicable presence, it engages. These spectacular outcroppings, those great spaces have been modified and even made vulnerable by our human need to know and to possess. Jorstad's photographs may be of the national parks, but they also reflect his preference for panoramic views in which the unconventional and the scenic are inextricable, in which the landscape is colored by the fall and spread of dramatic light.

Jorstad's varied treatment of different national park lakes—in Crater Lake, the Tetons, or Glacier—only partially indicates his range as a photographer. In each of the parks, he seems to adjust his sights to their distinctive characters. The sweeping views of Glacier or the Grand Canyon are radically different from the heavily wooded intimacy of Shenandoah or the subdued and misty clearings in Yellowstone. Often his photographs will surprise us

with an unexpected image—the sky at Sequoia, the boxworks at Wind Cave. His preference for early or late light is one that he shares with other photographers of the national parks, for early light offers spectacular clarity and late light, largely because of particulates in the air, presents dazzling sunsets. But why, one might ask, do our national parks need to be seen in extraordinary light? Aren't they impressive enough on their own? The answer is that they are never seen on their own; our vision of them is always dependent on one or another sort of light. Anything less than showing them in the best-possible light would be tantamount to normalizing the extraordinary, of forcing the parks's grandeur to fit the average or even banal nature of our expectations.

Jorstad relied on four cameras for these photographs: A Fuji 6 × 17 Panoramic, a Pentax 6 × 7, a V Pan 6 × 17 panoramic, and a ten-inch circuit camera, which, as its name suggests, has two motors that turn the camera. The width of his pictures is a gesture toward inclusiveness, but it is also a fitting response to the parks themselves. One cannot help but be struck by the extensiveness of the parks. As we walk, so they unfold. As we desire to see more, so they make more available for our viewing. The farther into them we go, the less apprehendable they become. We have to step back and look around. We take in as much as we can, which is precisely what Jorstad does.

These photographs draw us back to the parks, but in doing so they provide us with images of nature that fill us with pride, for in them we see a wildness and a brilliance that correspond to the best and most compelling elements in our own natures. Without such images, we would feel estranged not only from the natural world but from ourselves. Stan Jorstad's photographs are not only beautiful, they are necessary.

—*Mark Strand*

THESE RARE LANDS

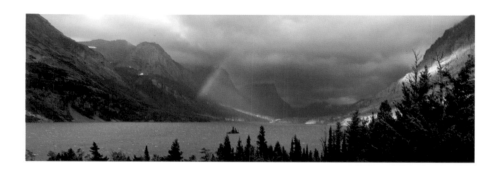

YELLOWSTONE NATIONAL PARK

WYOMING, MONTANA, IDAHO, ESTABLISHED 1872

The vastness of it, the spread of it, the variousness it encloses are unrivaled by any other park in the forty-eight contiguous states. Yellowstone is where Old Faithful erupts and where thousands of other hot springs bubble and steam, breaking through the sandy crust of earth, tinting it with mineral deposits of amazing colors. It is a thermal extravaganza. But this is also where one of America's most picturesque rivers, the Yellowstone, winds, falls, slips though high rocky canyons, where buffalo forage, where elk, grizzly bear, black bear, and moose range. Yellowstone is also where eagles, ospreys, and trumpeter swans drift overhead. It goes on and on. Its forests are immense, its meadows wide, its vitality unending.

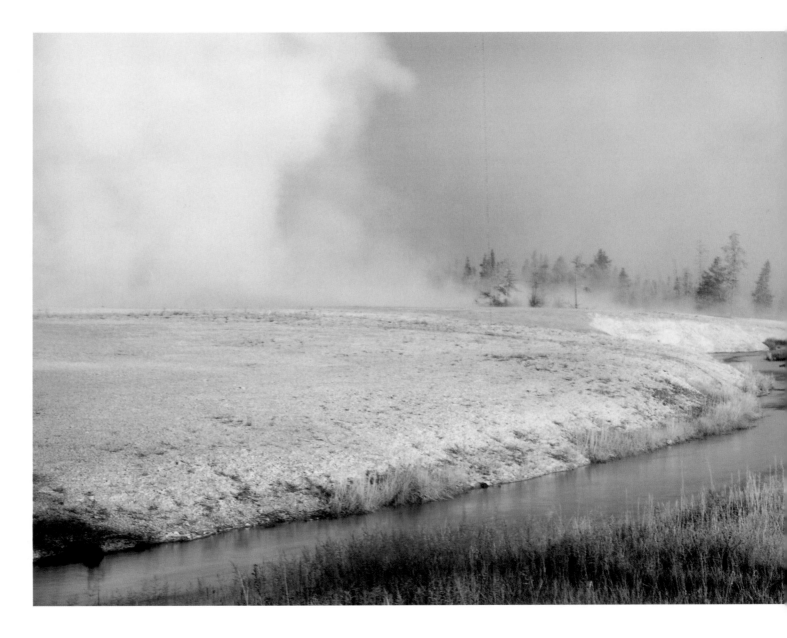

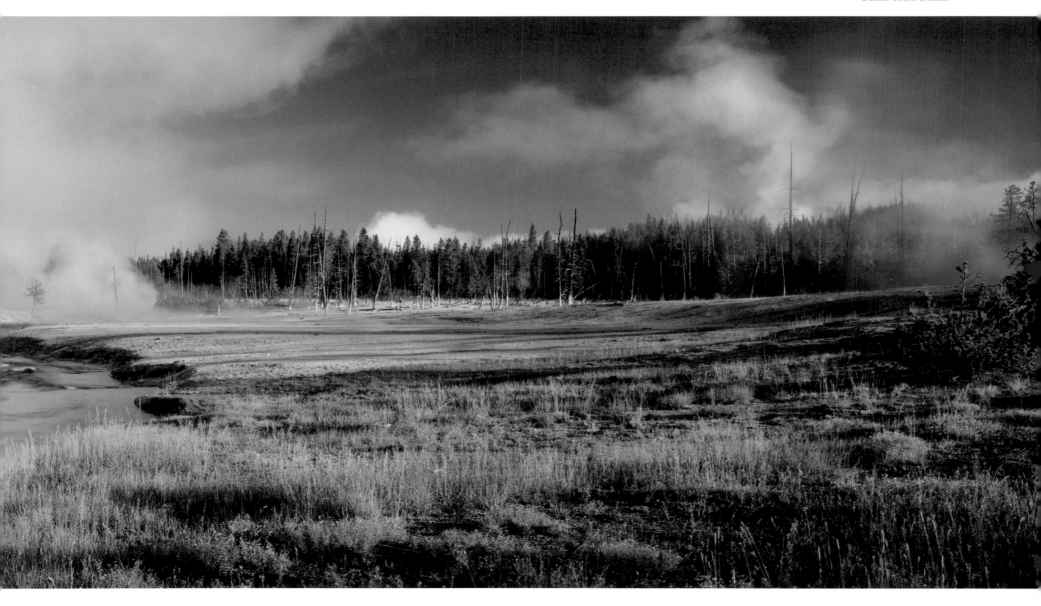

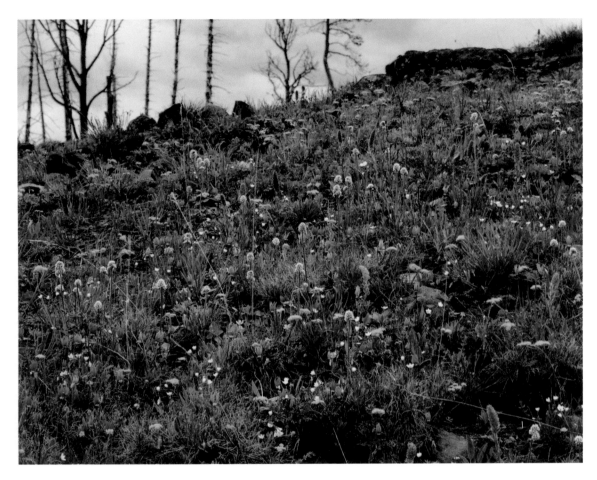

ABOVE: Pink shooting stars and other
native wildflowers blanket Dunraven Pass.

OPPOSITE: The metamorphosis of the
geothermal landscape.

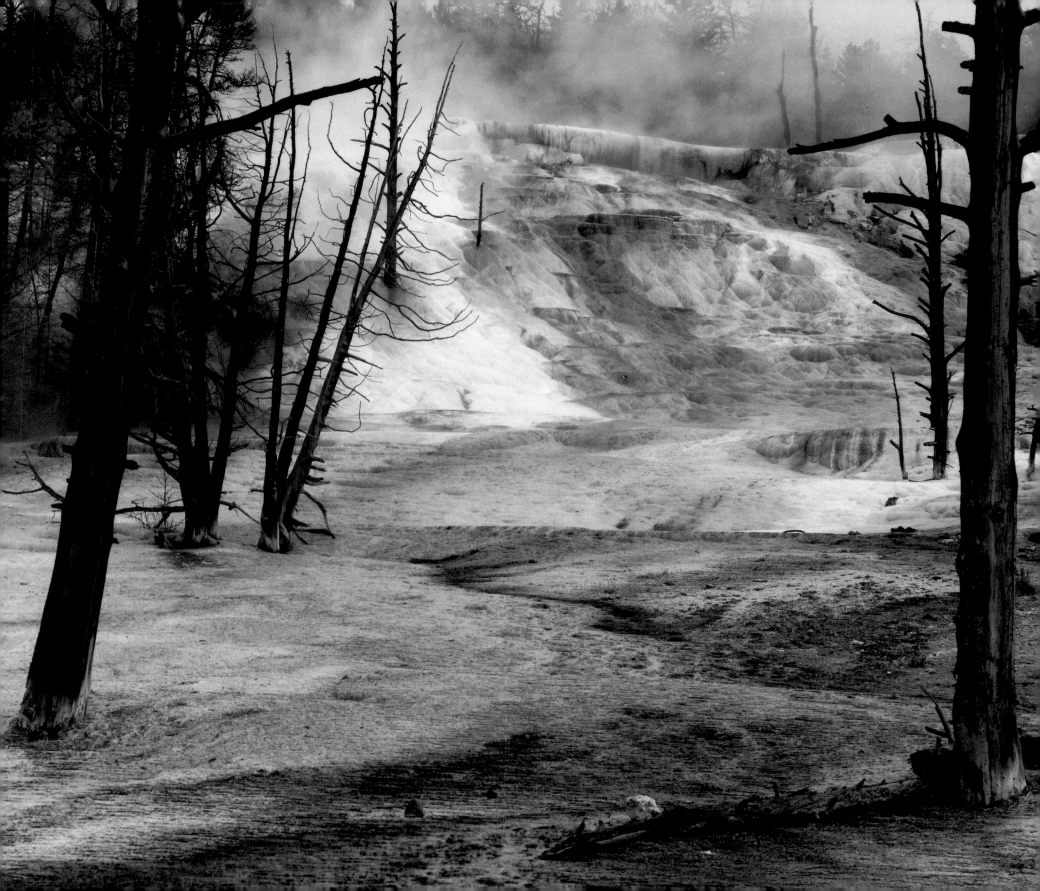

SEQUOIA NATIONAL PARK

California, Established 1890

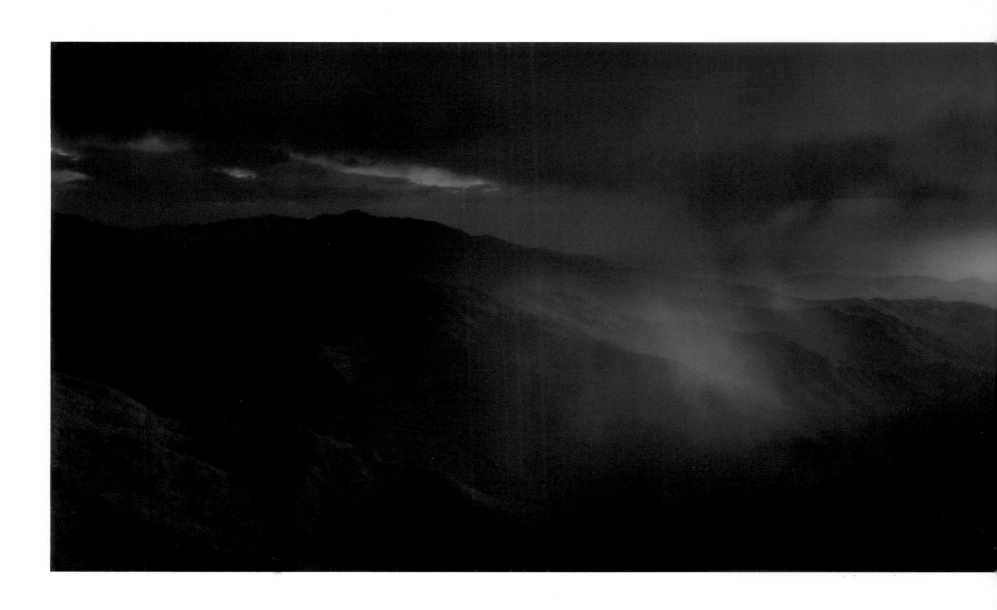

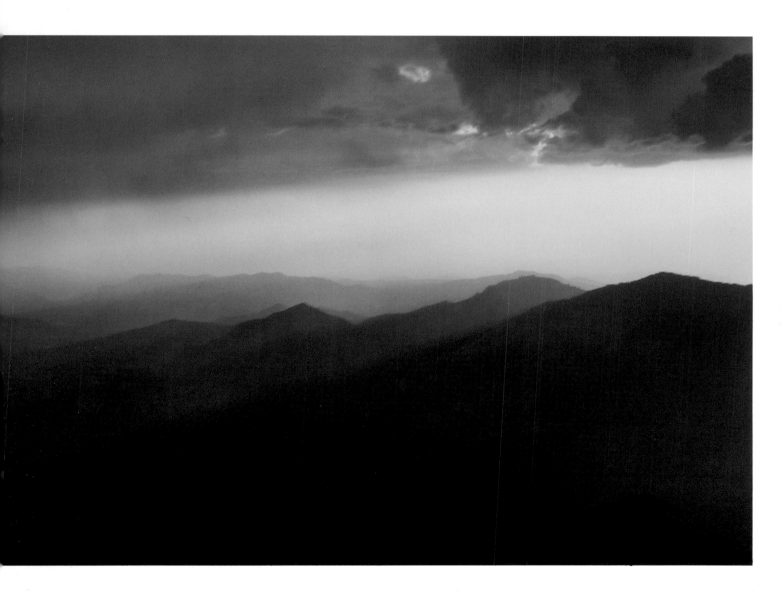

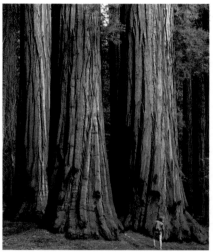

ABOVE: Sequoias, the largest living things on earth.

LEFT: Approaching storm from Moro Rock.

YOSEMITE NATIONAL PARK

CALIFORNIA, ESTABLISHED 1890

Everyone knows what Yosemite looks like. Of all the parks, it is undoubtedly the most photogenic and the one least compromised by repeated images of its sweep and grandeur. Half Dome, Cathedral Rock, El Capitan—the whole Yosemite Valley, in fact, is as familiar and identifiable a place as any that exists in the United States. But here, being in the midst of such sheer cliffs, such an unprecedented exaltation of verticality is an experience unto itself. The immense grayness of the place, the great shoulders worn to a smoothness that appears, from a distance at least, otherworldly, is like nothing else. It is a staggering sight.

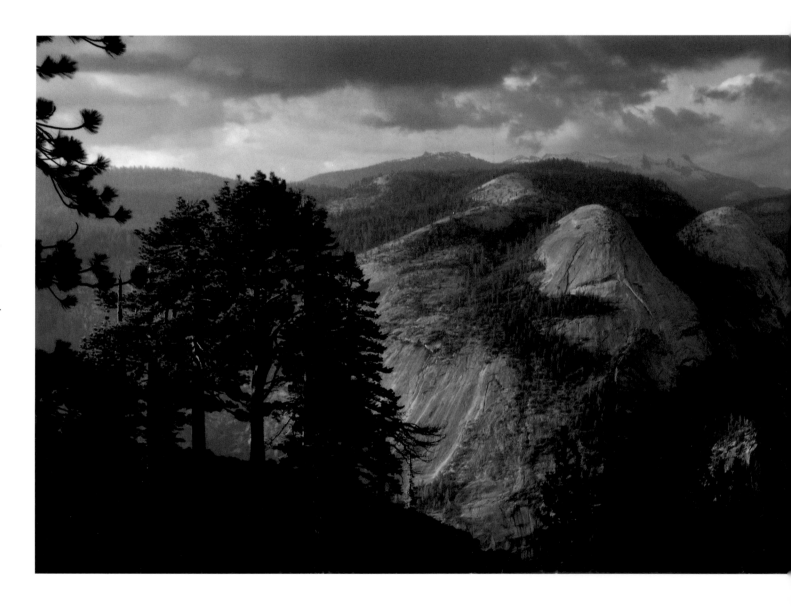

South Dome, North Dome,
and Half Dome from Glacier Point.

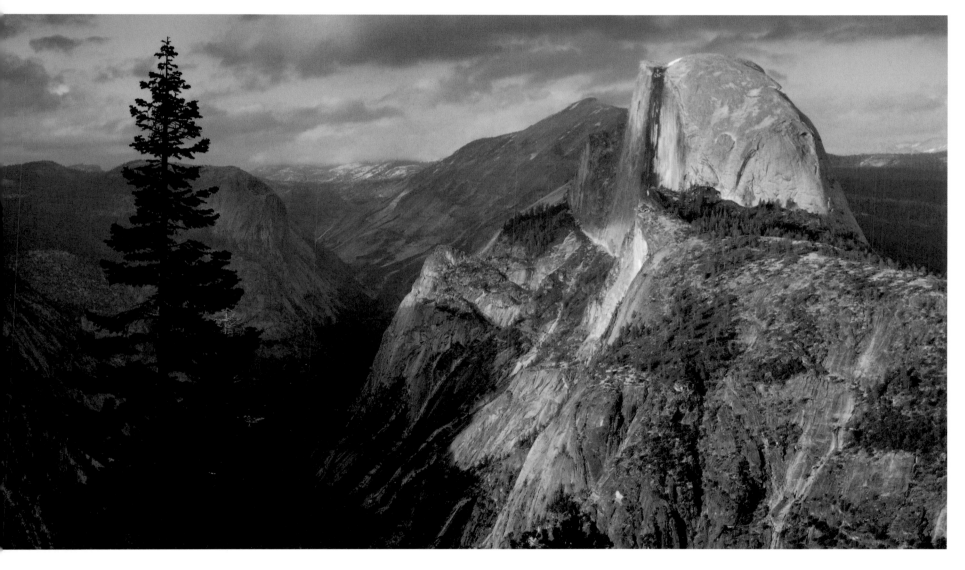

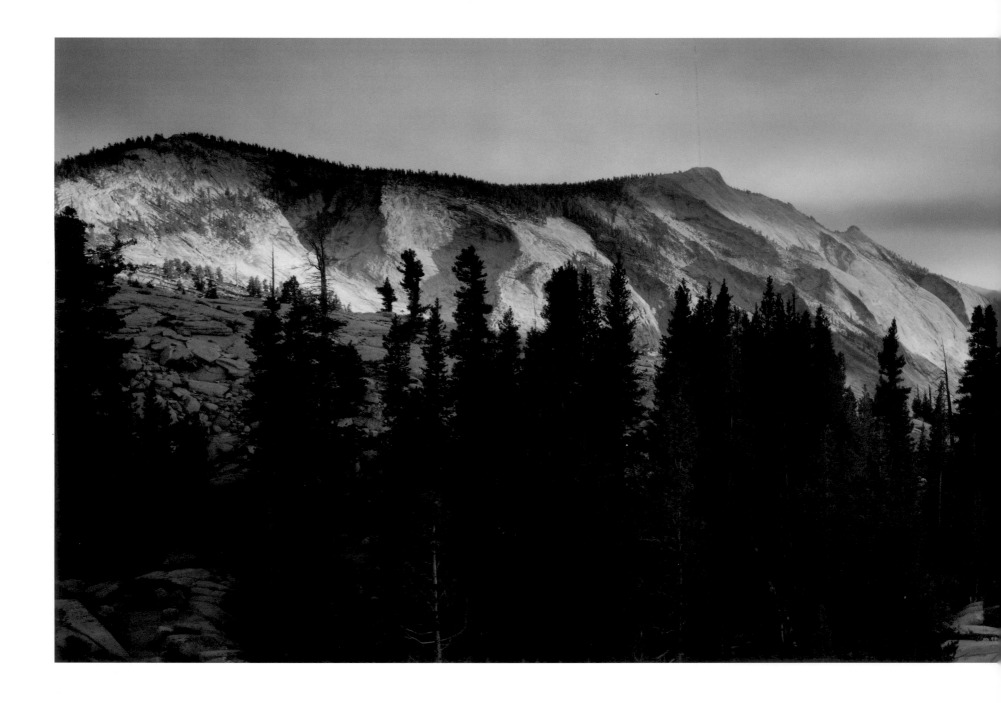

THESE RARE LANDS

Fire and smoke color the sky.

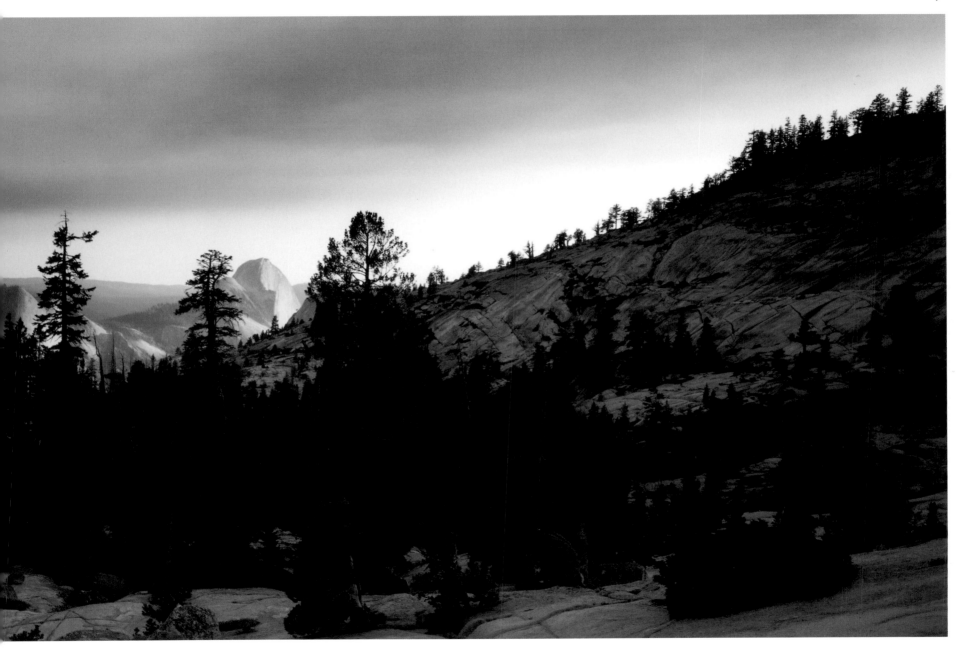

MOUNT RAINIER NATIONAL PARK

Washington, Established 1899

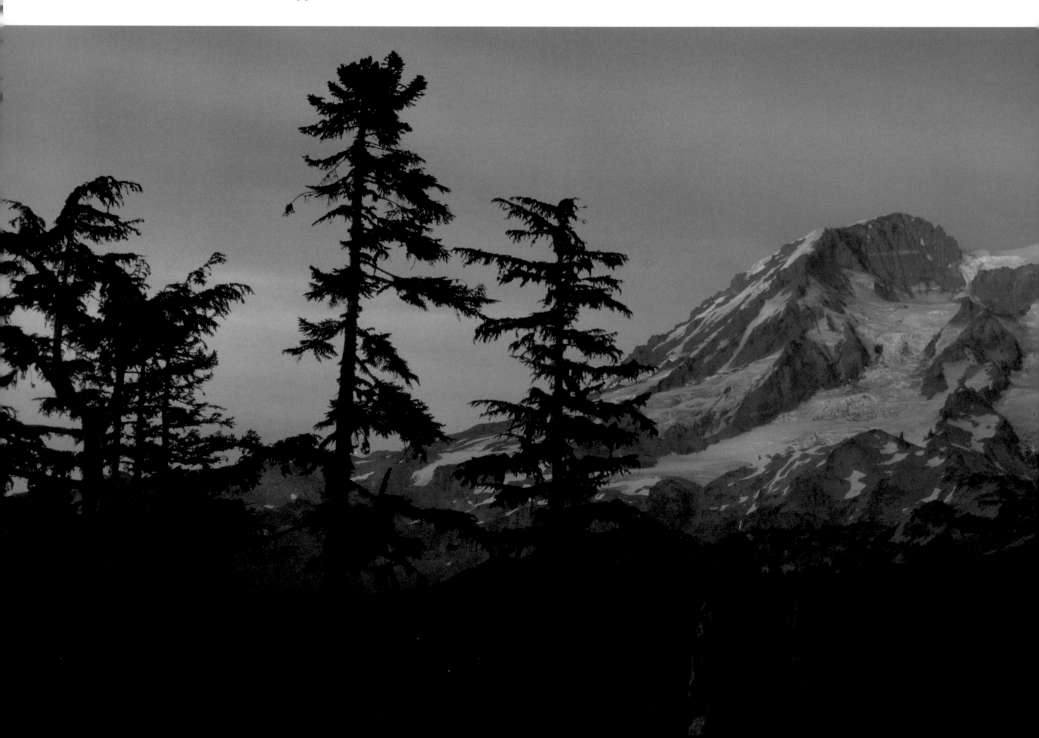

Mount Rainier, known to Native Americans as Tahoma ("The Great Mountain"), is nearly three miles high.

CRATER LAKE NATIONAL PARK

Oregon, Established 1902

This image of Crater Lake at sunrise shows Jorstad's preference for the unexpected. Typically photographed as a cold blue eye cast heavenward or as a round dish of such a deep and penetrant blueness that the memory of all previous blues is diminished by the comparison, Crater in Jorstad's photograph is neither blue nor entirely open. The rising sun is blocked out by the hills on the lake's far side and by the tops of trees on its near side. The source of light is not fully present, nor is the lake as we have come to know it from other photographs. Its surface in Jorstad's image appears coated by a grayish-whitish violet light. That blue eye that used to stare heavenward has a cataract. Its vision, figuratively speaking, is blocked, just as ours is. This photograph presents the lake as a singularity that will not suffer reduction nor permit anymore than the customary aggrandizements.

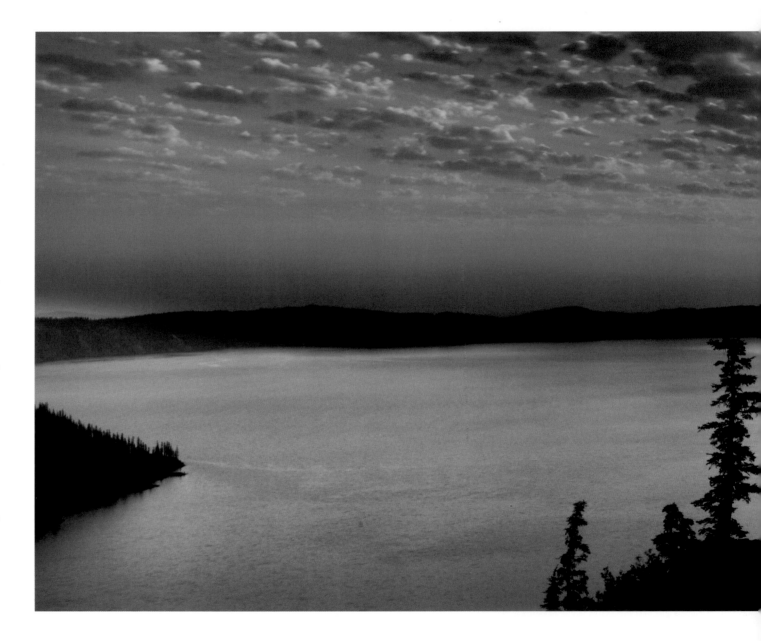

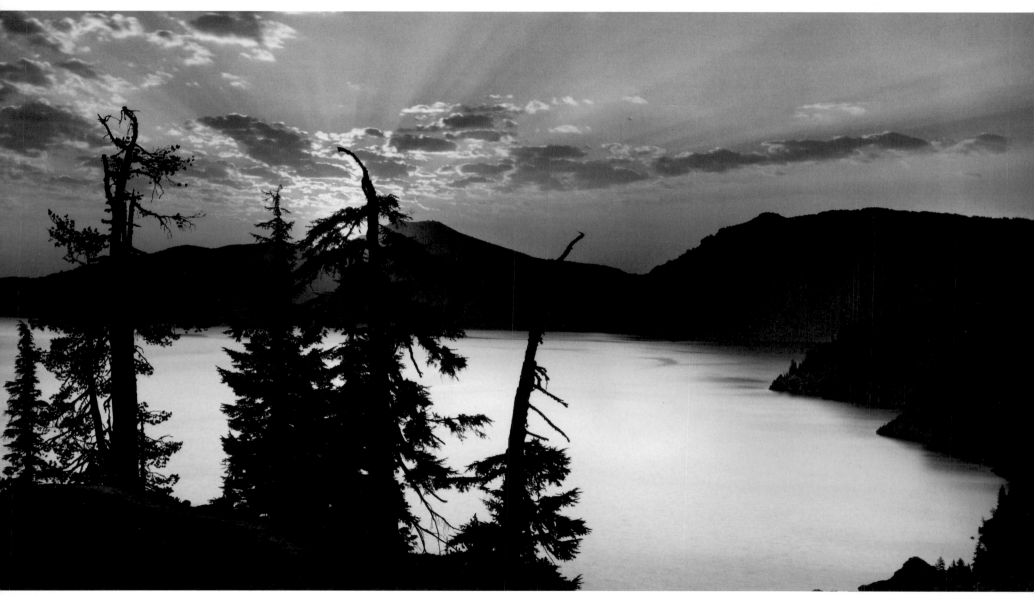

WIND CAVE NATIONAL PARK

South Dakota, Established 1903

Calcite Boxwork.

MESA VERDE NATIONAL PARK

COLORADO, ESTABLISHED 1906

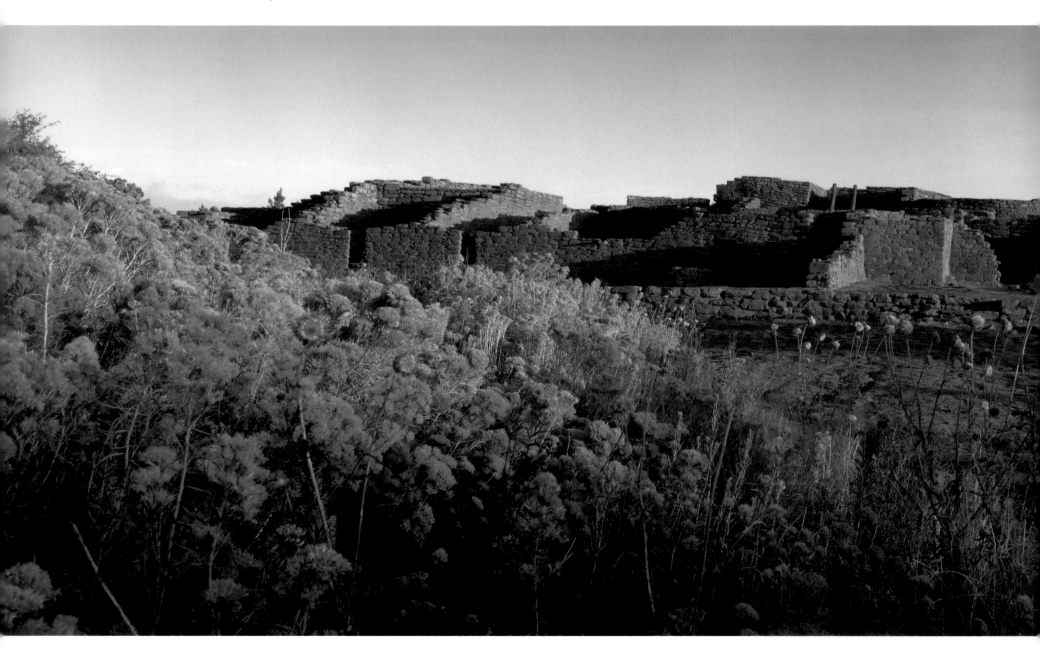

LEFT: Far View House on Chapin Mesa.

BELOW: Glyph created by the Anasazi.

OVERLEAF: Spruce Tree House.

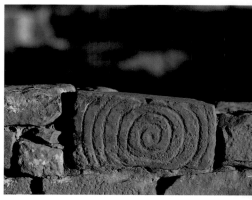

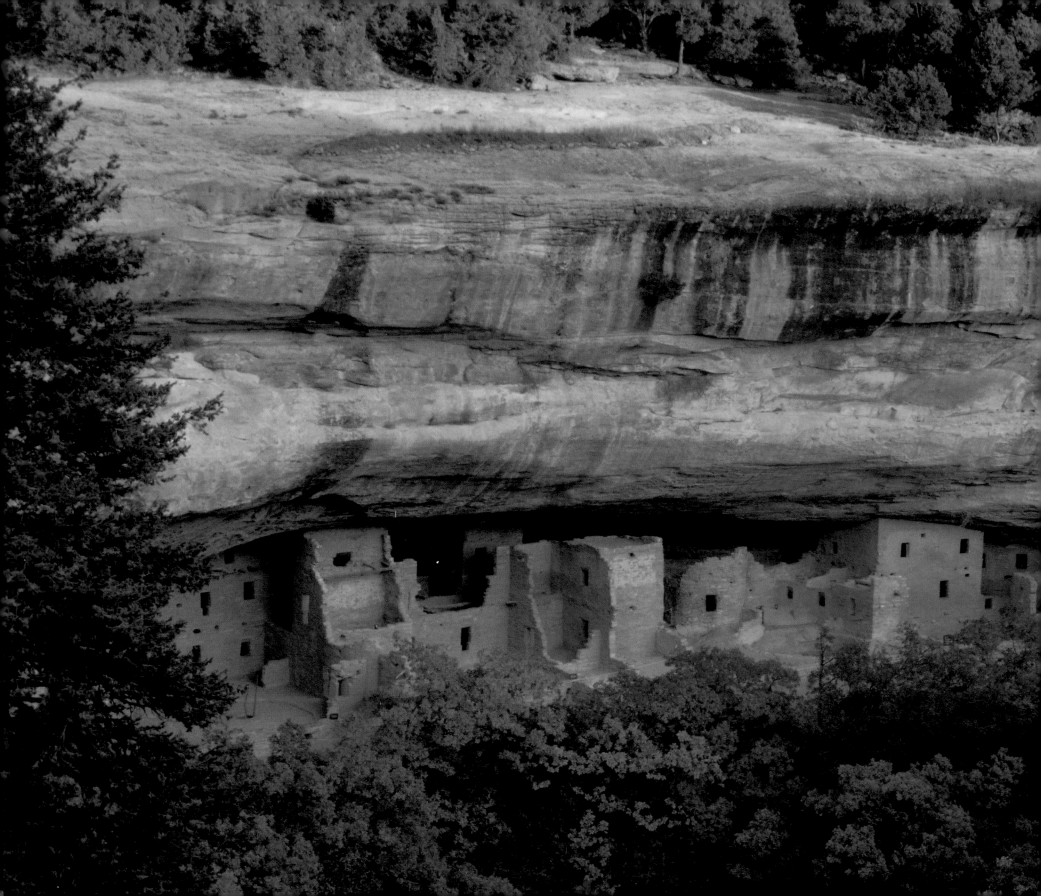

GLACIER NATIONAL PARK

Montana, Established 1910

Glacier is a park with an extraordinary spread and variety to its wilderness. Its splendor can be experienced by walking along its high alpine trails where mountain goats or big horn sheep or grizzly bears can be seen, along the banks of glacial lakes, or through long meadows over which white globes of bear grass sway. To gain the best sense of Glacier's landscape, however, take a long drive on the Going-to-the-Sun Road, perhaps in the late afternoon and traveling away from the sun, west to east. Following its route, you will enter a place of high craggy peaks illuminated by the sun. The colors will change. As it gets late and the sun begins to set, the peaks turn yellow, then pink, then reddish violet, with the sky behind them a dark velvety blue. Of all the roads in America, this one may offer the most spectacular vistas. And it is one that should be taken again and again because it changes so much from season to season and even from hour to hour.

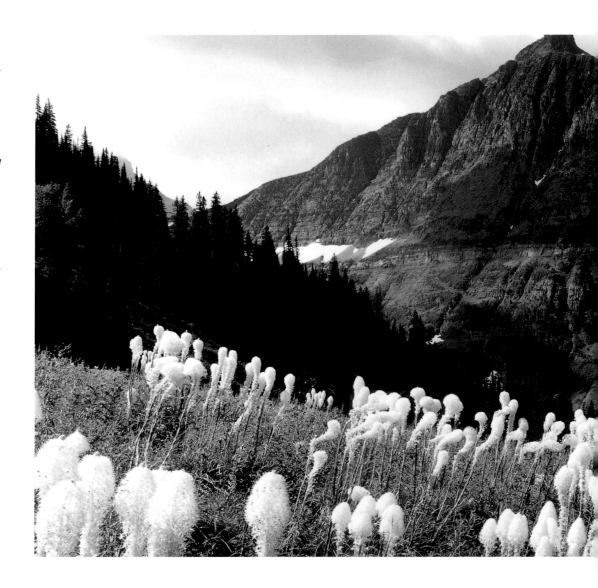

Bear grass blooms near
Going-to-the-Sun Road.

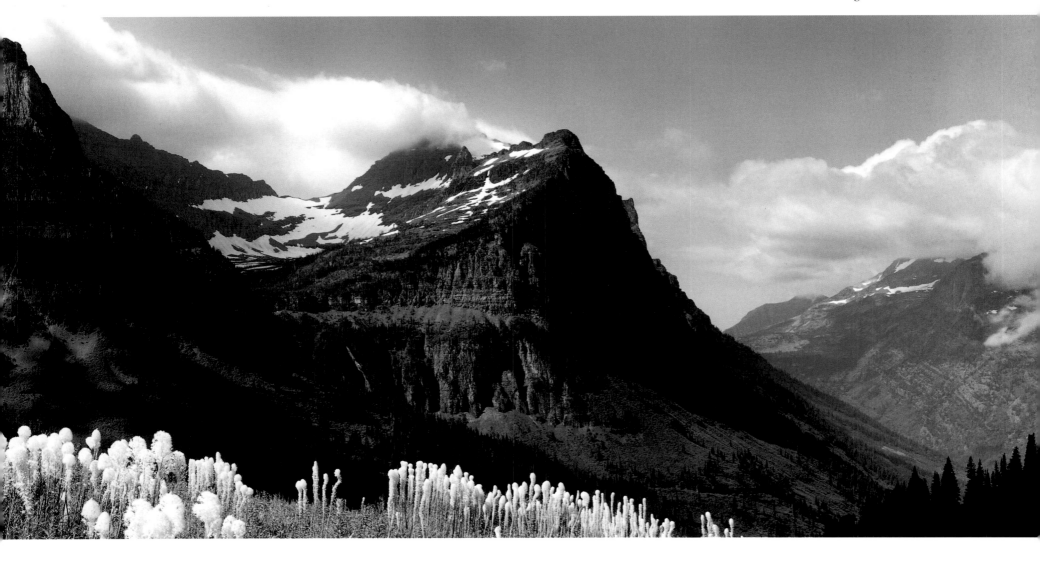

Sherburne Lake.

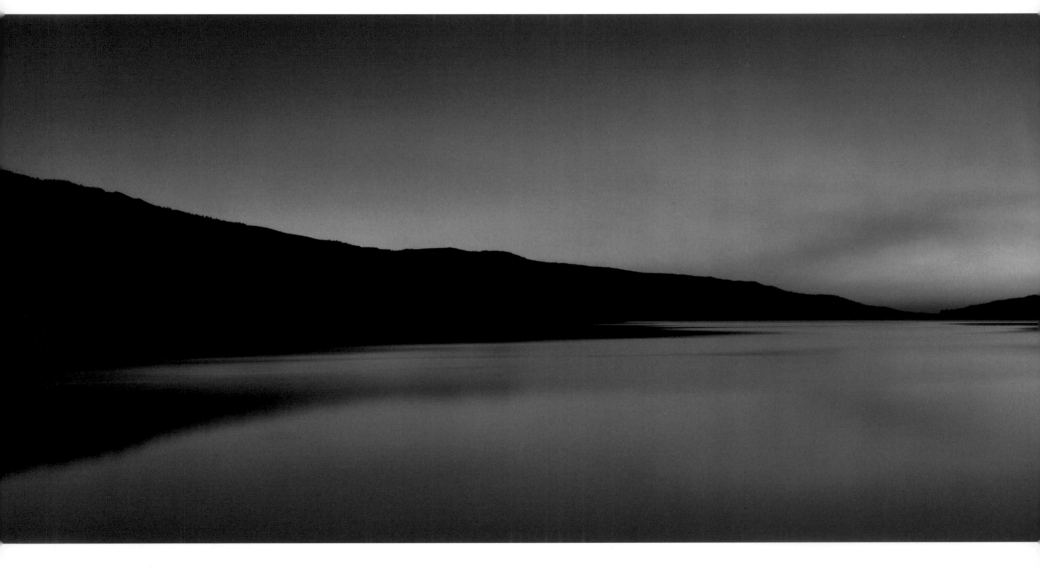

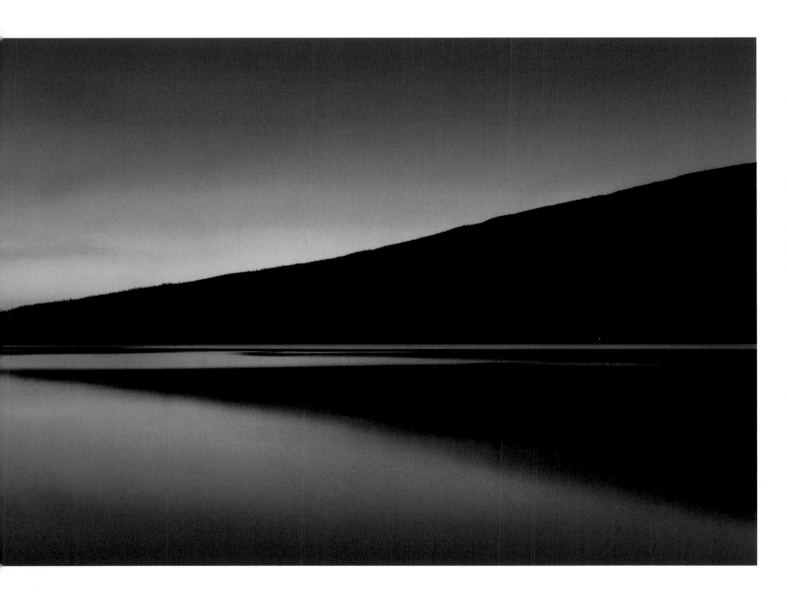

This panoramic view of Sherburne Lake reads, of course, like a landscape, but the more the viewer looks, the more peculiar it seems. It is as if the sun were announcing its arrival in the boldest possible way. And yet, the stridency and volatility of the brilliant orange color is gentled by the two wedges of silhouetted shoreline. All is calm and yet all is on fire, a vision of contraries joined, of air and water as if they were one. What we see is almost an hourglass, but one that is equally full on top and on bottom, one that, because it need never be turned, seems oddly, paradoxically eternal. What we also see is the most luminous of vanishing points, as if human time had suddenly, in a colorful instant, merged with another time, one that hitherto had been beyond us, beyond even our ability to imagine. This vision will disappear. That radiant moment of stillness will be absorbed in the productions of a full and normalizing daylight.

ROCKY MOUNTAIN NATIONAL PARK

Colorado, Established 1915

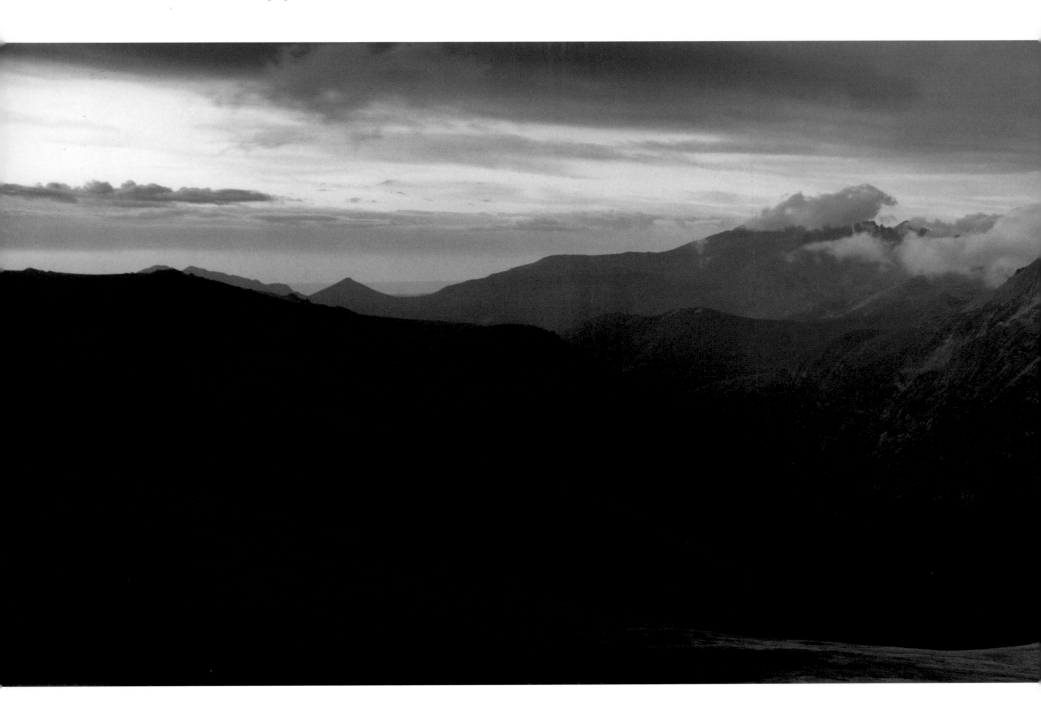

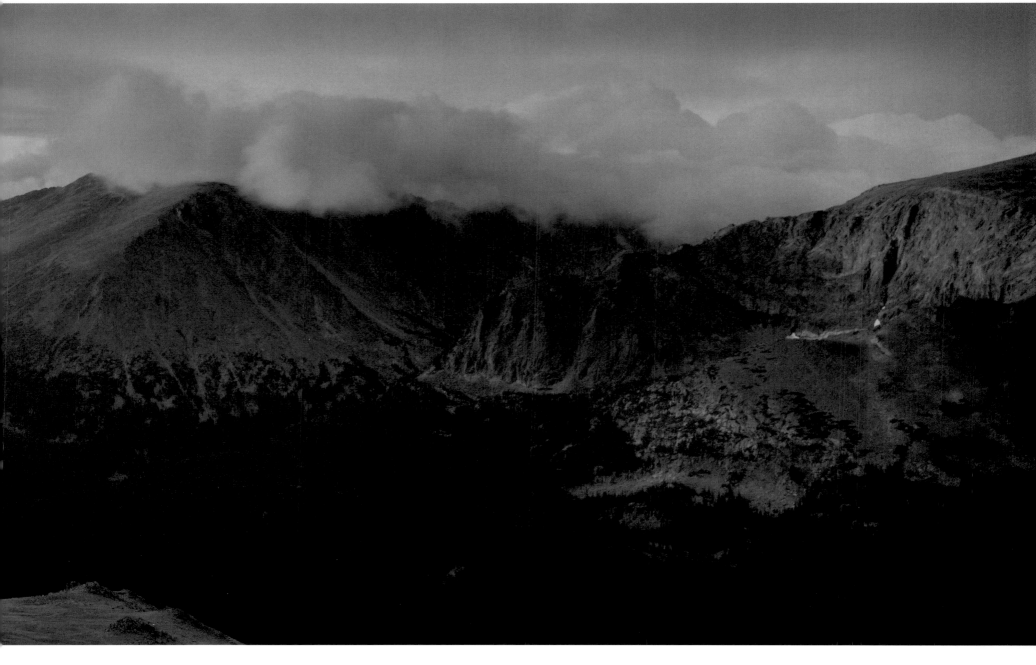

Alpine tundra from
Trail Ridge Road.

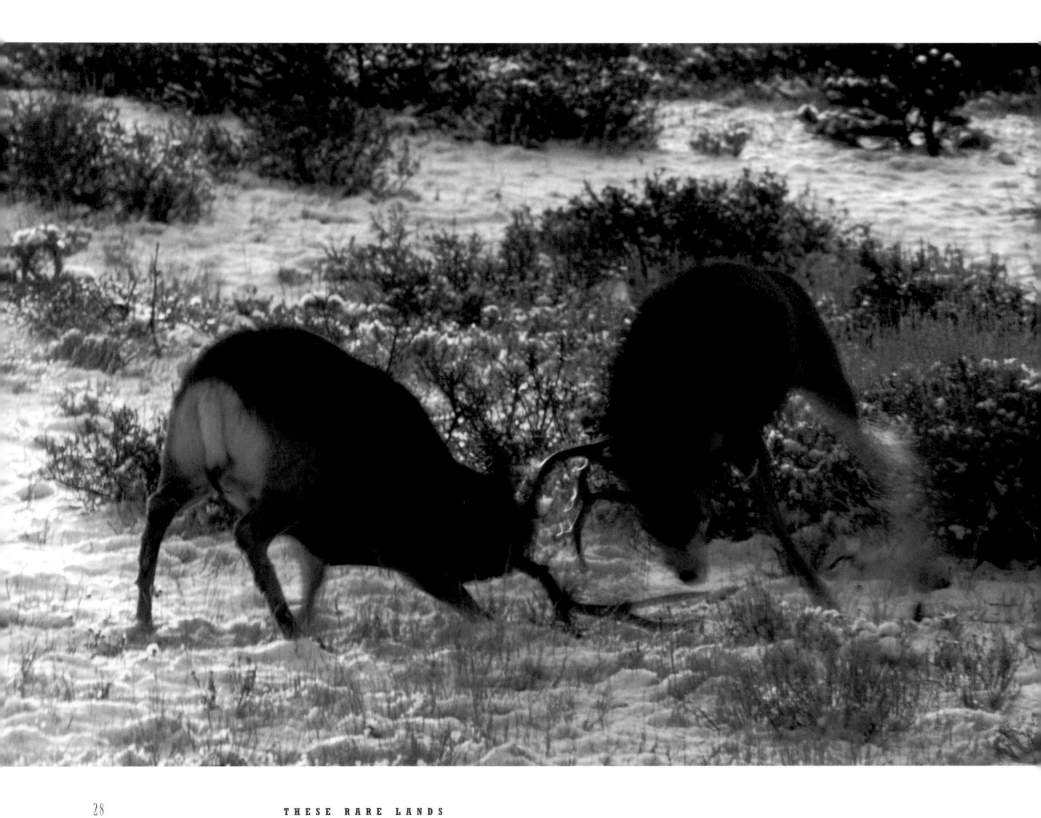

THESE RARE LANDS

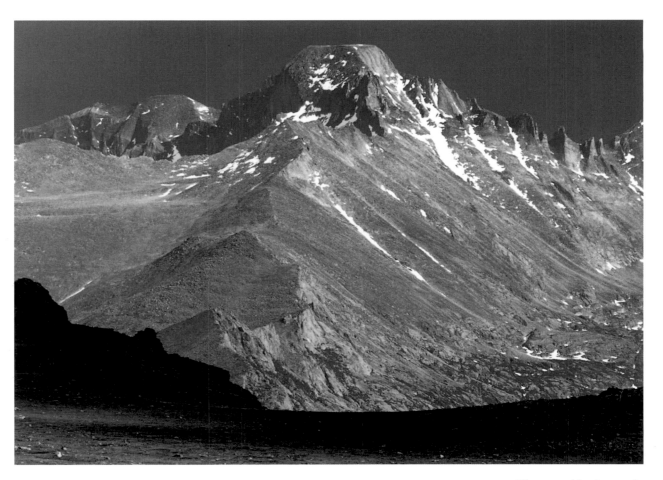

ABOVE: The rugged landscape of Longs Peak.

OPPOSITE: Mule deer in territorial battle.

HAWAII VOLCANOES NATIONAL PARK

HAWAII, ESTABLISHED 1916

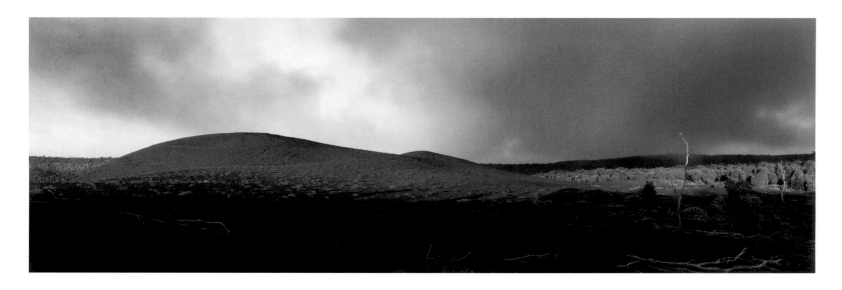

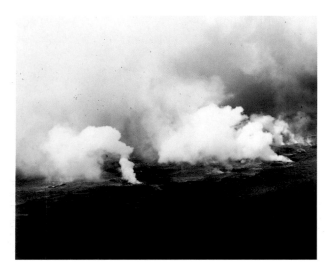

ABOVE: Devastation Trail.

LEFT: Fumaroles at Puu Oo.

OPPOSITE: Early Hawaiian petroglyph at Puu Loa.

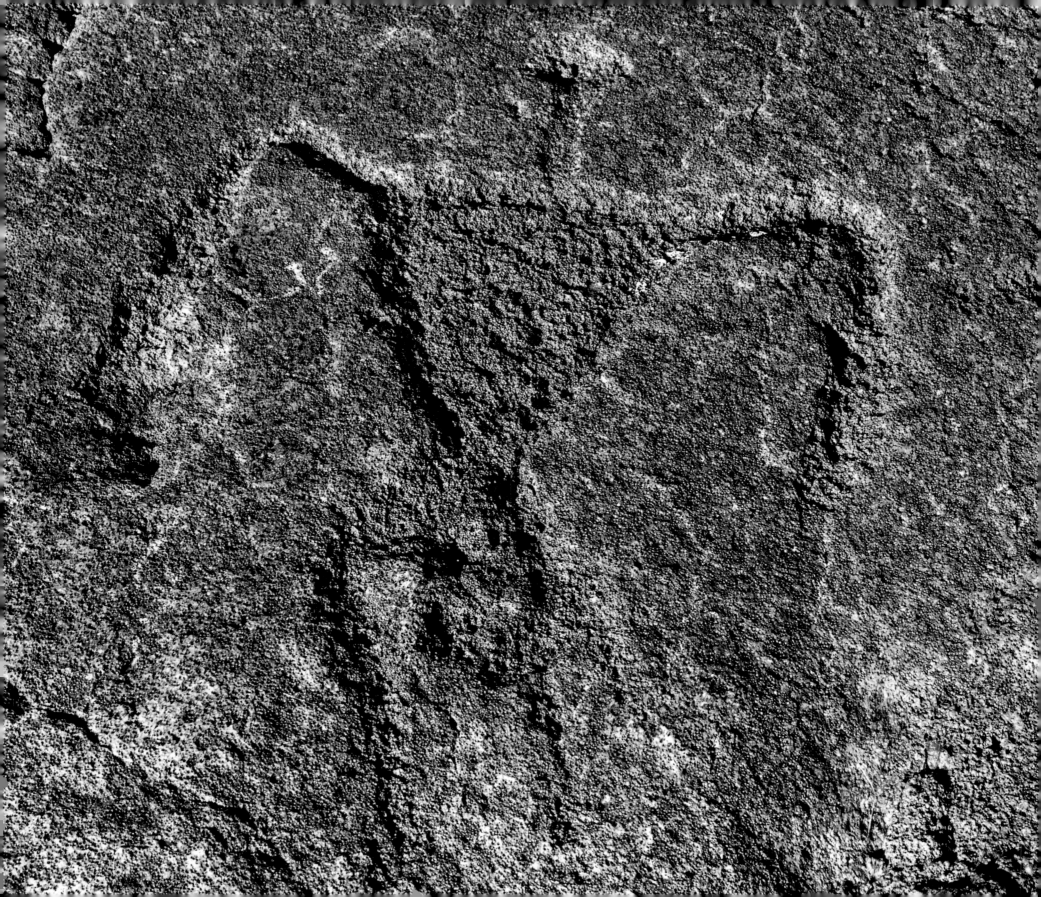

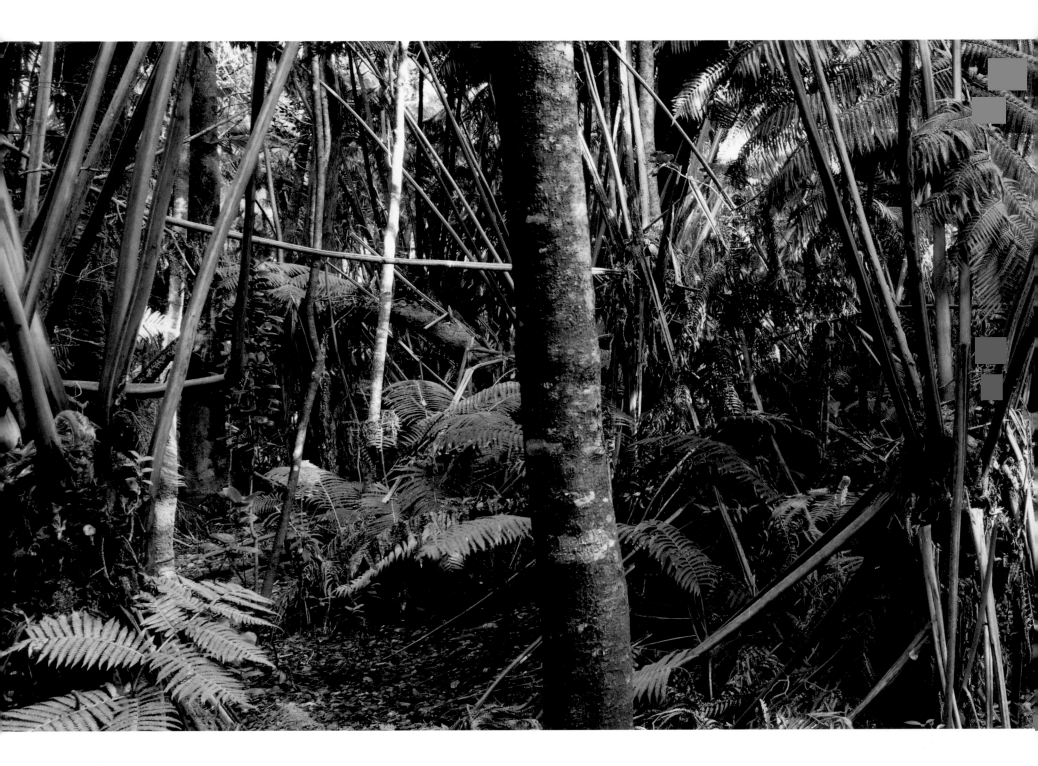

THESE RARE LANDS

HALEAKALA NATIONAL PARK

Hawaii, Established 1916

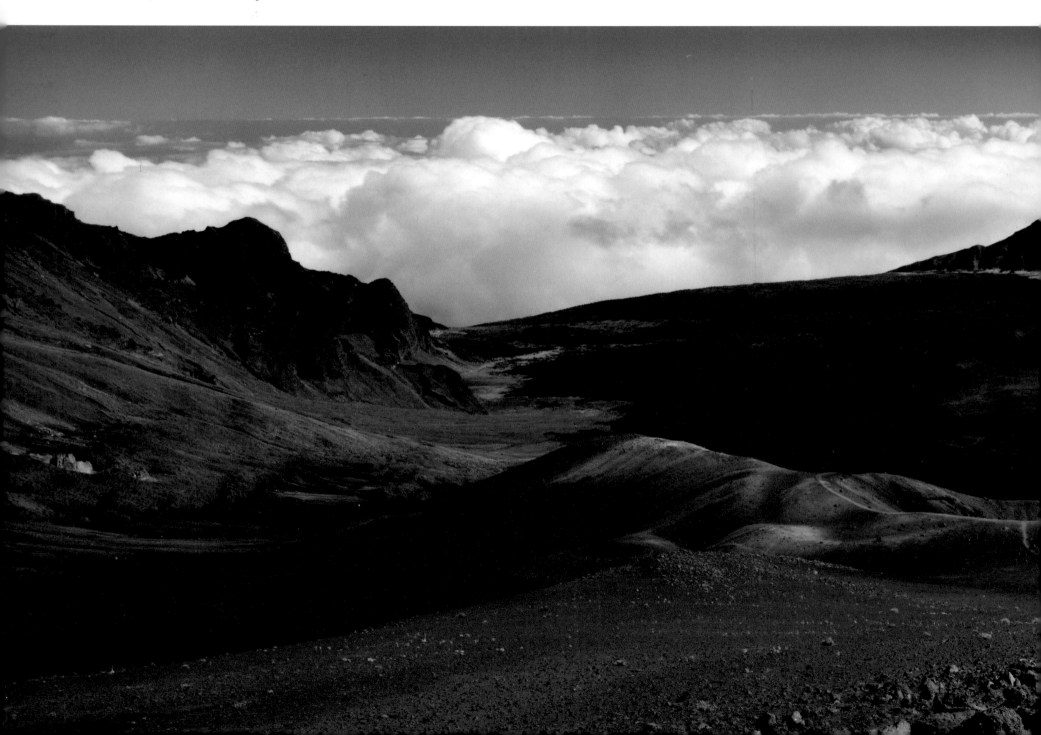

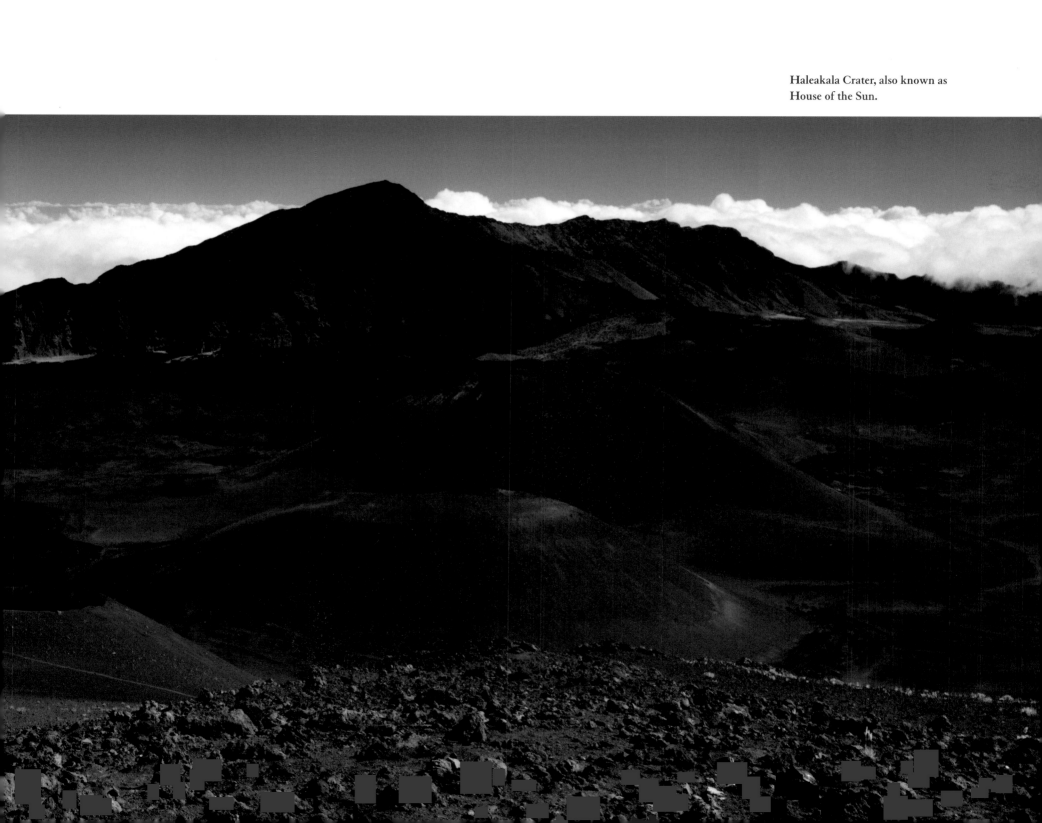

Haleakala Crater, also known as
House of the Sun.

LASSEN VOLCANIC NATIONAL PARK

CALIFORNIA, ESTABLISHED 1916

Lassen is an astonishing piece of geography. A substantial portion of the park, the area around Lassen Peak itself, is all that remains of Mount Tehama, an 11,000-foot mountain that was destroyed over the course of thousands of years by repeated eruptions and finally by glacial erosion. The experience of walking in Lassen is eerie, for one actually walks within a phantom mountain in the space that Mount Tehama occupied. The landscape itself is at spots a boulder-strewn expanse, at others a place of bubbling sulfurous hot springs that are obvious reminders of a violent past.

Born from a violent eruption, the Cinder Cone has been built up over centuries from volcanic ash and cinder.

DENALI NATIONAL PARK

Alaska, Established 1917

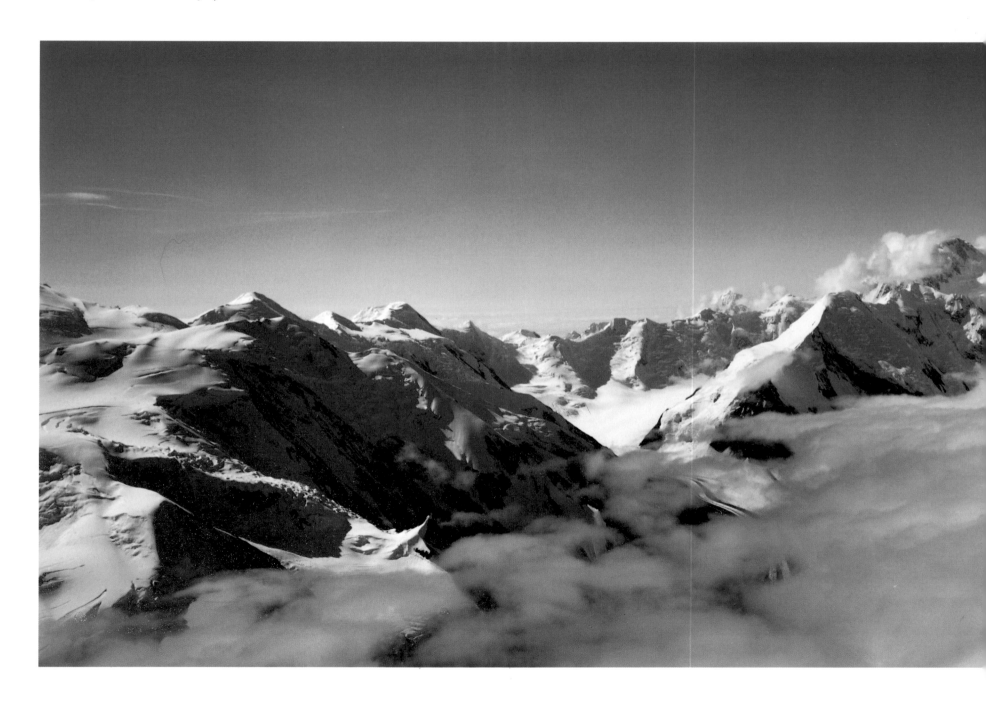

The rooftop of North America: North and South Peaks of Mt. McKinley.

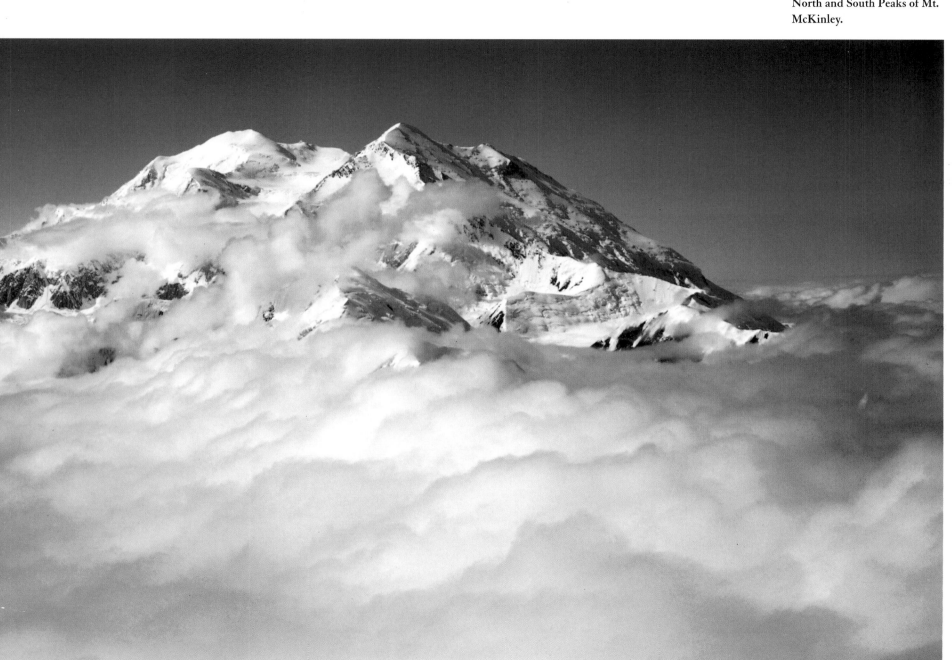

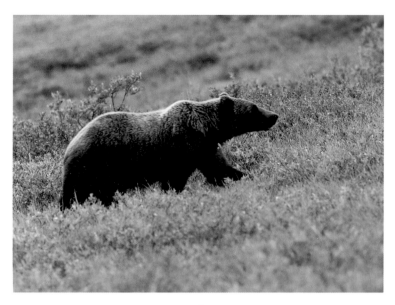

LEFT: A grizzly bear hunting near the Teklanika River.

OPPOSITE: The Wyoming Hills.

BELOW: Cathedral Mountain.

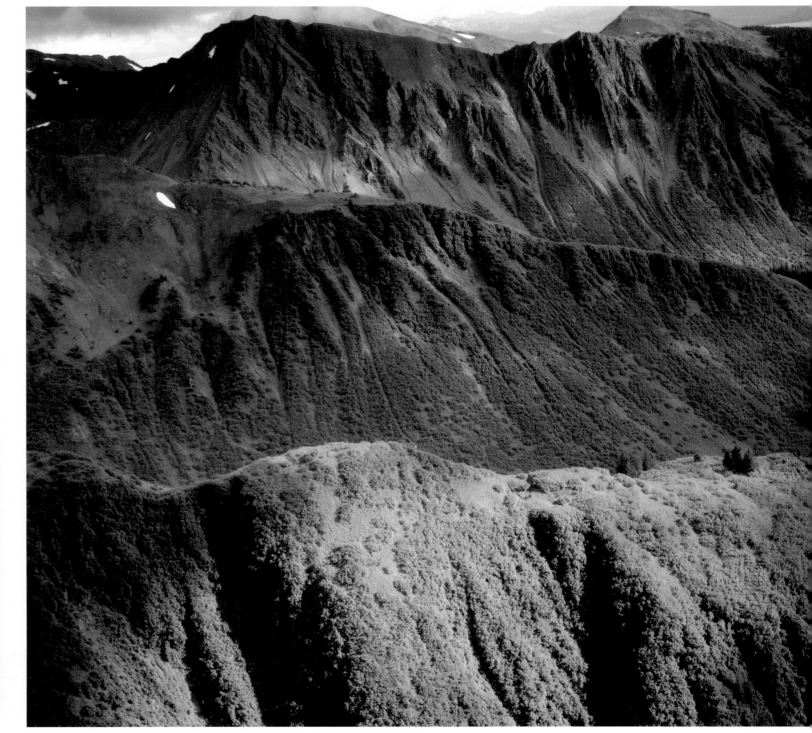

ACADIA NATIONAL PARK

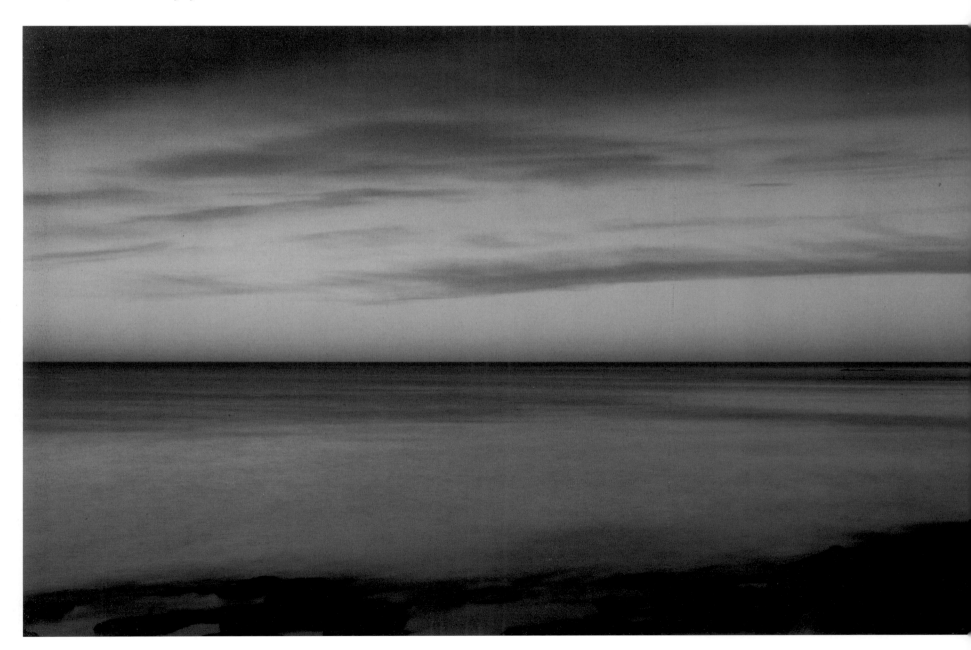

Dawn, Otter Cliffs.

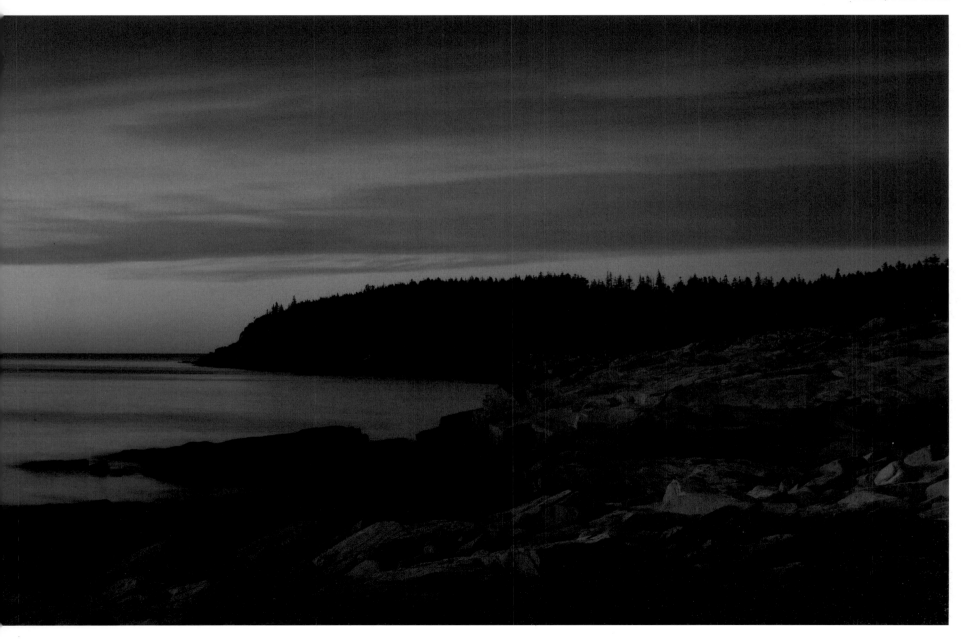

GRAND CANYON NATIONAL PARK

Arizona, Established 1919

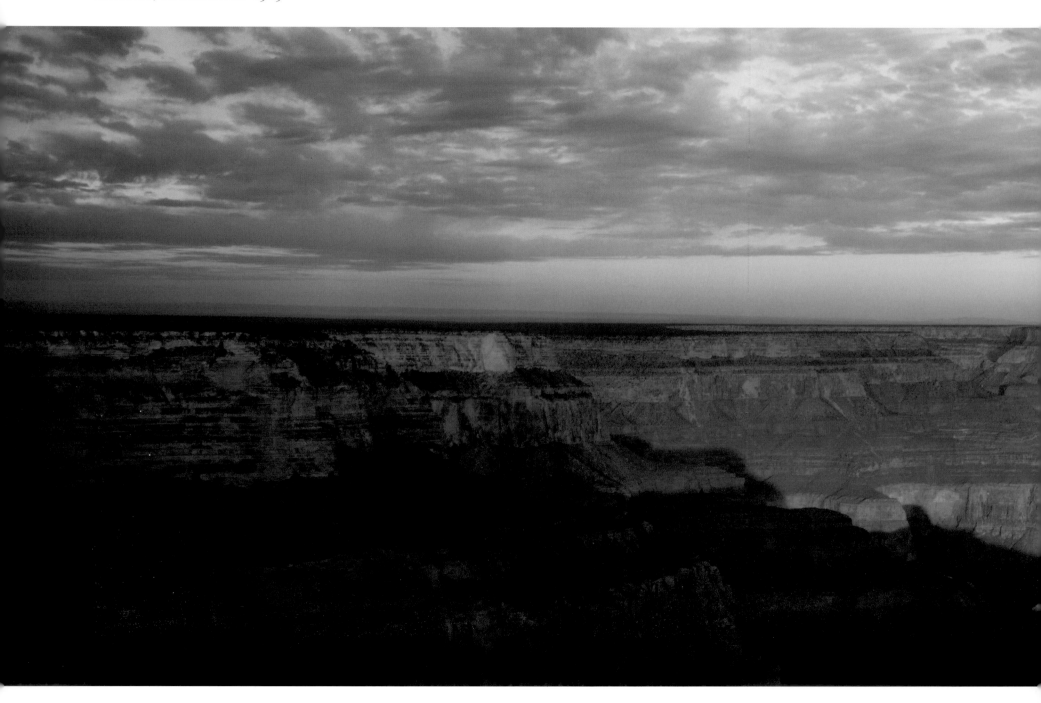

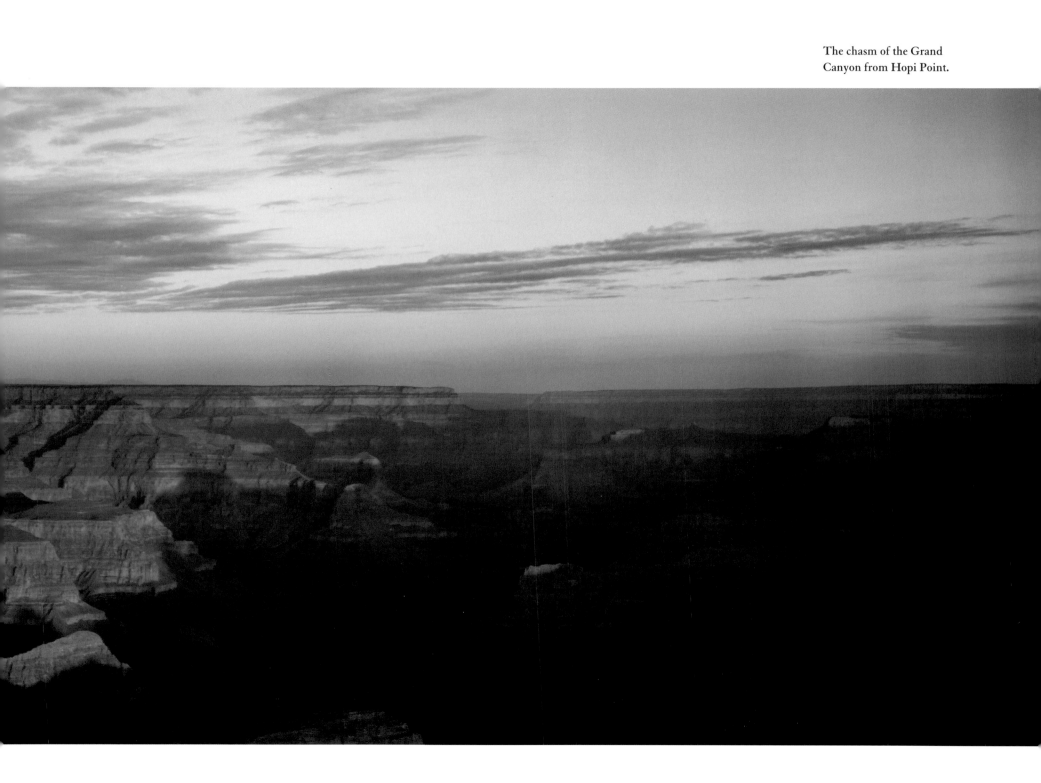

The chasm of the Grand
Canyon from Hopi Point.

ZION NATIONAL PARK

UTAH, ESTABLISHED 1919

Zion is the golden cousin of Yosemite. But it is also, depending on the hour of the day and where the sun is shining, pink and red, white and yellow. Colors seem to stream down the sides of the great gorge that is Zion Canyon to the Virgin River below. Its sandstone towers not only glow in sunlight, they radiate a peculiar warmth to everything in the park. There is something oddly intact about Zion, as if it were the work not only of natural forces but of a master designer. The grooves and scratches that mark the canyon walls seem like the creation of a fastidious sculptor. To walk in Zion is to be enveloped by languorous contours of light.

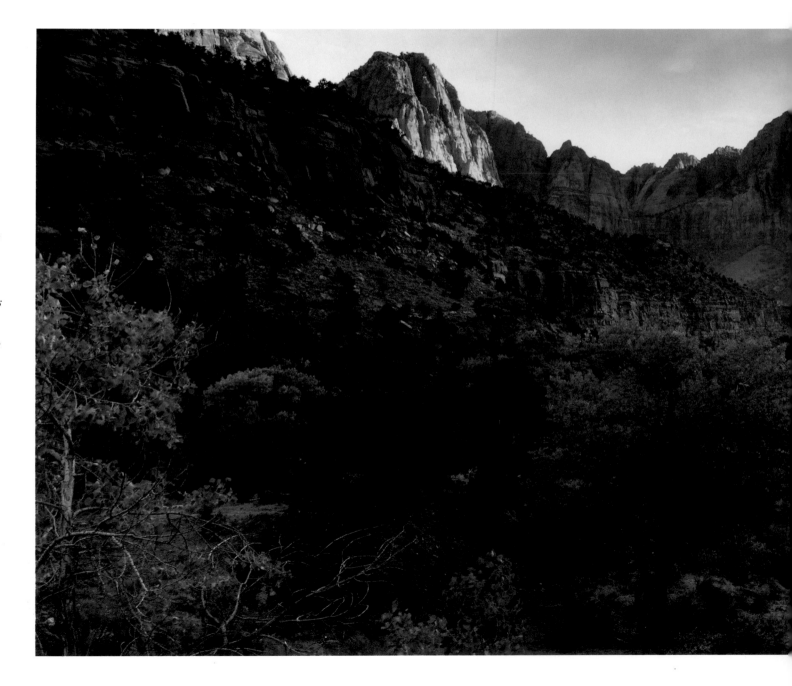

A distant rock formation known as the Watchman seems to guard the Virgin River.

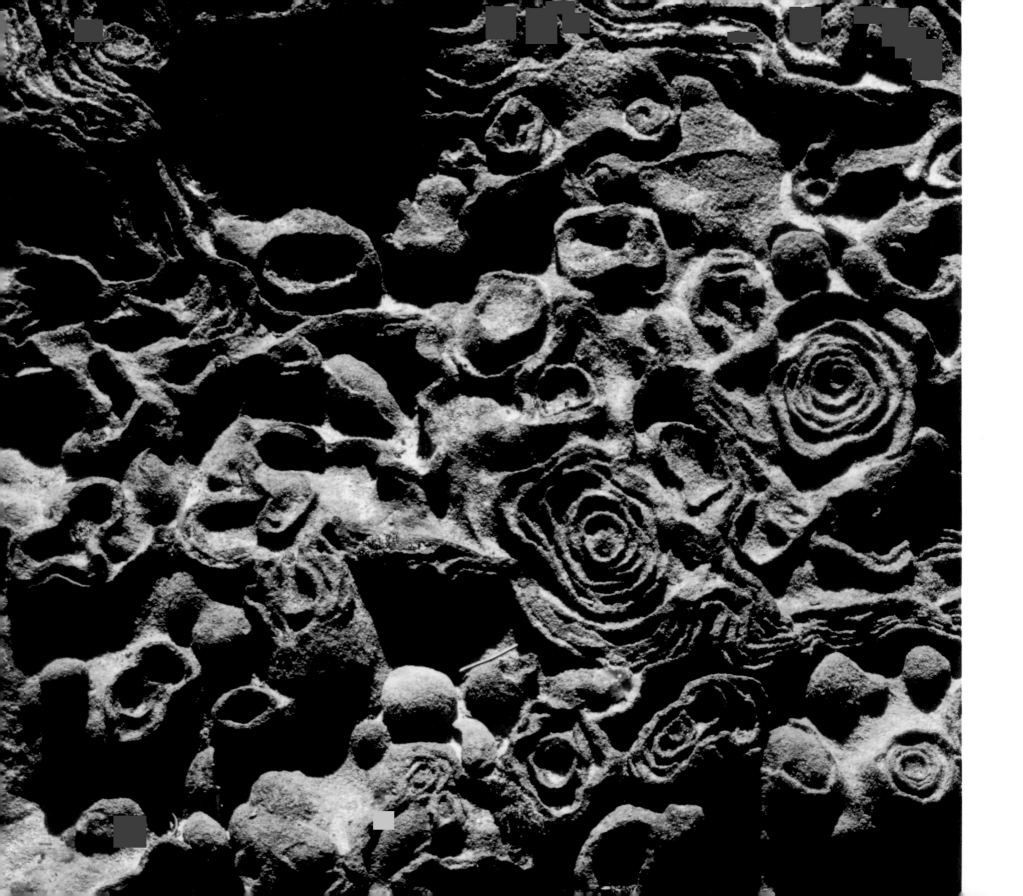

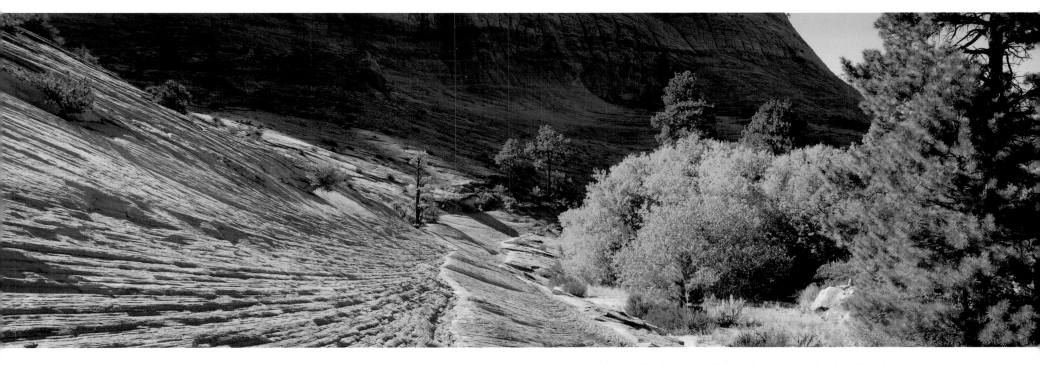

ABOVE: The track of ancient winds and waters on a bank of Navajo sandstone.
OPPOSITE: Concretions of rock weathered by wind and water.
BELOW: The multicolored palette near Pine Creek.

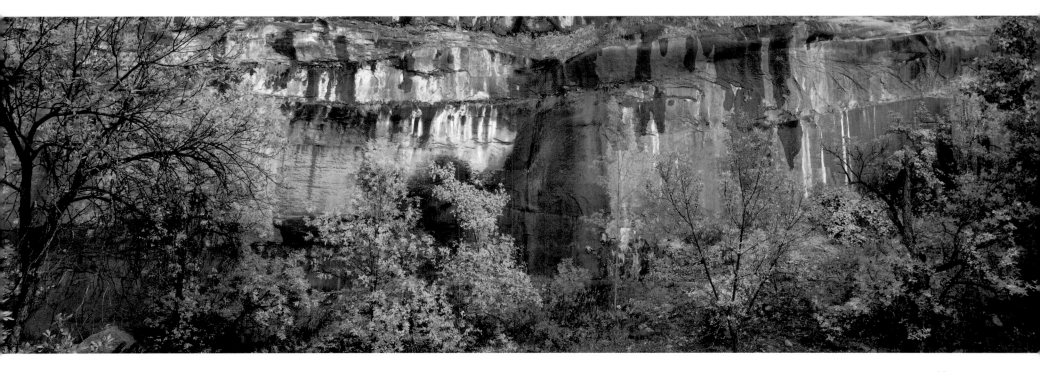

HOT SPRINGS NATIONAL PARK

ARKANSAS, ESTABLISHED 1921

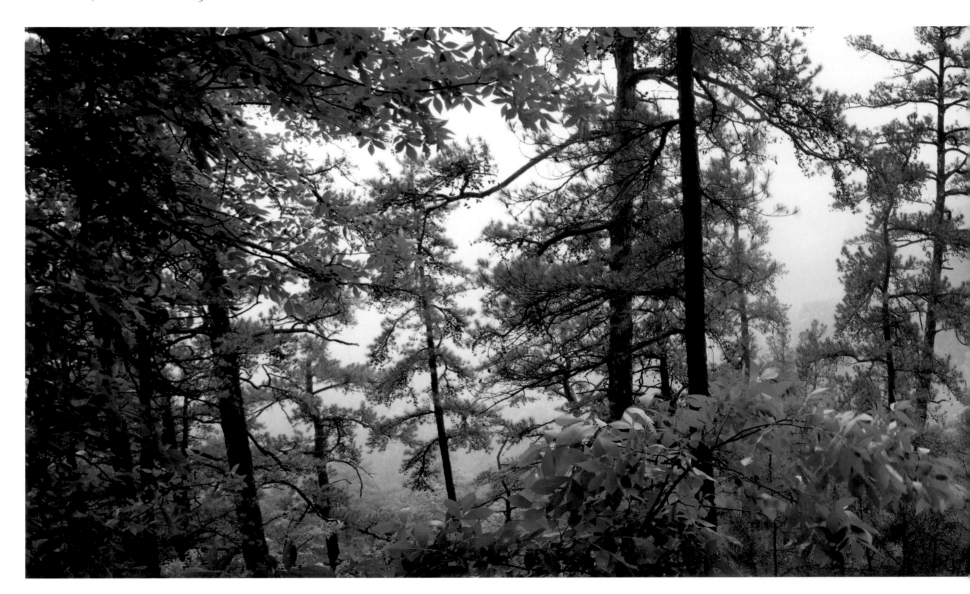

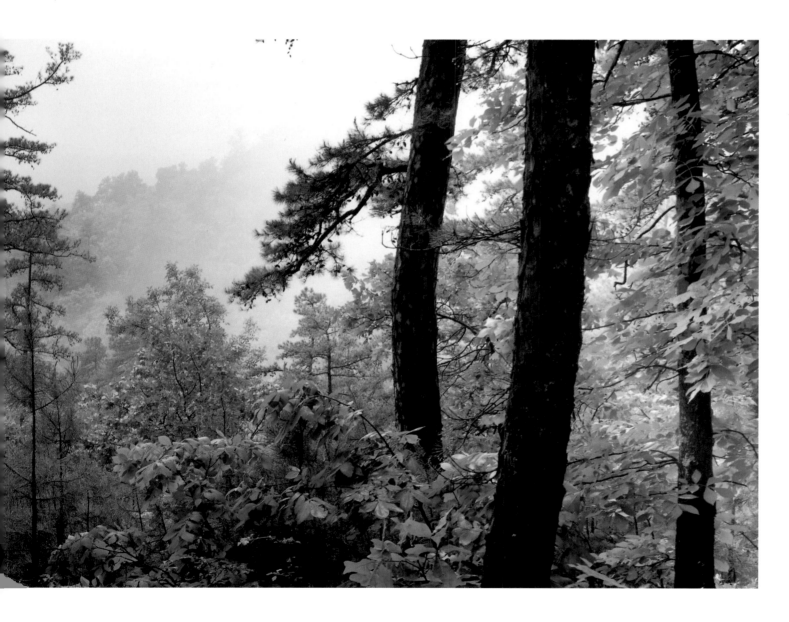

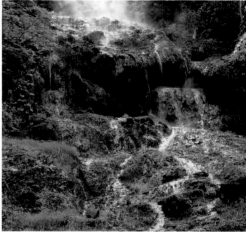

ABOVE: Thermal cascade.

LEFT: Goat Rock Trail.

BRYCE CANYON NATIONAL PARK

UTAH, ESTABLISHED 1928

Bryce Canyon, though made up of curious formations of red rock and only sparsely populated by trees, manifests an air of intimacy. Located in south-central Utah and at an elevation of about 9,000 feet, Bryce has a look and a feel that is different from any of the other parks in the Southwest. The bands of ochre, white, and pink that spread throughout the park with remarkable consistency not only contrast with but emphasize the bizarrely shaped results of differential erosion.

It has often been remarked that the park's pinnacles and spires give it the look of a decayed city, silenced by the abrasions of time. Its quality of intimacy, however, comes from the ease with which we can stroll among its strange formations as we would among the tall trees of Redwood National Park. Bryce has a localness about it. We walk among its spires and crumbled crenelations, in steep and narrow canyons, as if we were wending our way through the streets of a medieval village. So unusual is Bryce that even when we are in the middle of it, we will liken our being there to being in another place.

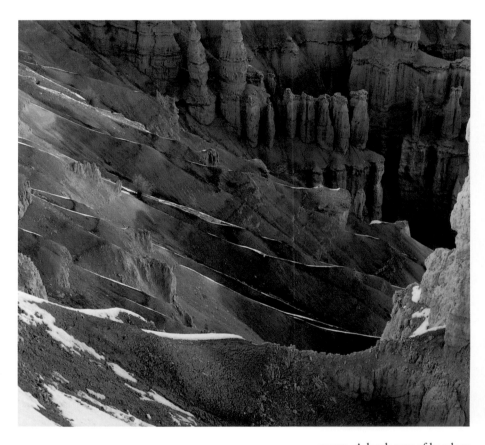

ABOVE: A landscape of hoodoos below Inspiration Point.

RIGHT: Thor's Hammer seen from Navajo Loop Trail.

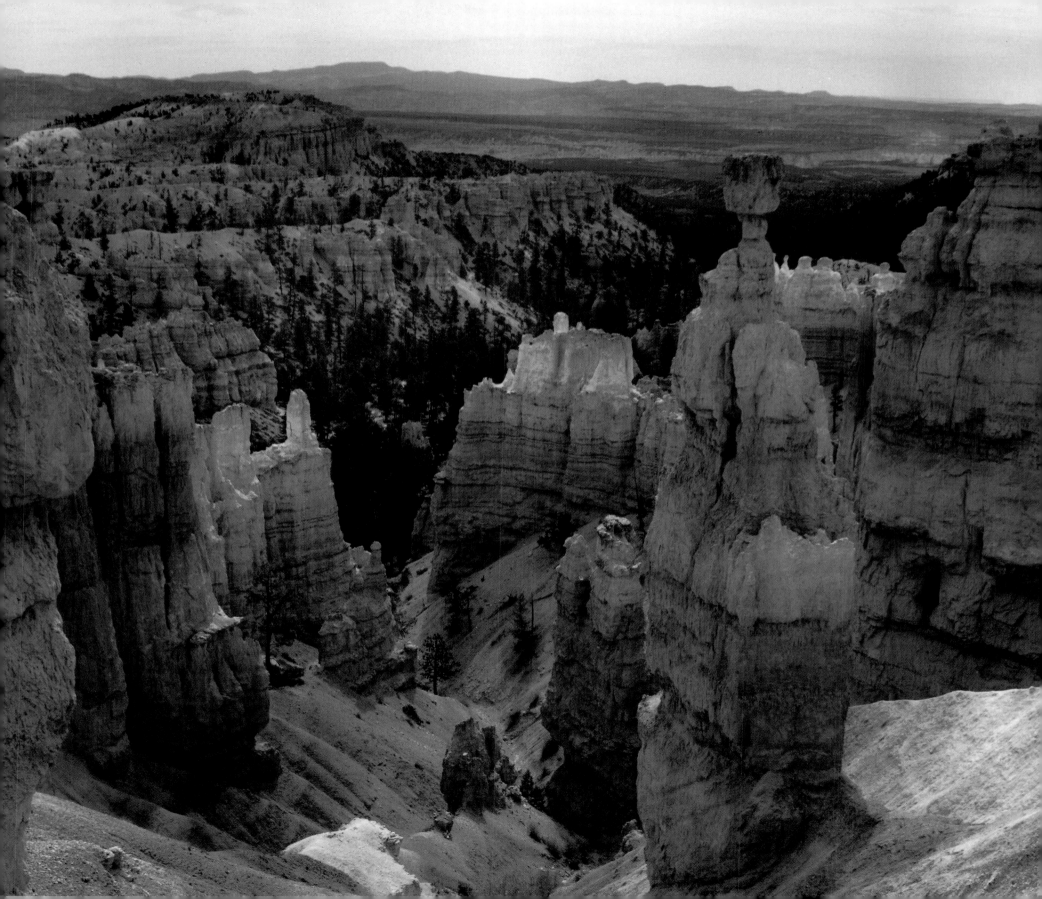

CARLSBAD CAVERNS NATIONAL PARK

New Mexico, Established 1930

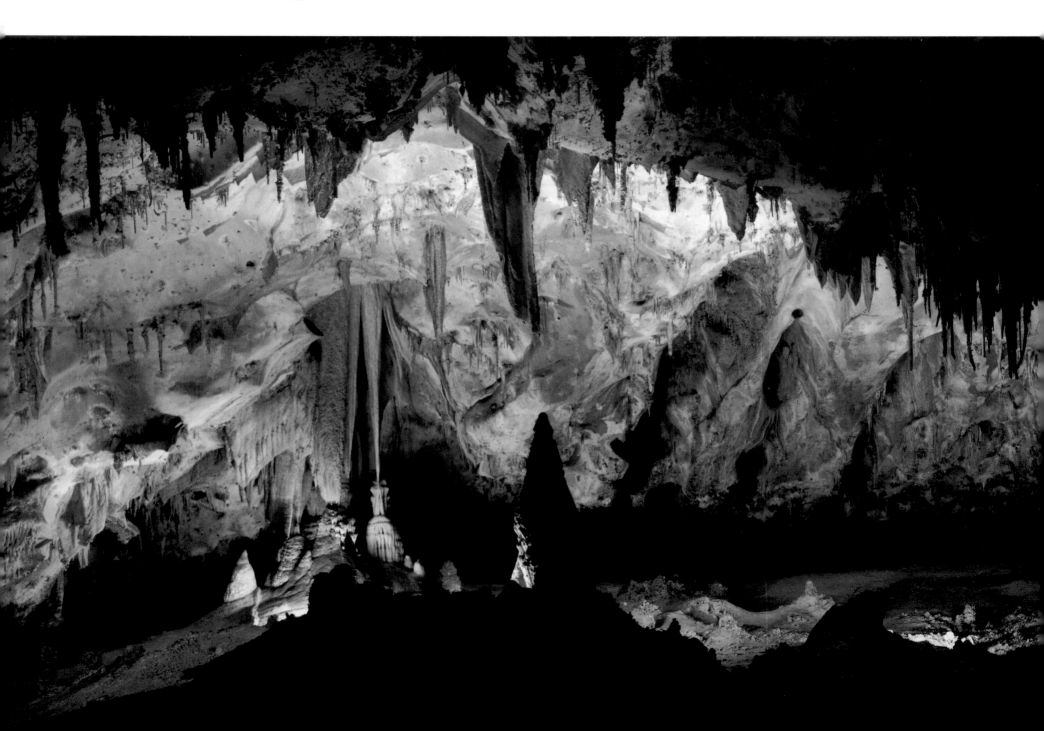

A formation called the Witch's Broomstick stands on the left in the Papoose Room of the Caverns.

GREAT SMOKY MOUNTAINS NATIONAL PARK

Tennessee, North Carolina, Established 1934

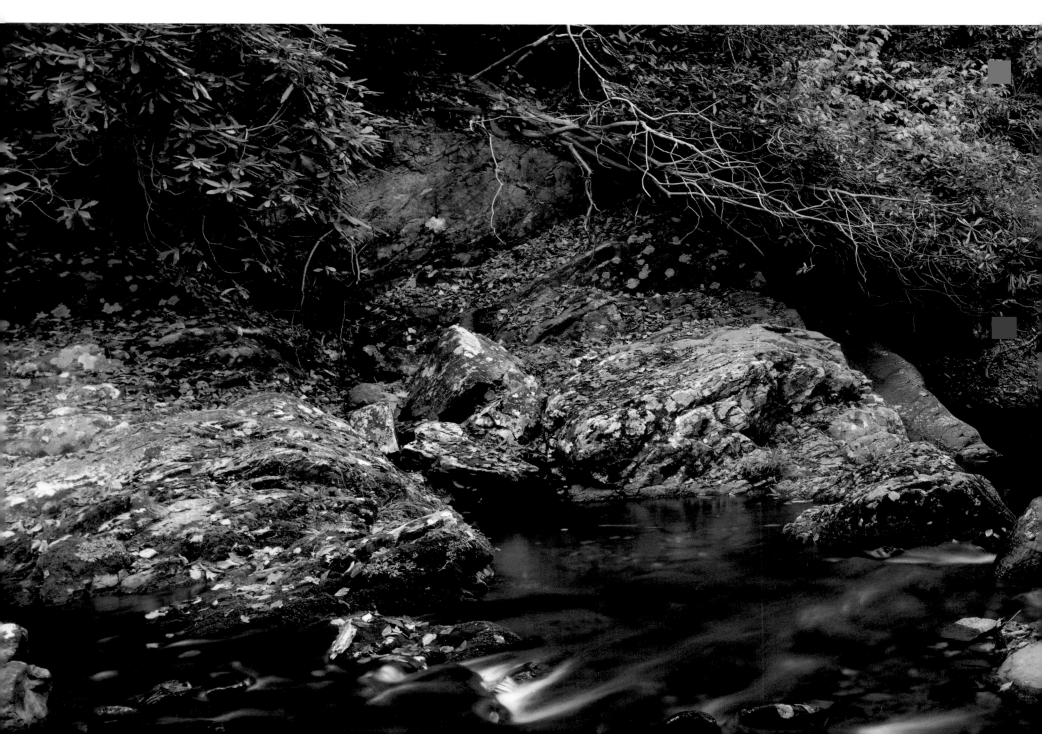

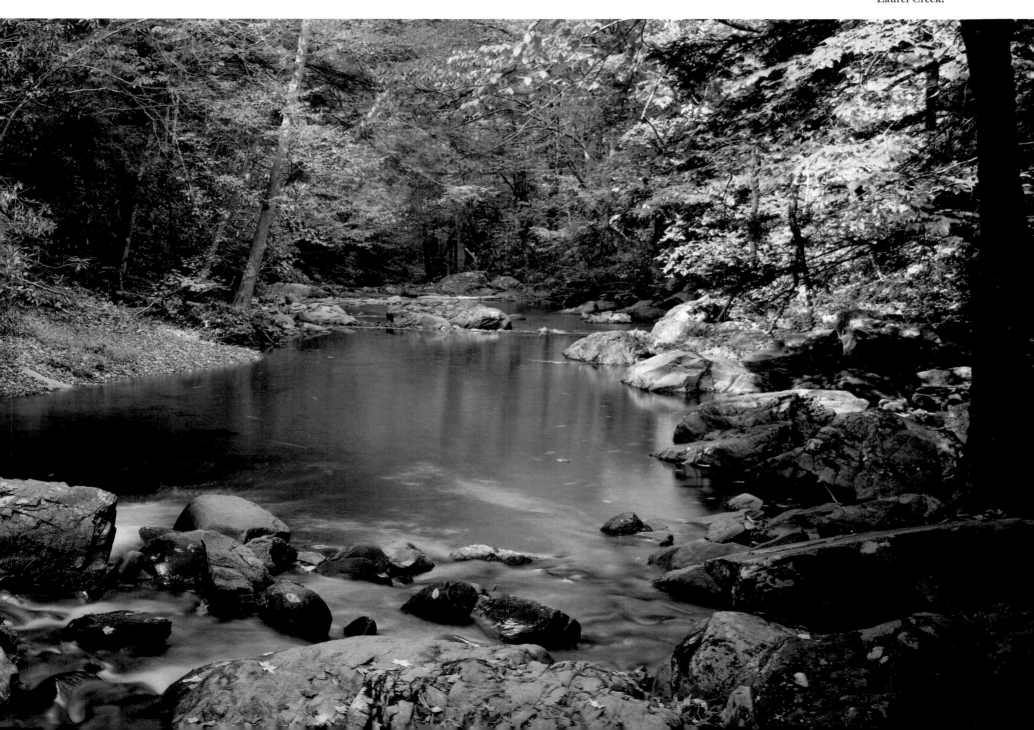

Laurel Creek.

SHENANDOAH NATIONAL PARK

VIRGINIA, ESTABLISHED 1935

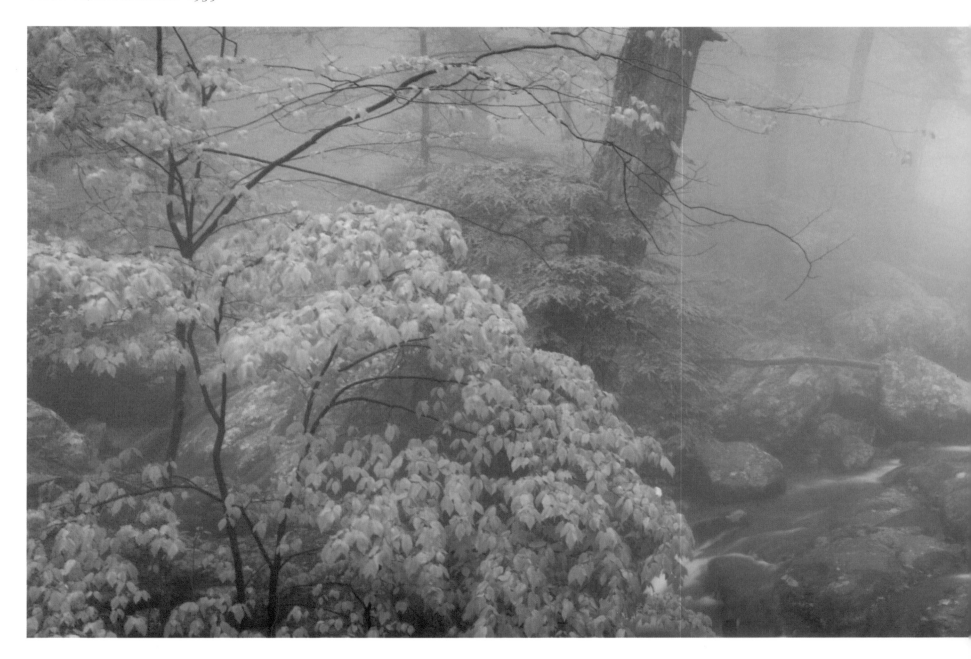

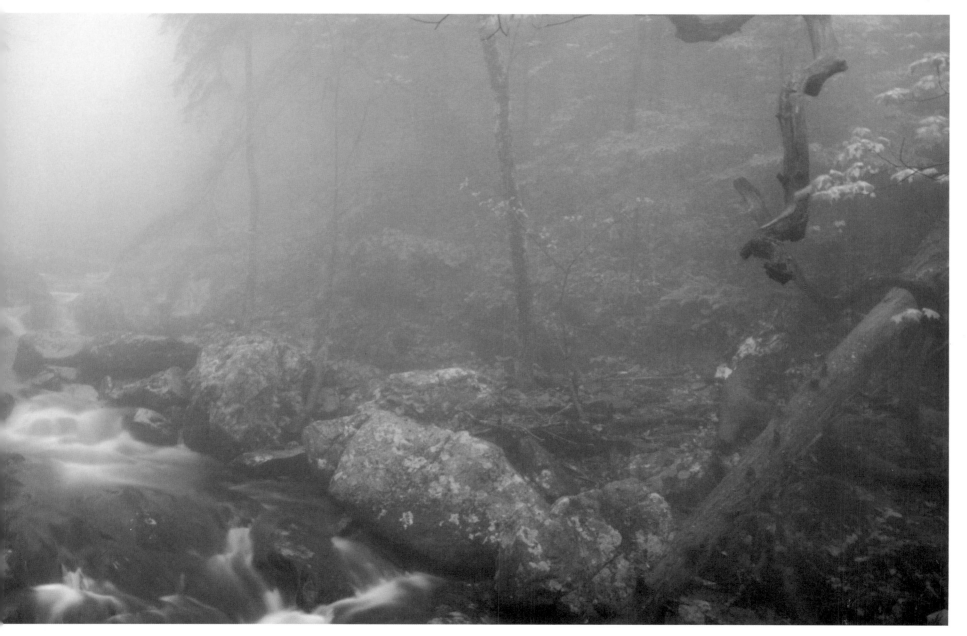

OLYMPIC NATIONAL PARK

Washington, Established 1938

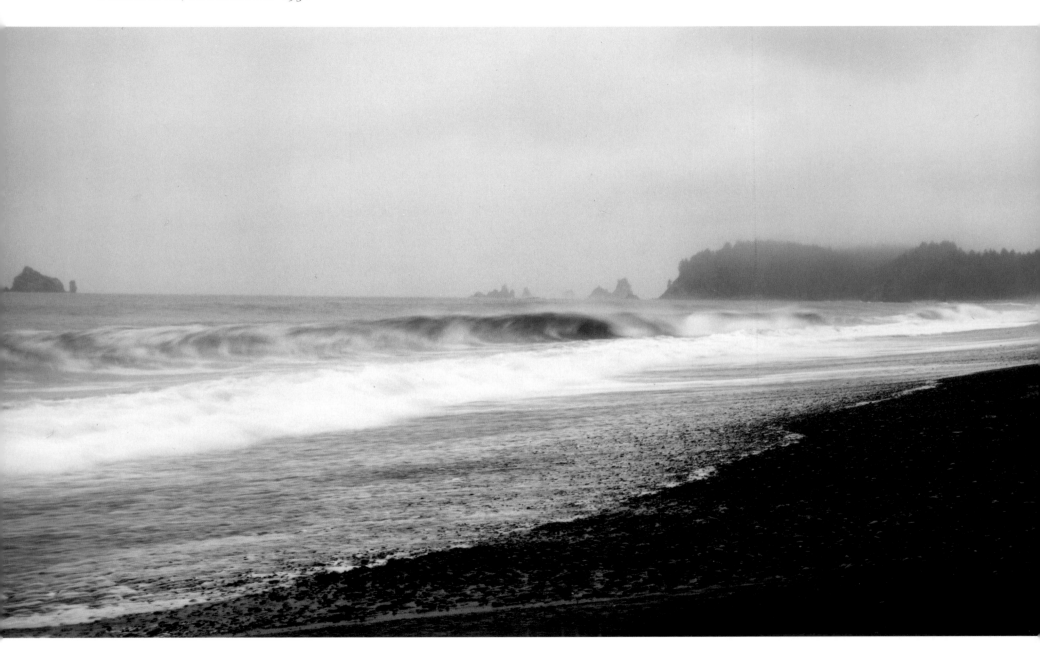

BELOW: Rialto Beach.

OVERLEAF: The dense and secluded Quinault Rain Forest.

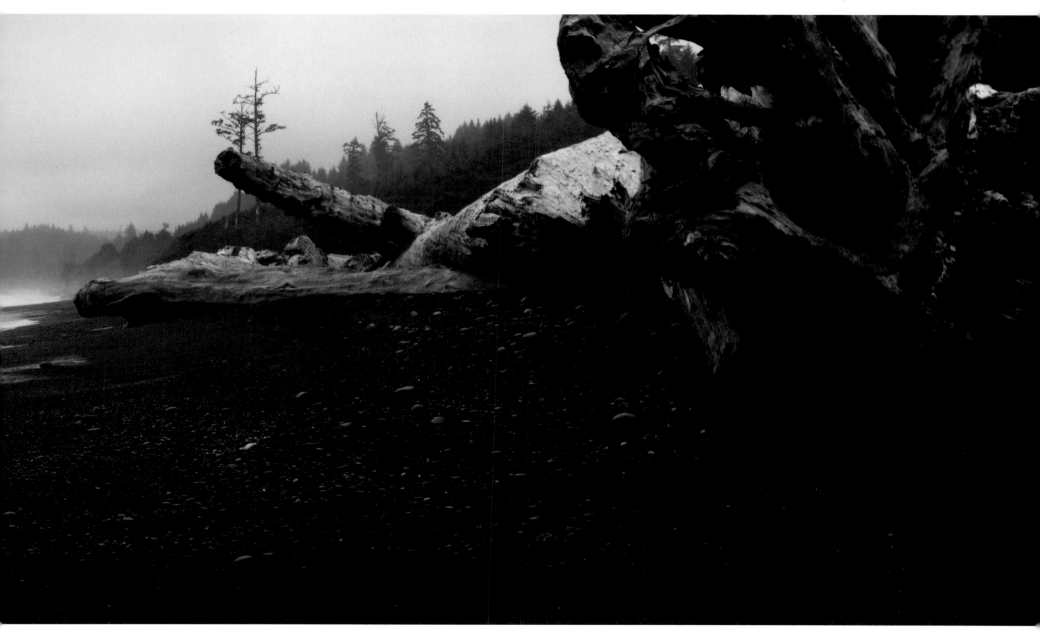

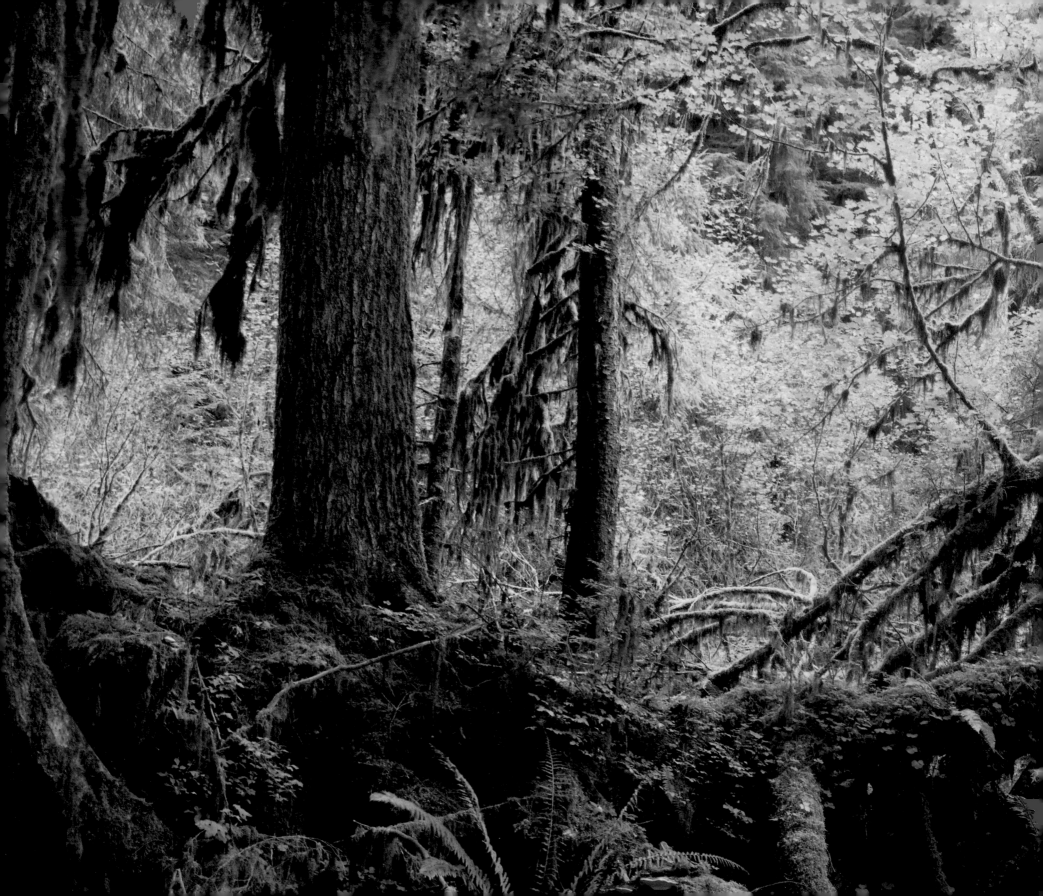

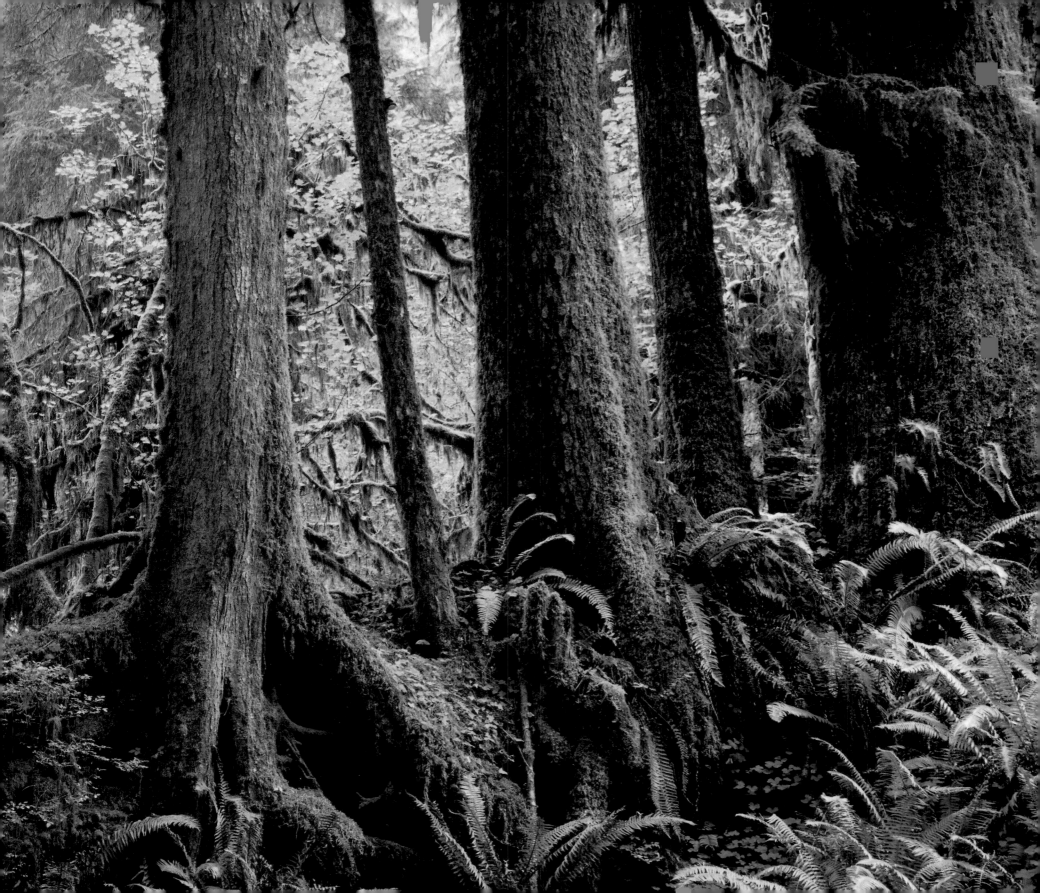

KINGS CANYON NATIONAL PARK

CALIFORNIA, ESTABLISHED 1940

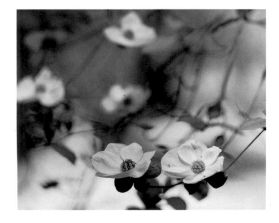

ABOVE: Dogwood in flower.

RIGHT: The scenic region near Knapp's Cabin.

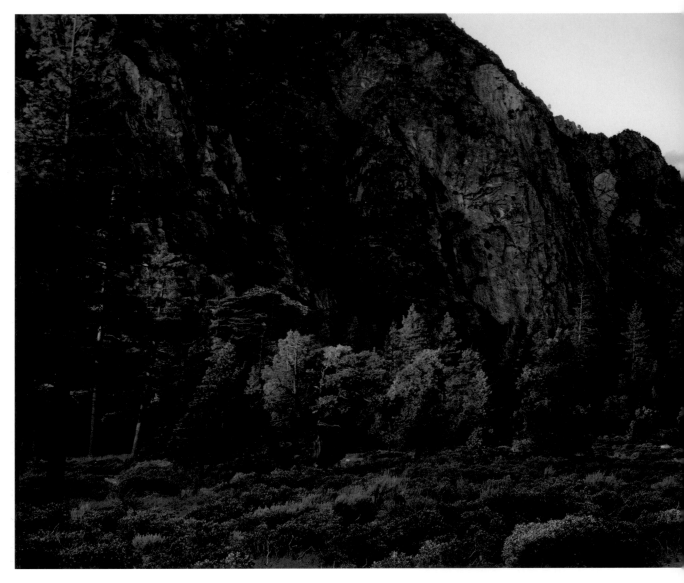

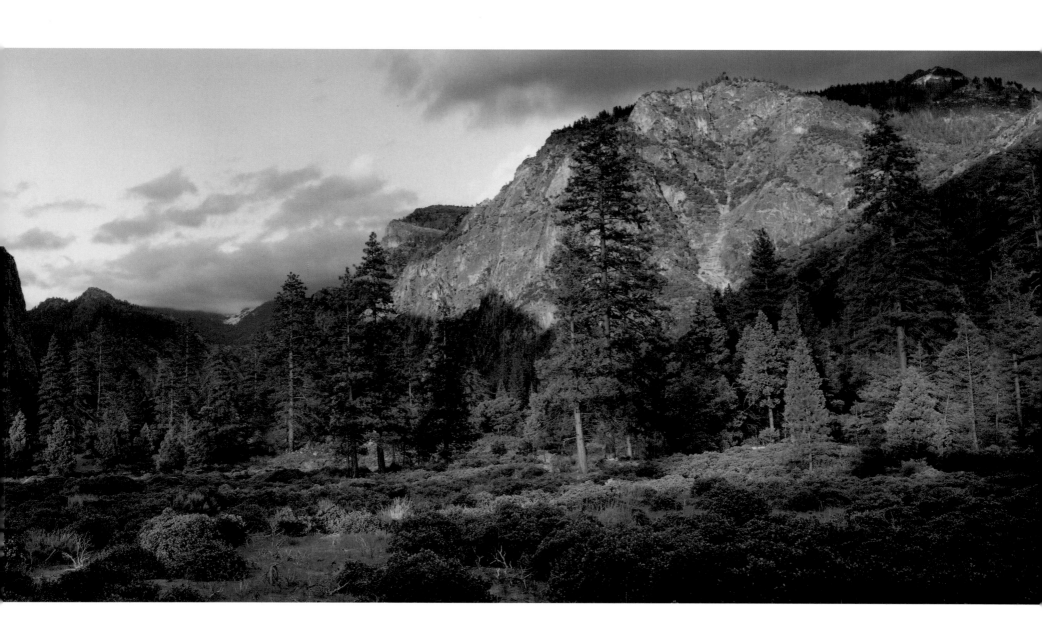

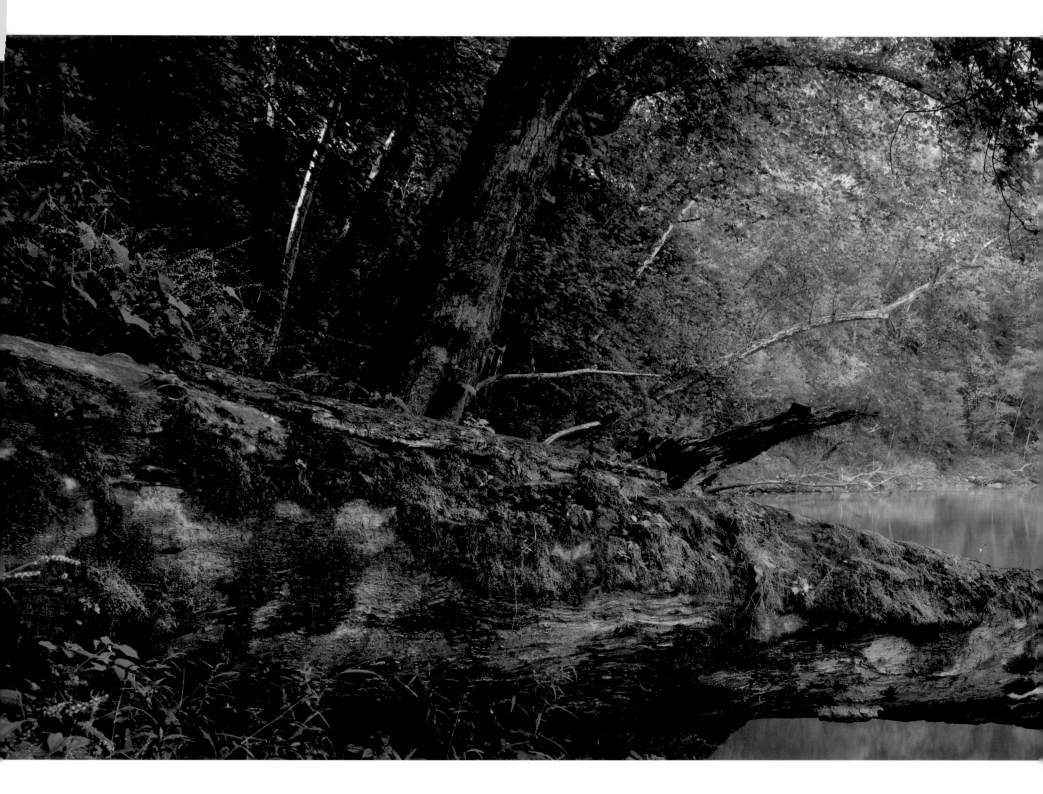

THESE RARE LANDS

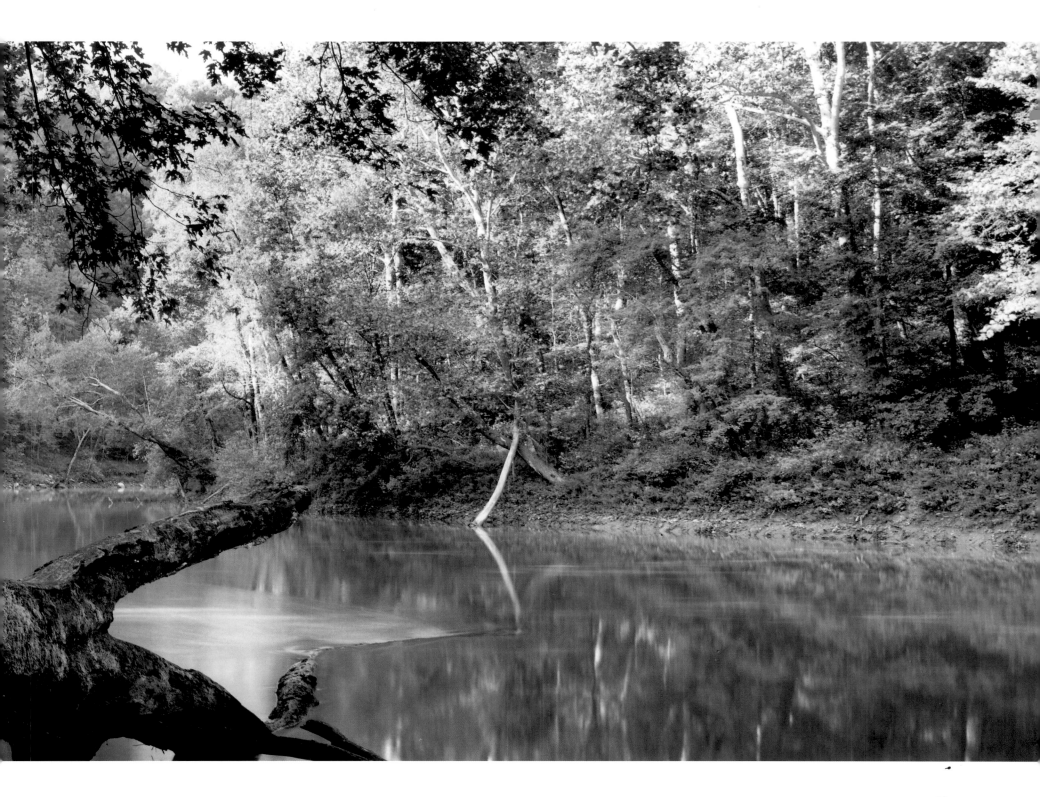

BIG BEND NATIONAL PARK

Texas, Established 1944

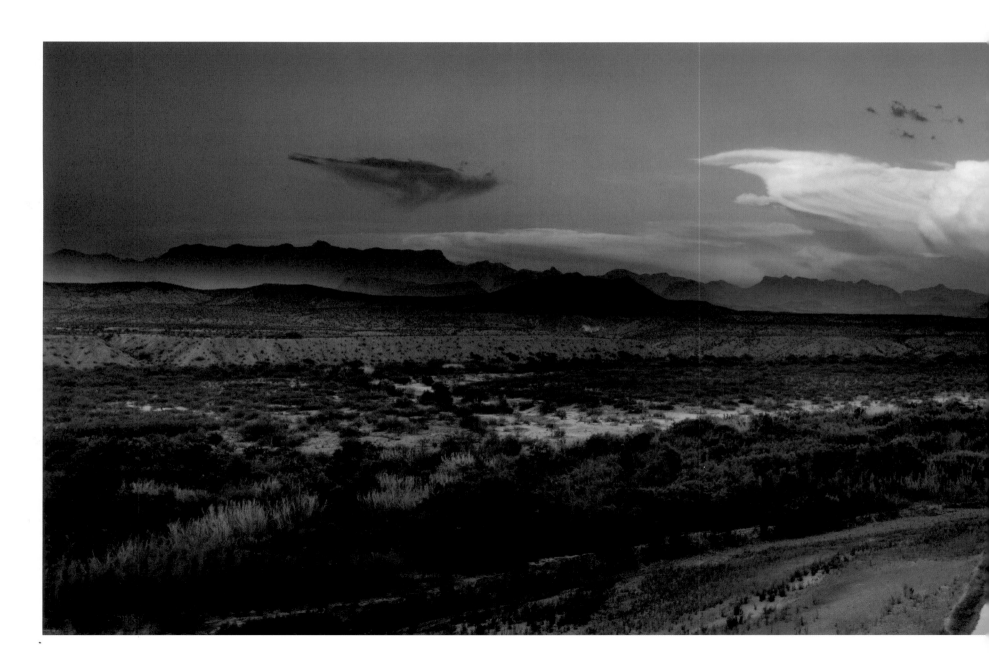

BELOW: The Rio Grande.

FOLLOWING PAGES: (PAGES 76–77)
Lightning seen from Sotol Vista.
(PAGES 78–79) Santa Elena Canyon.

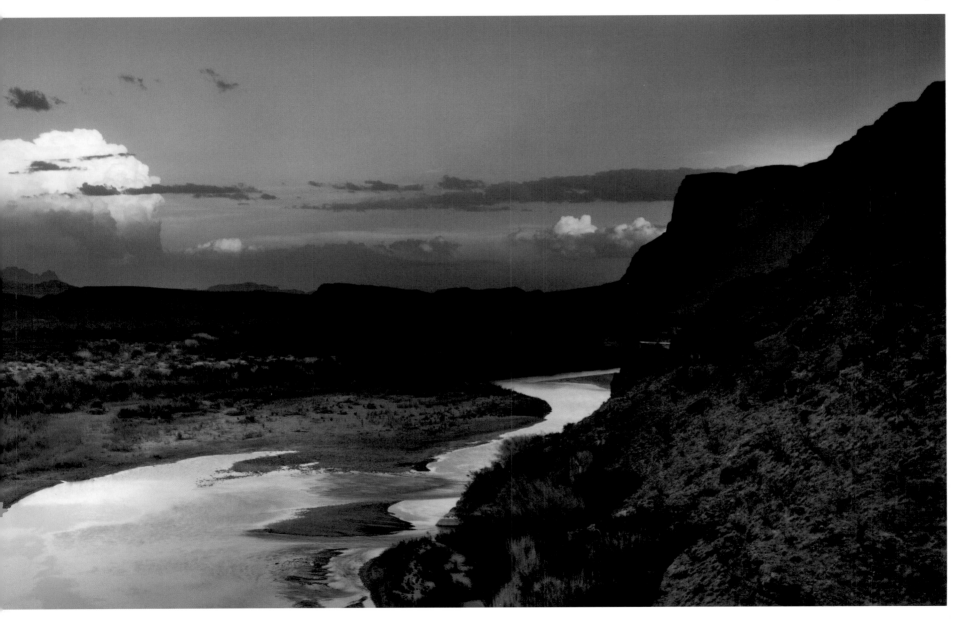

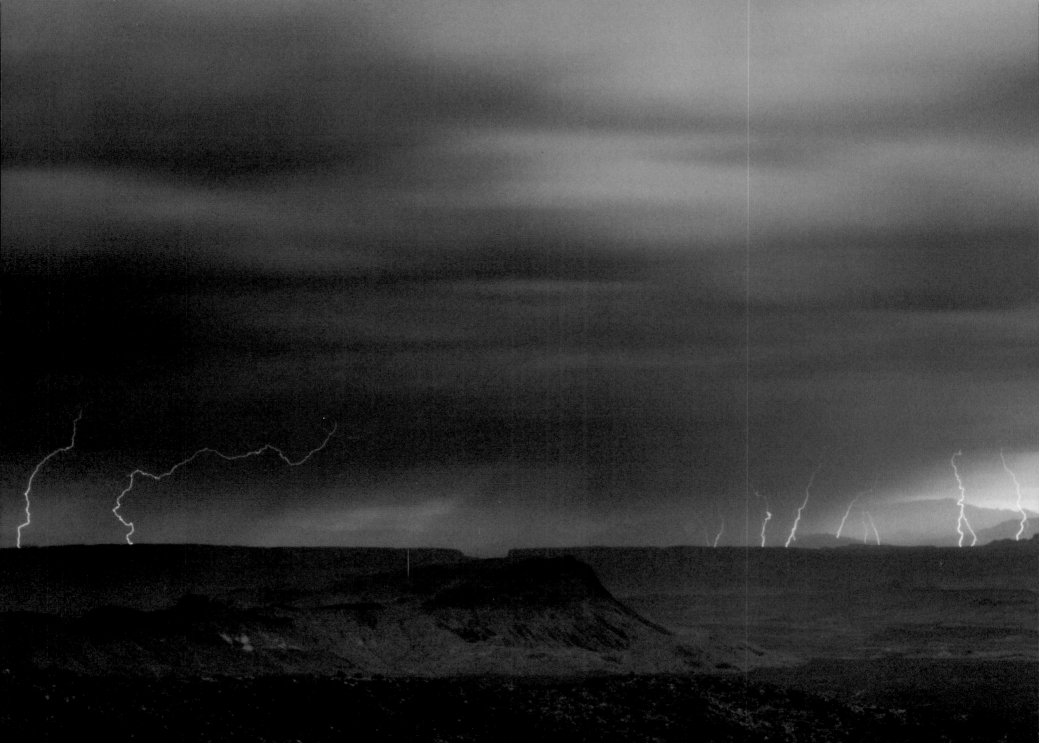

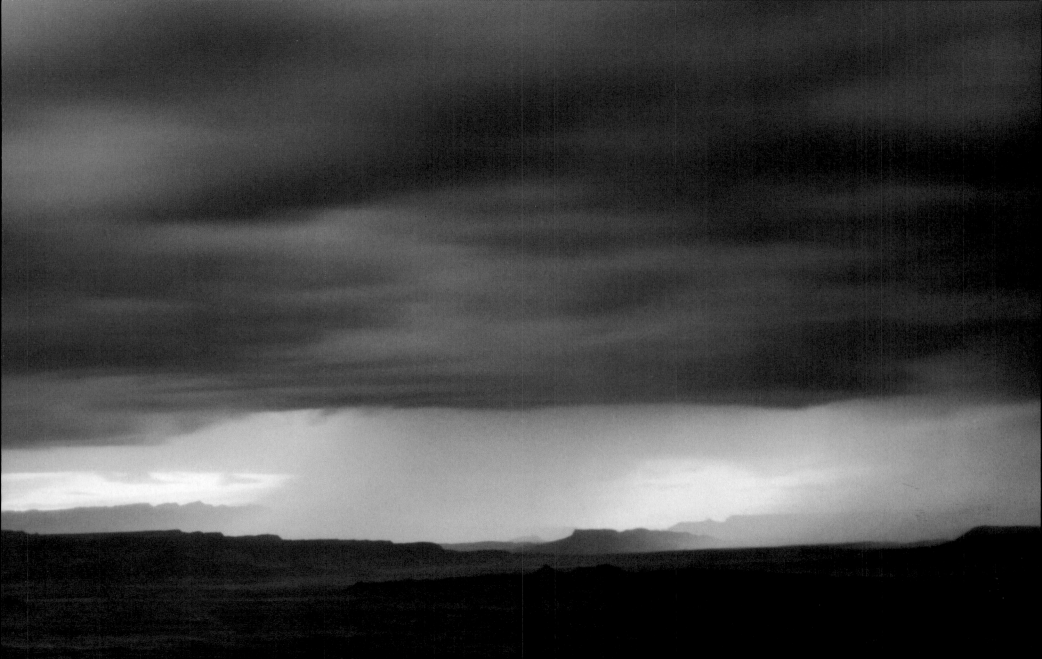

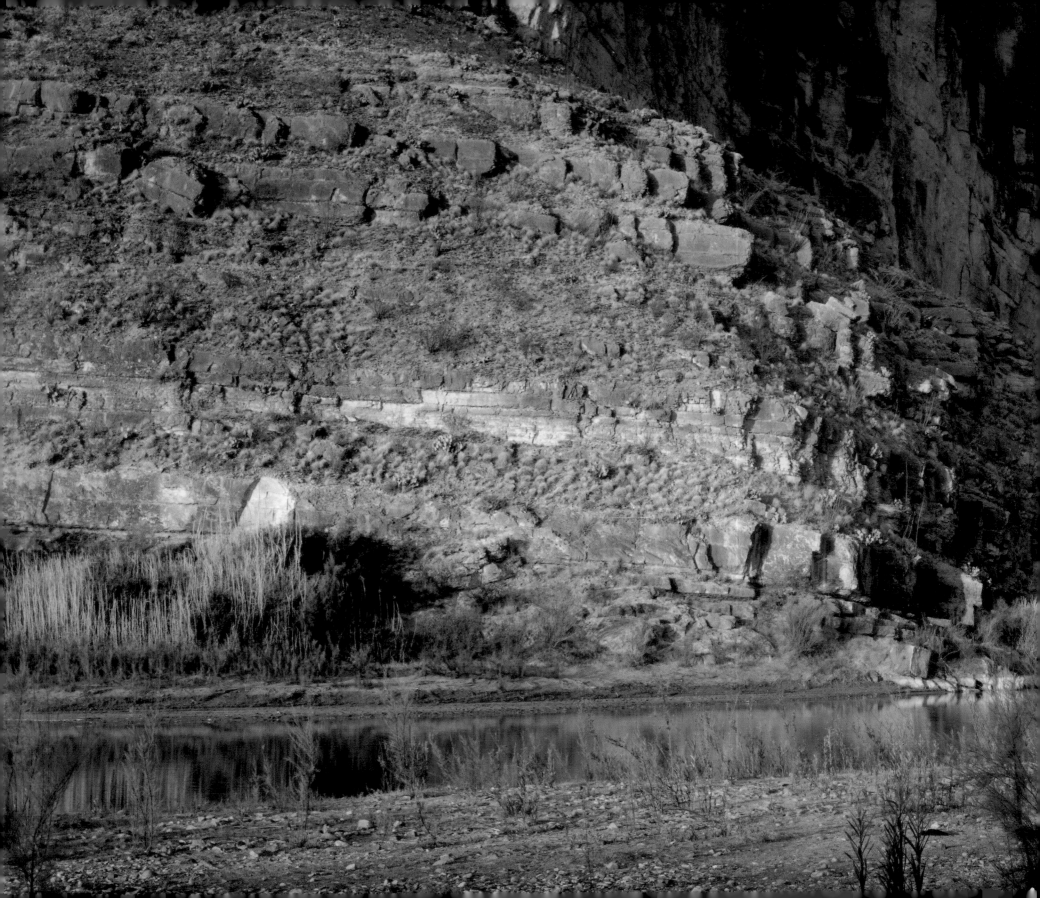

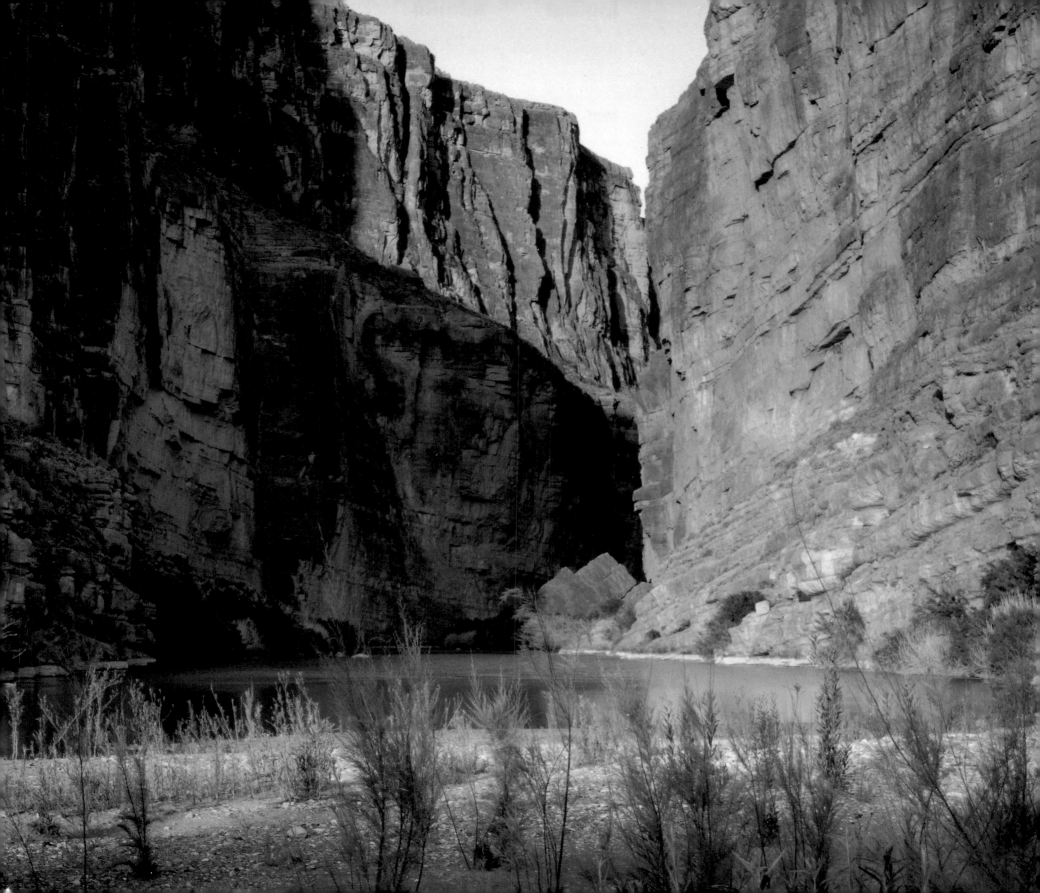

EVERGLADES NATIONAL PARK

FLORIDA, ESTABLISHED 1947

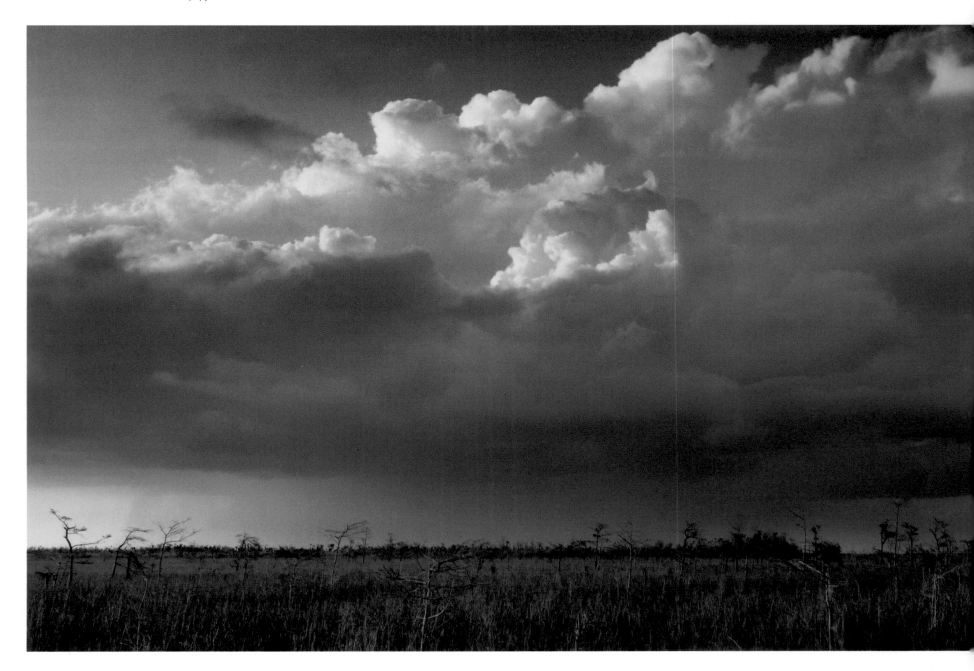

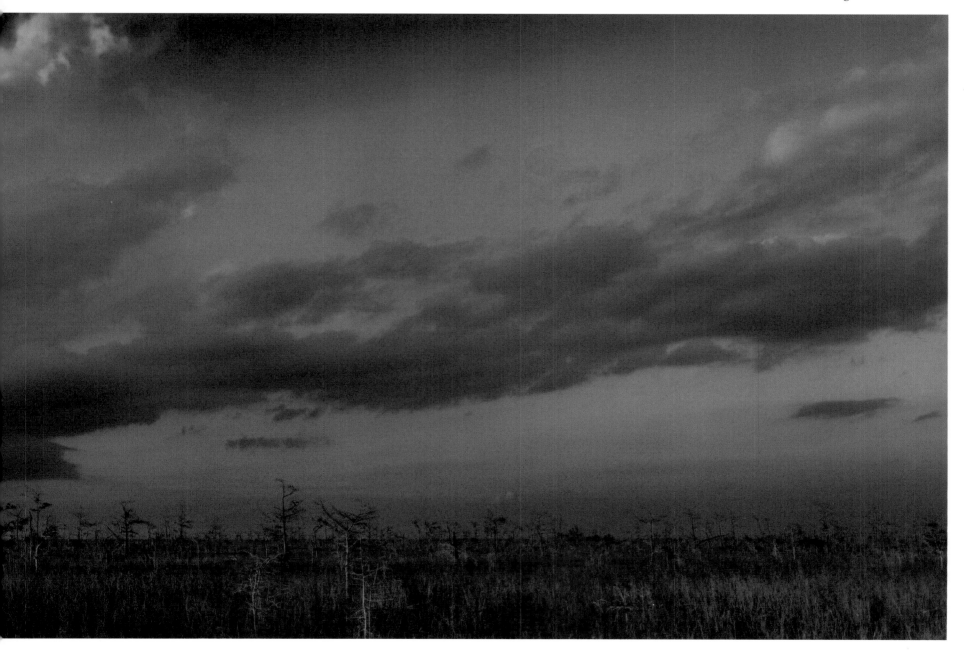

Dwarf cypress and saw grass grow in the Pa-hay-okee section of the Everglades.

VIRGIN ISLANDS NATIONAL PARK

Virgin Islands, Established 1956

St. John in the U.S. Virgin Islands is a national park unlike any other. Its warm waters range in color from bright piercing ultramarine blue to dark, green-tinged cobalt blue, from cool jade green to deepest tourmaline green. Its beaches are pristine, made of white, almost powdery sands. St. John is the wilderness at its most friendly, at its most inviting. The park almost dares you not to relax.

But only part of it is immediately visible—the other half is underwater. And that is where the trail we will take, will fash-ion for ourselves, lies hidden. To explore not just another place but another place in another element is what St. John offers. This is a frontier of a different sort. Close to shore sparkle small clumps and shelves of coral around which swoop schools of tang and sergeant major, and where angelfish or parrotfish will slip by. Farther out the menace of the unknown becomes palpable. Fear becomes part of the frontier. The color of the water darkens, and we no longer know where we are—or if we are being followed, silently, by a shark or a barracuda.

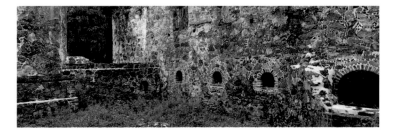

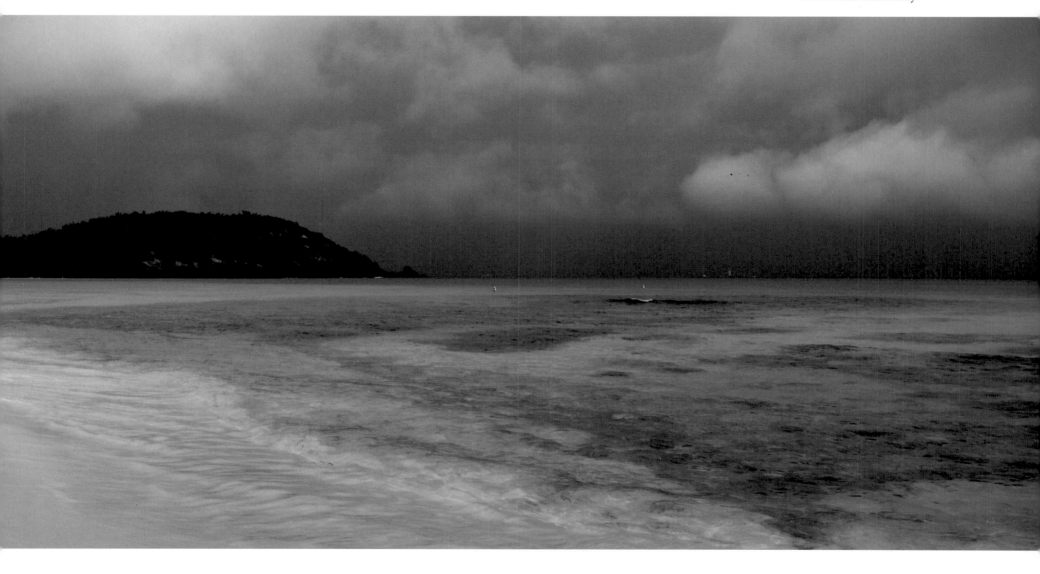

PETRIFIED FOREST NATIONAL PARK

Arizona, Established 1962

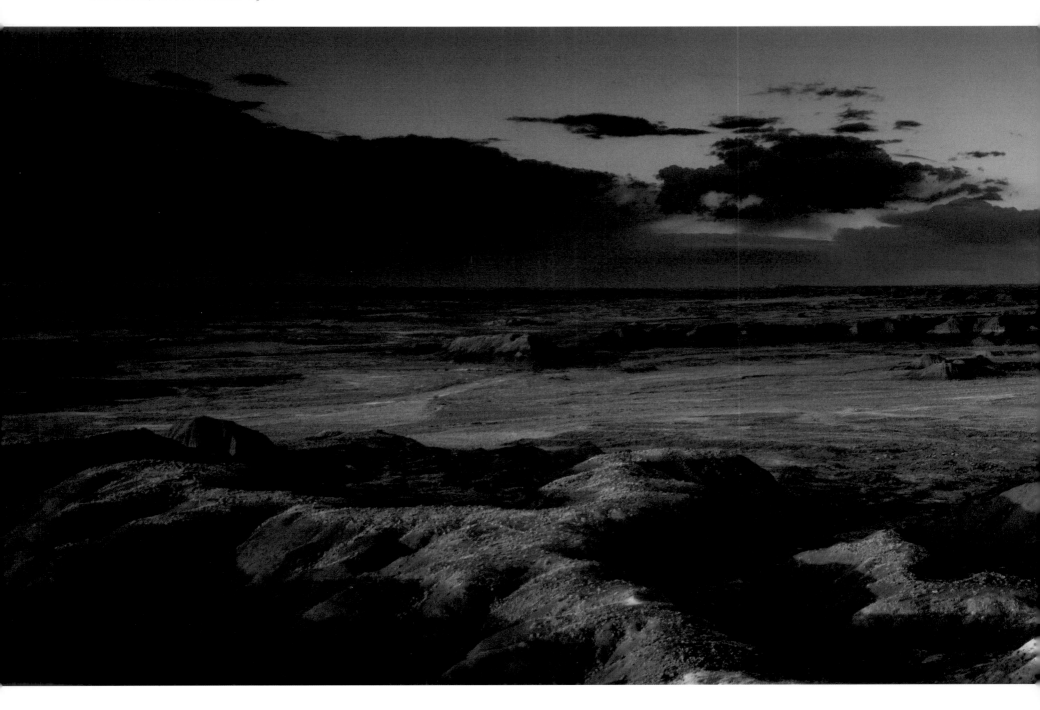

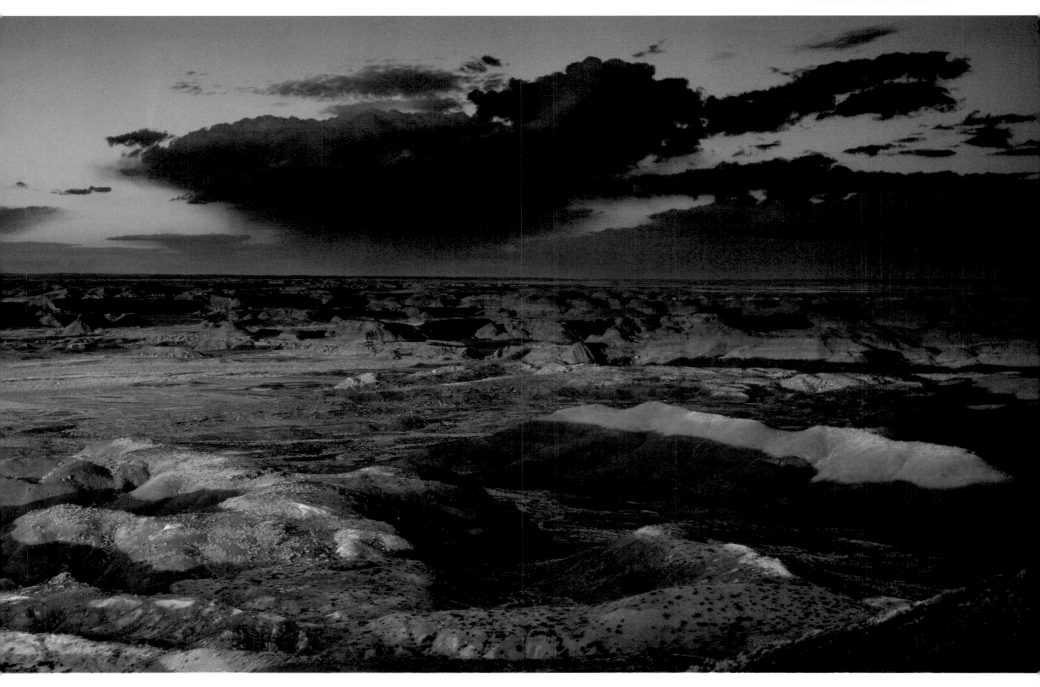

The Painted Desert Wilderness.

CANYONLANDS NATIONAL PARK

Utah, Established 1964

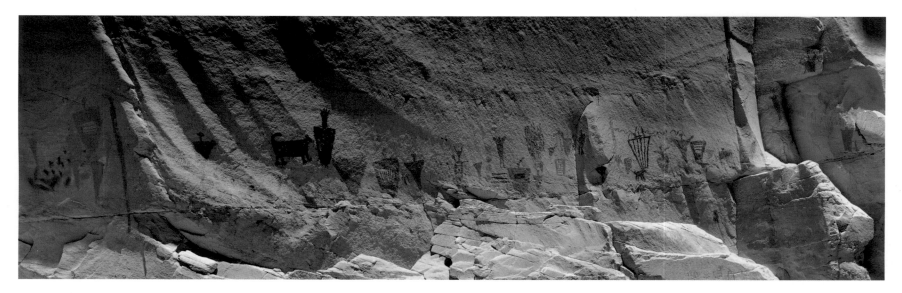

ABOVE: Prehistoric rock art at Horseshoe Canyon.

OPPOSITE: The face of erosion.

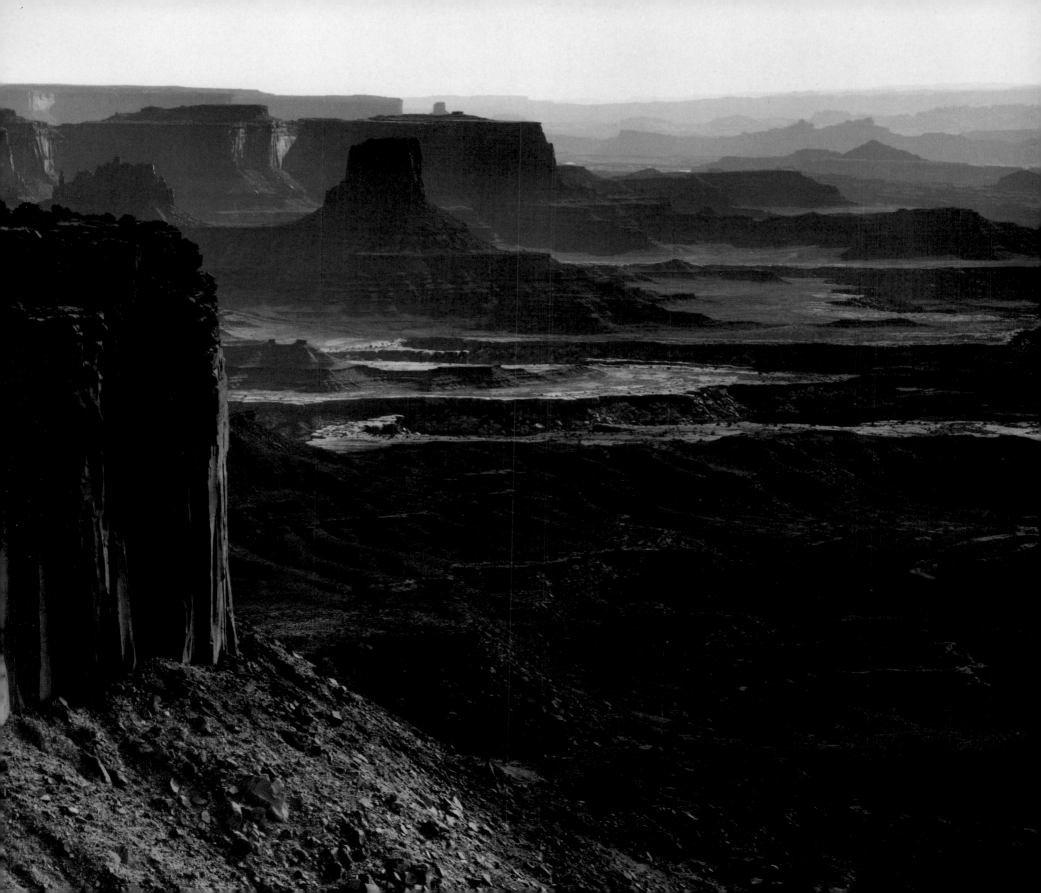

REDWOOD NATIONAL PARK

CALIFORNIA, ESTABLISHED 1968

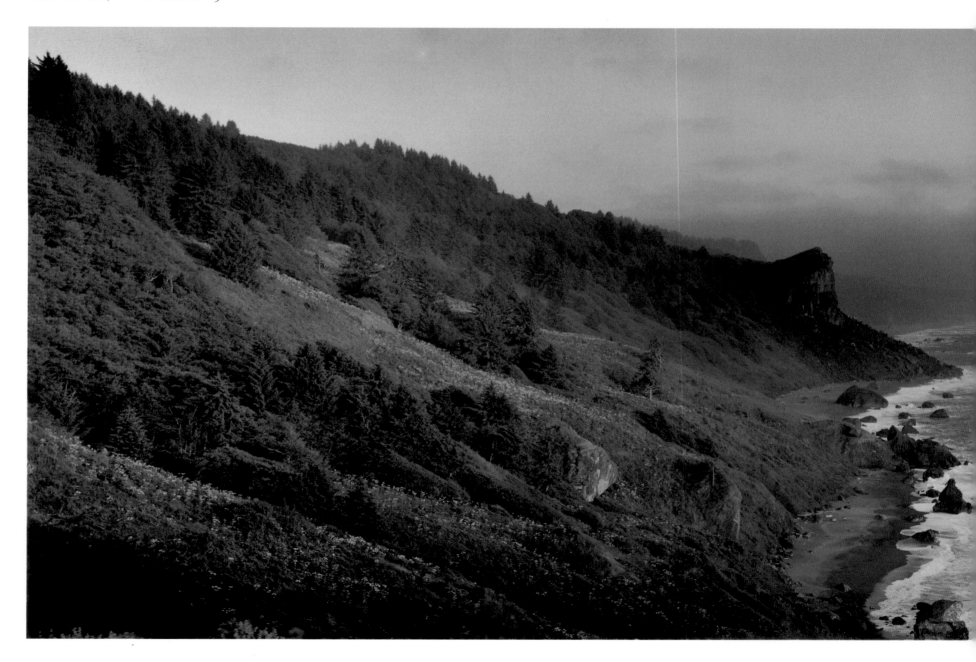

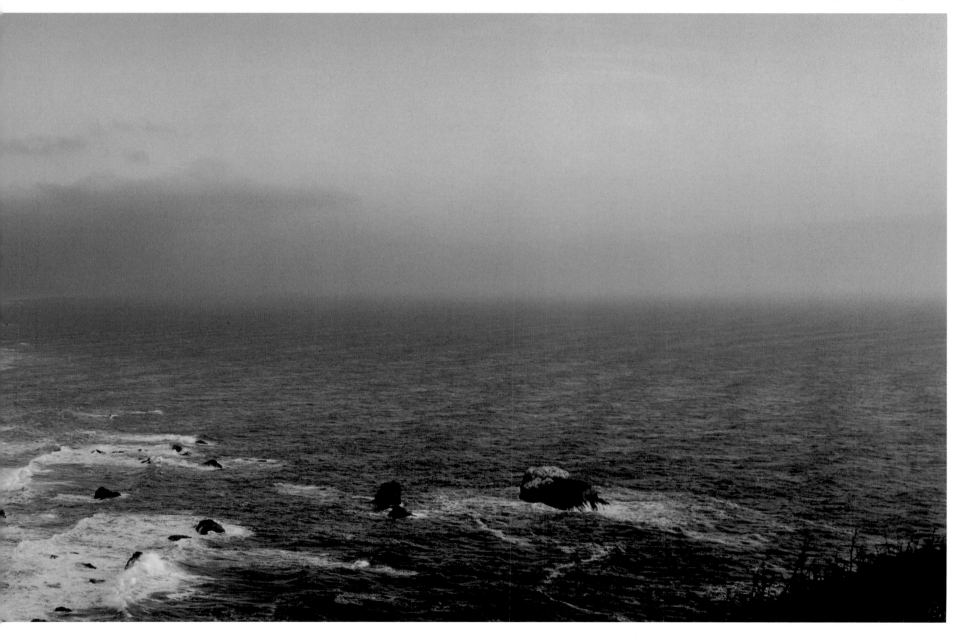

Coastal grandeur at Split Rock.

Redwood National Park, which stretches along the California coast north of Eureka, is perhaps the most approachable of all the western parks. The visitor is not overwhelmed by a grand vista or mesmerized by bizarre rock formations. One does not look out across great distances, unless, of course, one stands on the shore and looks to sea. Walking among the great redwoods is essentially an experience of verticality. All other trees are small next to them; even the long, elegant Douglas fir must be gauged by another standard. There is a gloom at the base of these giants, but one that is tempered by a calming tranquillity. Sunlight filters down through shades of greenish gray to an almost smoky dark. The forest floor is covered with a soft carpet of ferns. A palpable intimacy is everywhere. A quiet different from the quiet of the outside world insinuates itself. Great trees stand in the semiclosed shaded rooms of the forest. It is profound and perfectly still, like the quiet one imagines at the center of sleep.

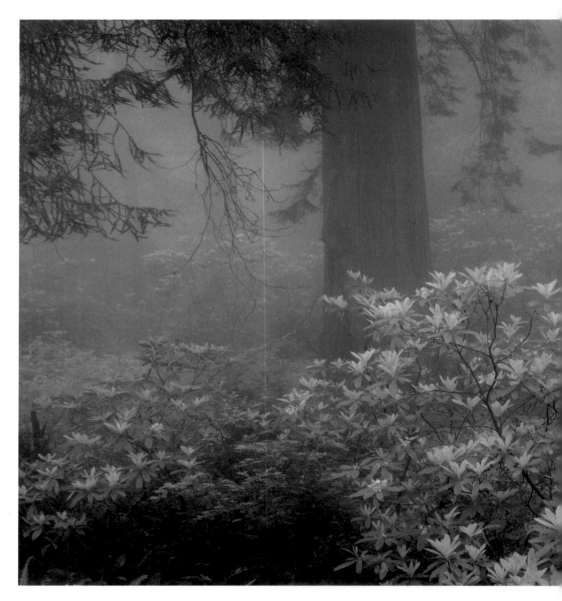

ABOVE: Rhododendrons in Lady Bird Johnson Grove.
LEFT: Lost Man Creek.

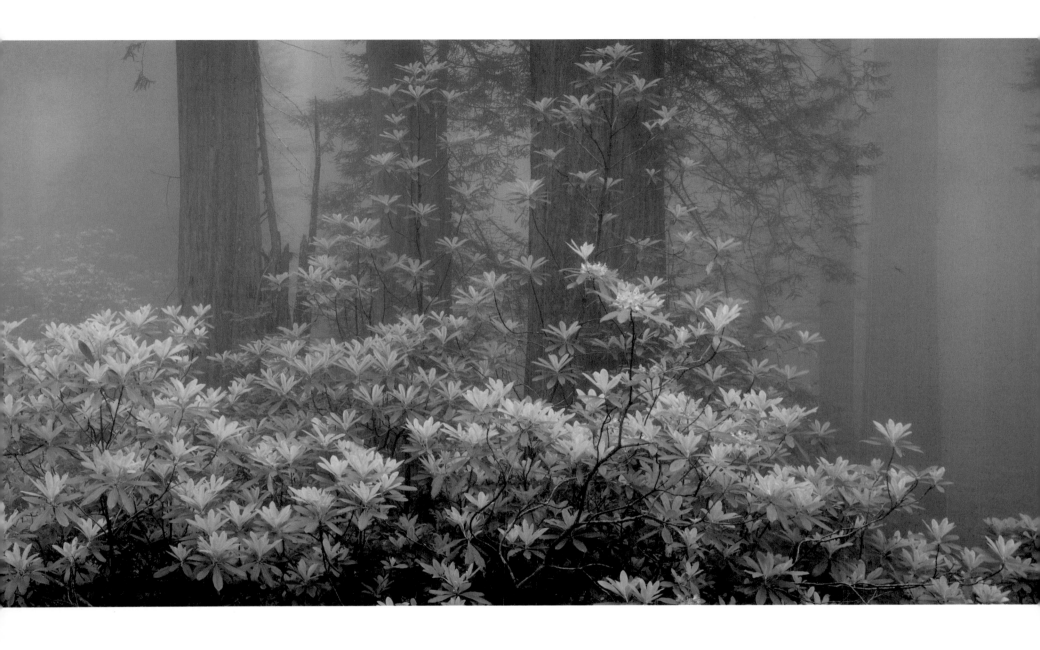

NORTH CASCADES NATIONAL PARK

Washington, Established 1968

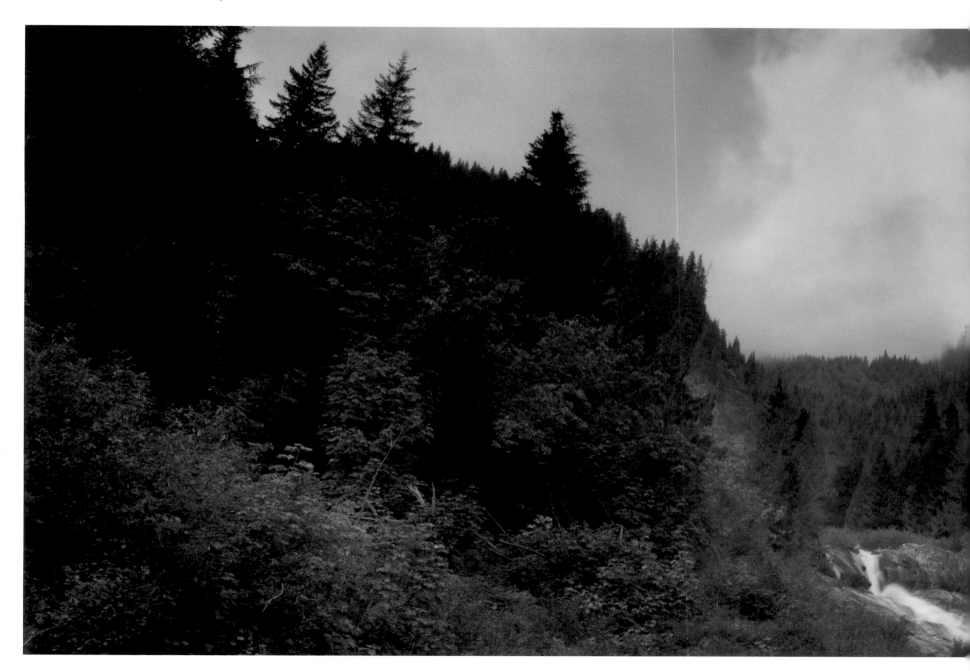

The falls of Boston Creek.

ARCHES NATIONAL PARK

Utah, Established 1971

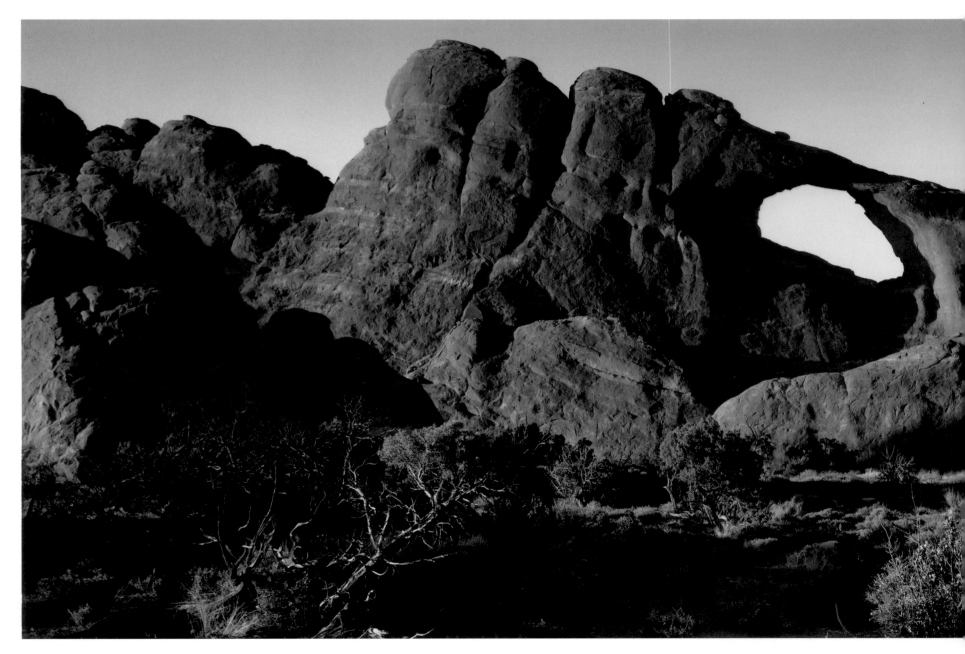

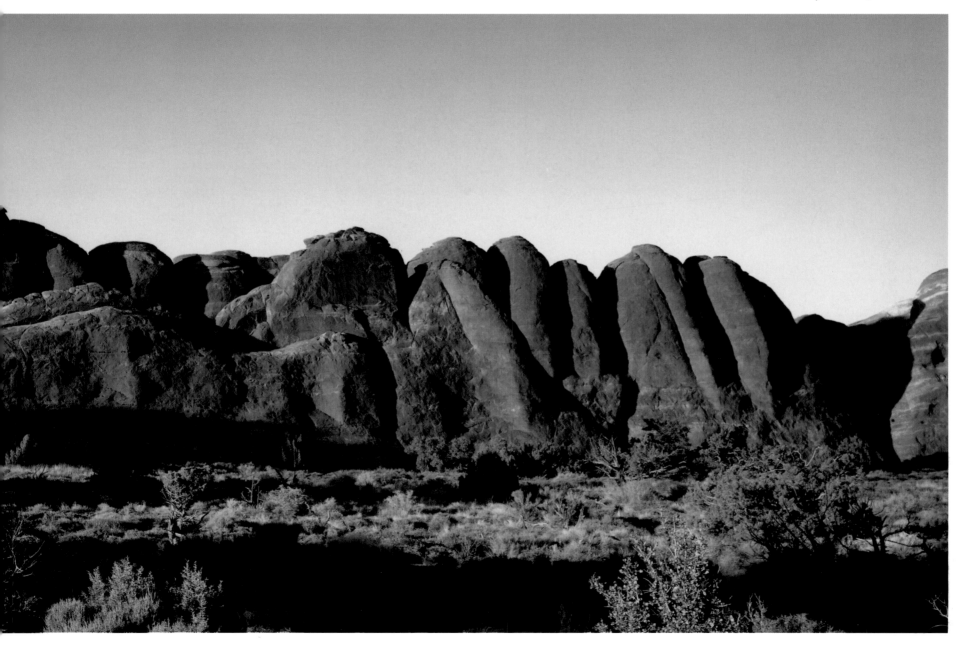

CAPITOL REEF NATIONAL PARK

Utah, Established 1971

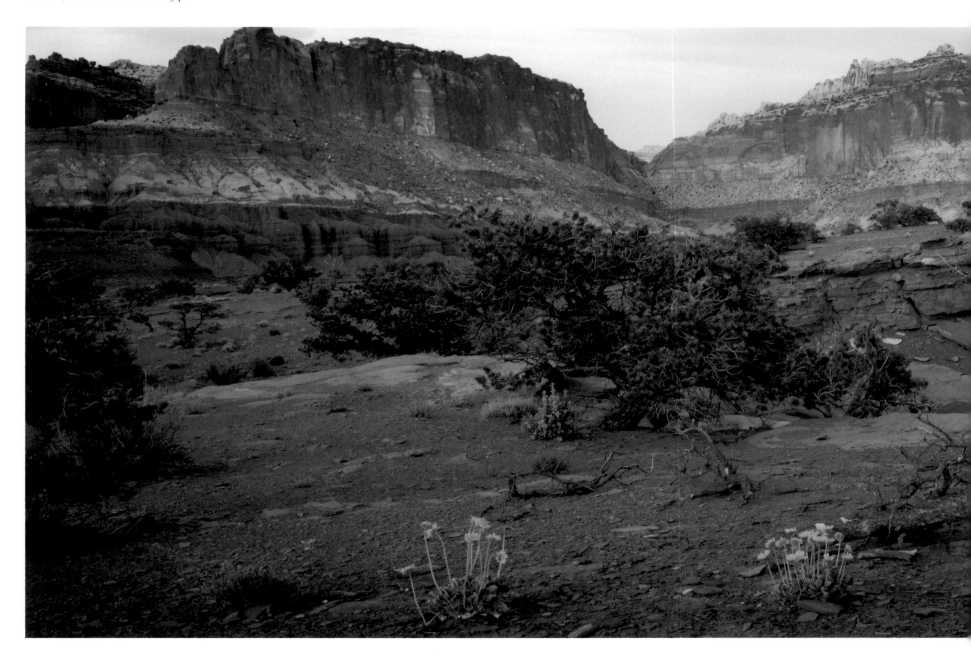

Capitol Reef is located nowhere near the sea; instead, its name derives from the resemblance of some of its formations to ocean reefs.
It is also known as "the land of the sleeping rainbows" by the Paiute Indians.

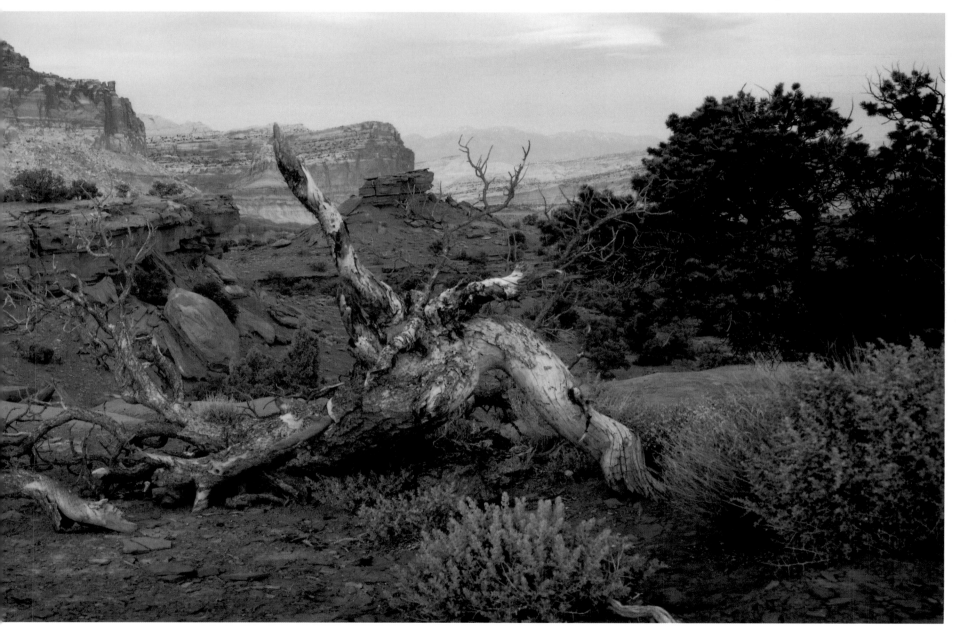

Capitol Reef is remarkable in the way it combines many of the features that characterize some of the other national parks. At times it has the look of Zion or of Arches, at others oddly enough of Death Valley. Golden sandstone domes, red rock cliffs, narrow river gorges, pockets of gray and purple shale, these elements are abundant and found surprisingly juxtaposed. Numerous trails all reveal spectacular vistas. Indeed this is one of the best parks for walking. If one climbs to Chimney Rock, the landscape that spreads out toward the Henry Mountains seems measured and rhythmic in its long undulations with the graphic, linear quality of a drawing by Mantegna. If one takes a longer walk to a section of the park like the Golden Throne, the quick twists and turns will reveal close views of unusual rock formations alternating with panoramas. What makes Capitol Reef special besides the variety of landscape is that it is one of the few parks where one can walk a six- or seven-mile trail without encountering another hiker.

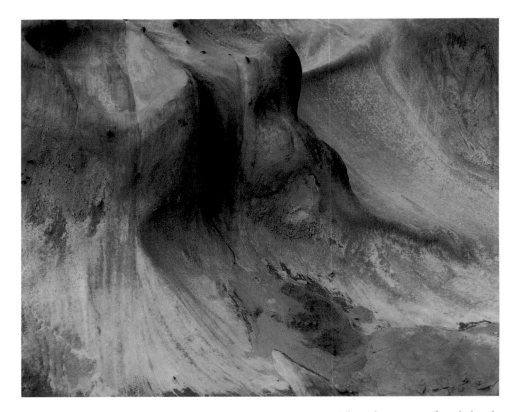

ABOVE AND OPPOSITE: The soft contours of eroded rock.

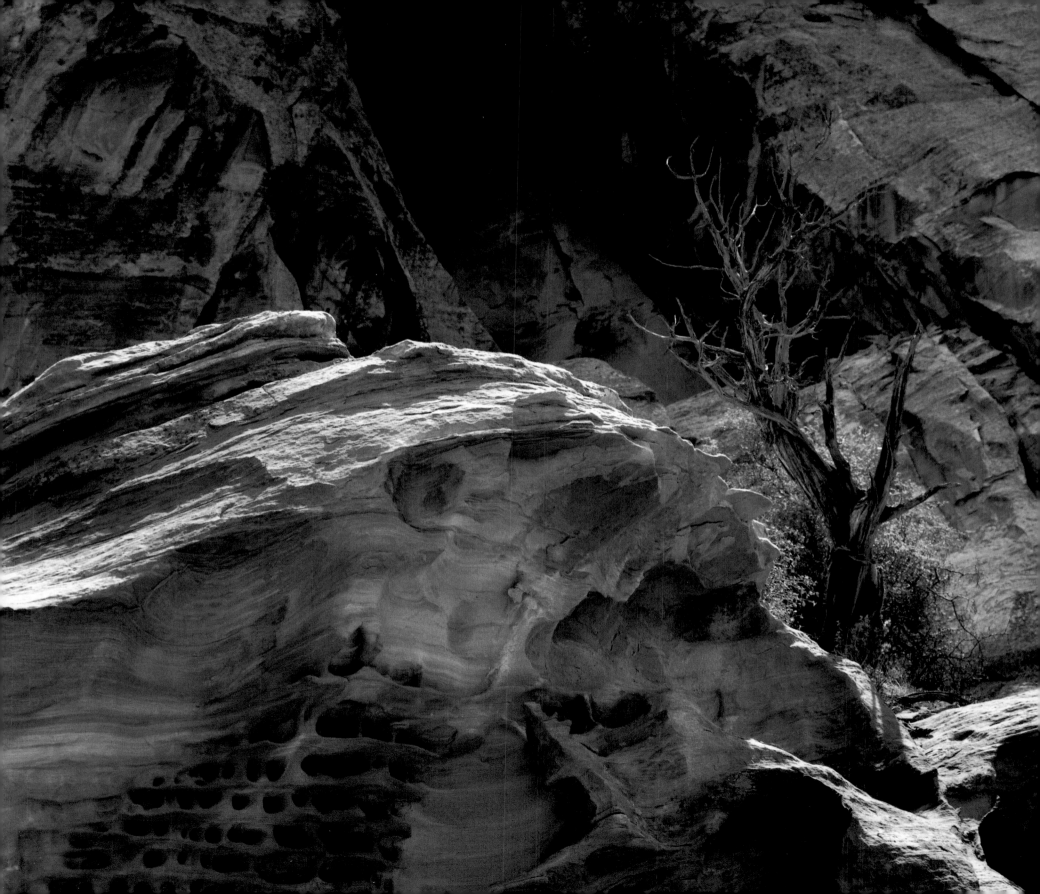

GUADALUPE MOUNTAINS NATIONAL PARK

TEXAS, ESTABLISHED 1972

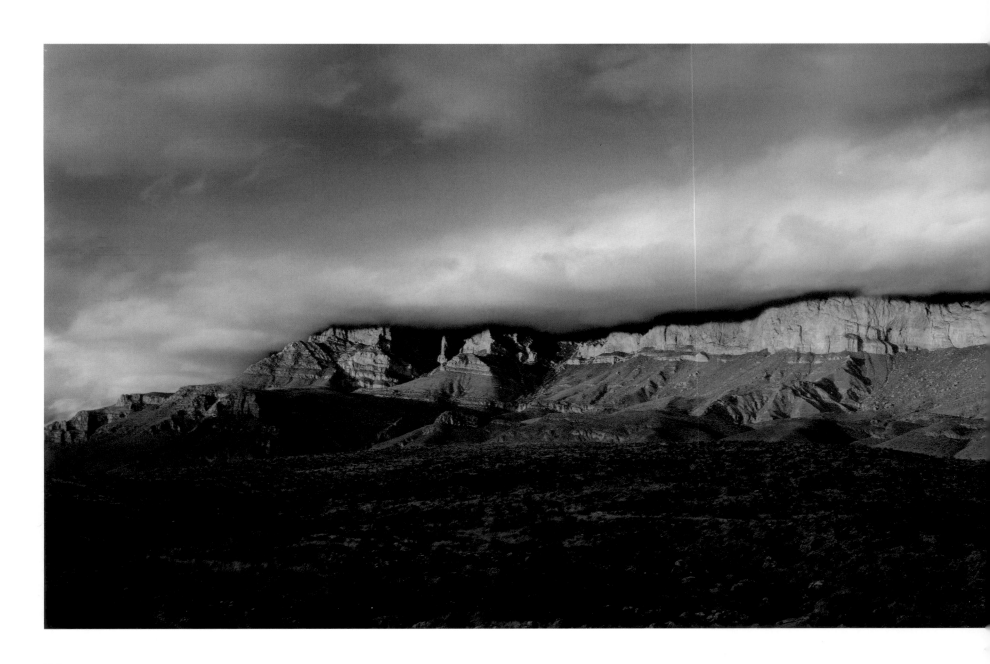

El Capitan, monarch of the mountains.

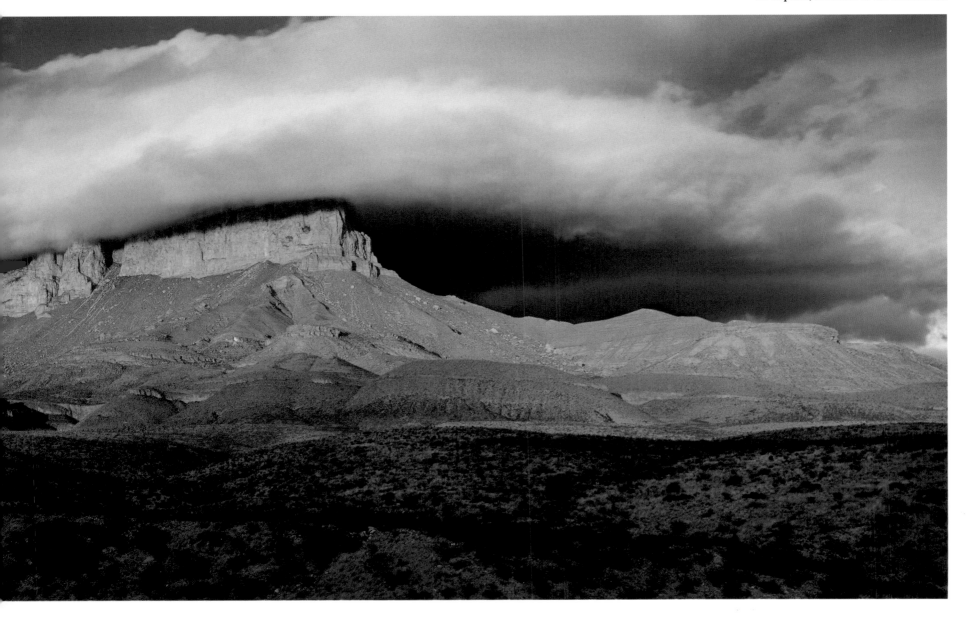

VOYAGEURS NATIONAL PARK

MINNESOTA, ESTABLISHED 1975

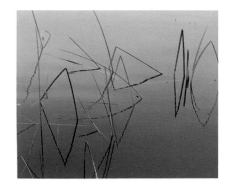

ABOVE: Reeds growing in one of the many lakes of Voyageurs.

RIGHT: September morning light.

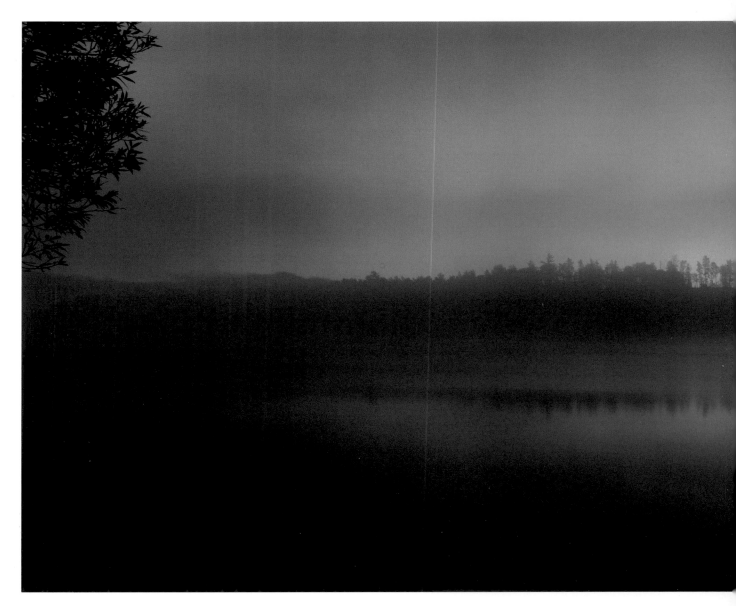

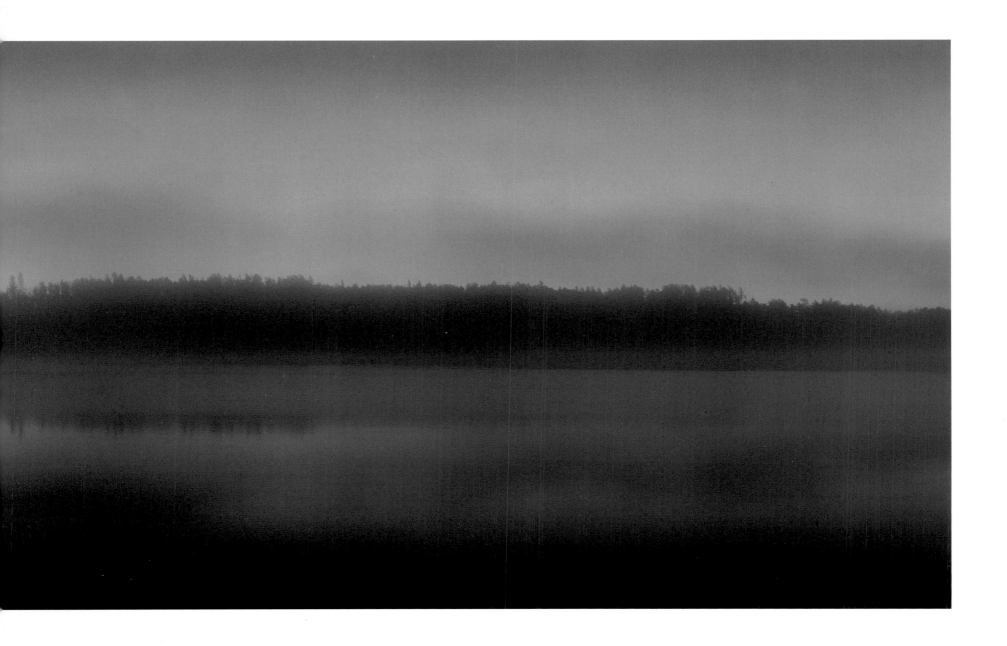

THEODORE ROOSEVELT NATIONAL PARK

North Dakota, Established 1978

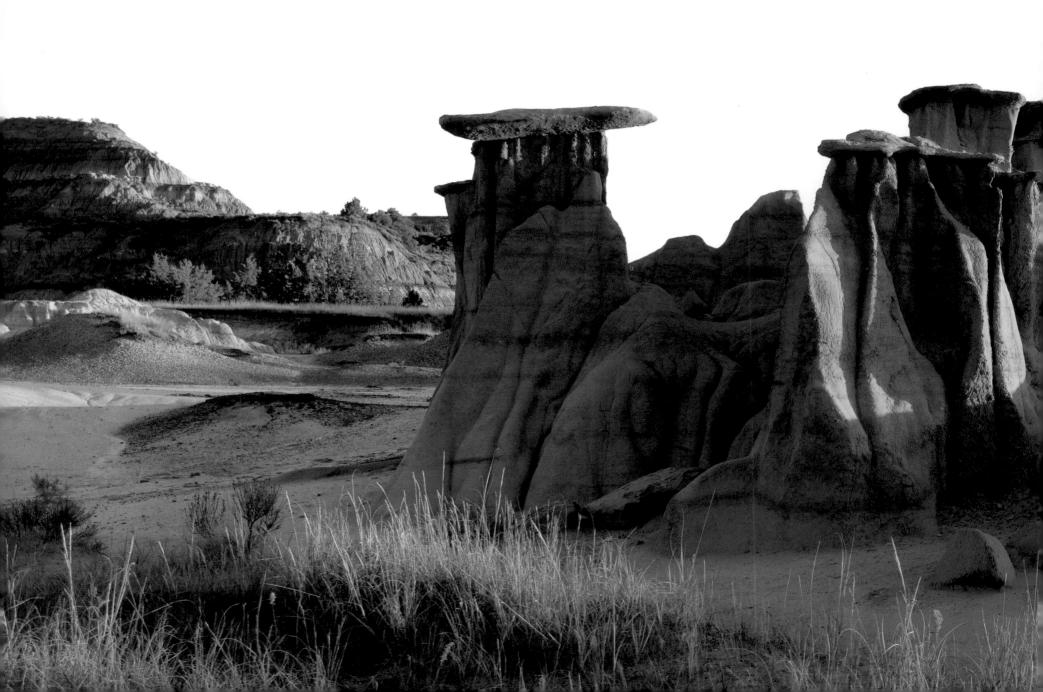

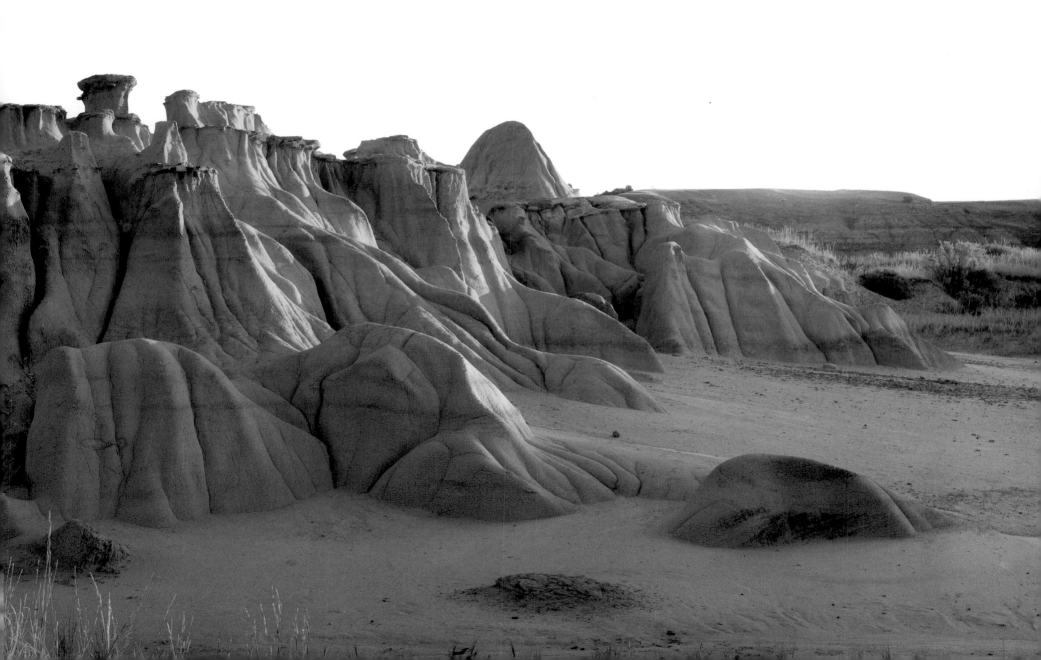

Caprock formations.

BADLANDS NATIONAL PARK

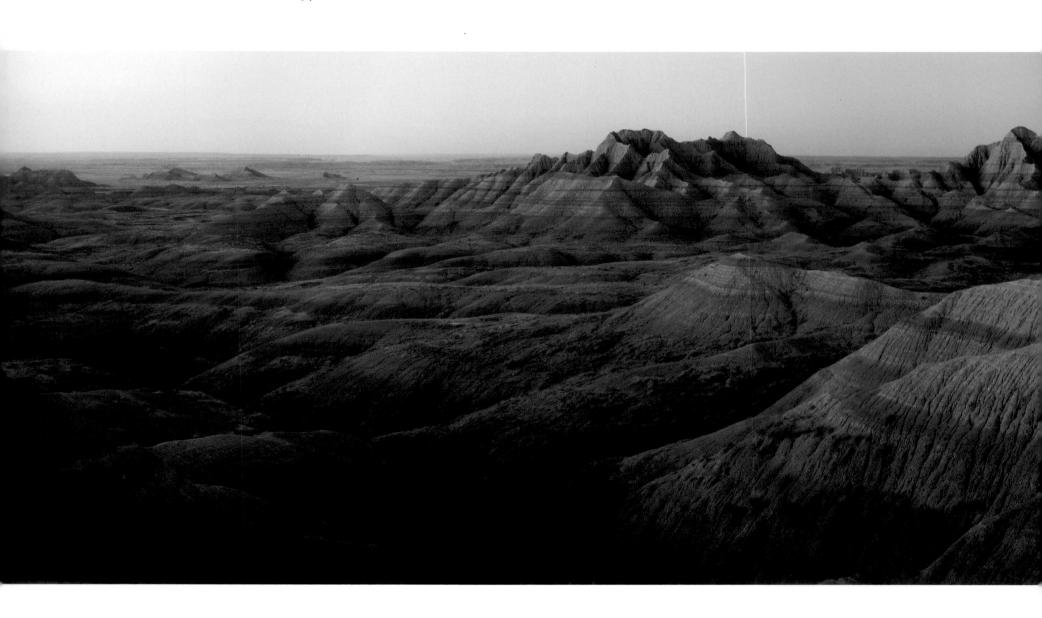

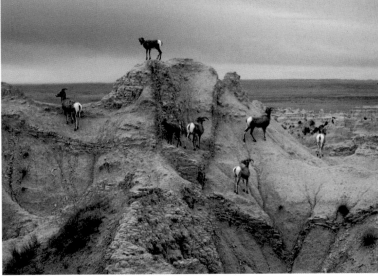

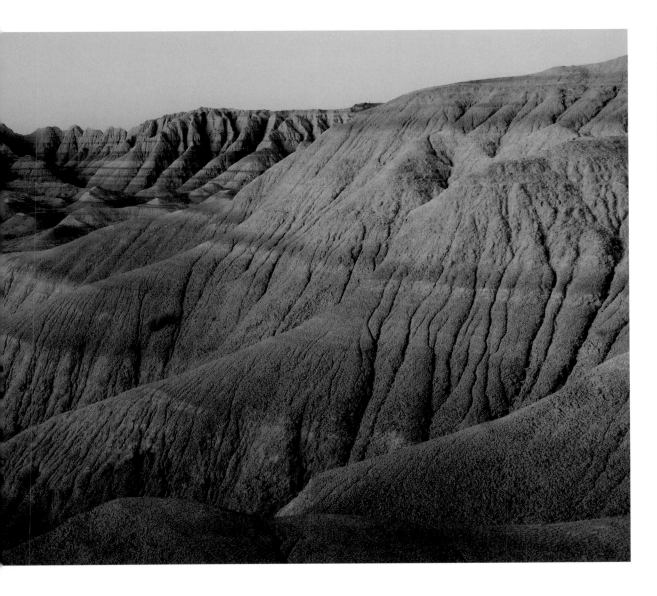

ABOVE: Bighorn sheep.

LEFT: These parklands have long been considered sacred by Native Americans.

CHANNEL ISLANDS NATIONAL PARK

CALIFORNIA, ESTABLISHED 1980

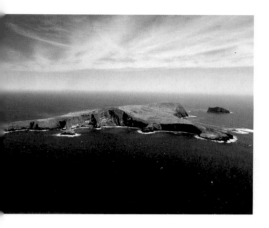

ABOVE: Aerial view of Santa Barbara Island, one of five islands in the park.

RIGHT: Dawn in the Caliche Forest, San Miguel Island. Caliche on San Miguel consists of the calcified sand-castings of once-living vegetation.

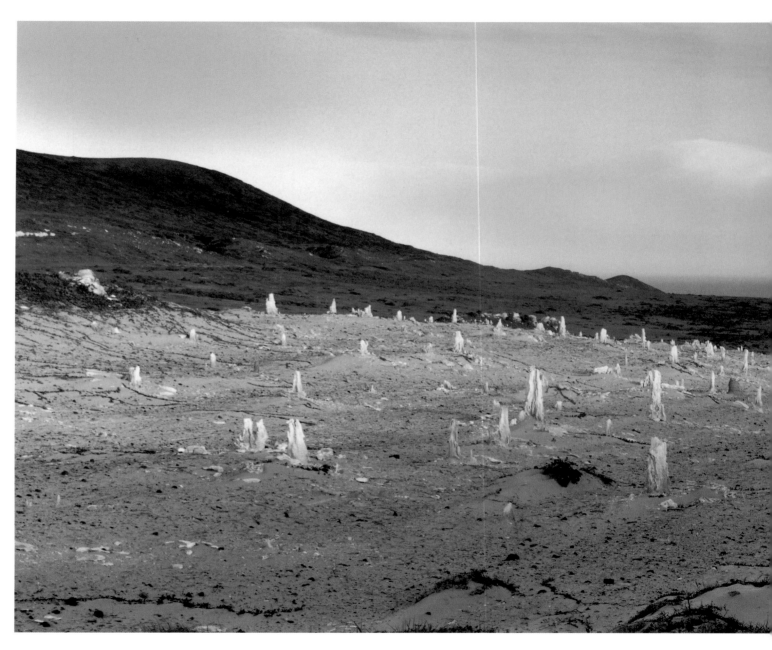

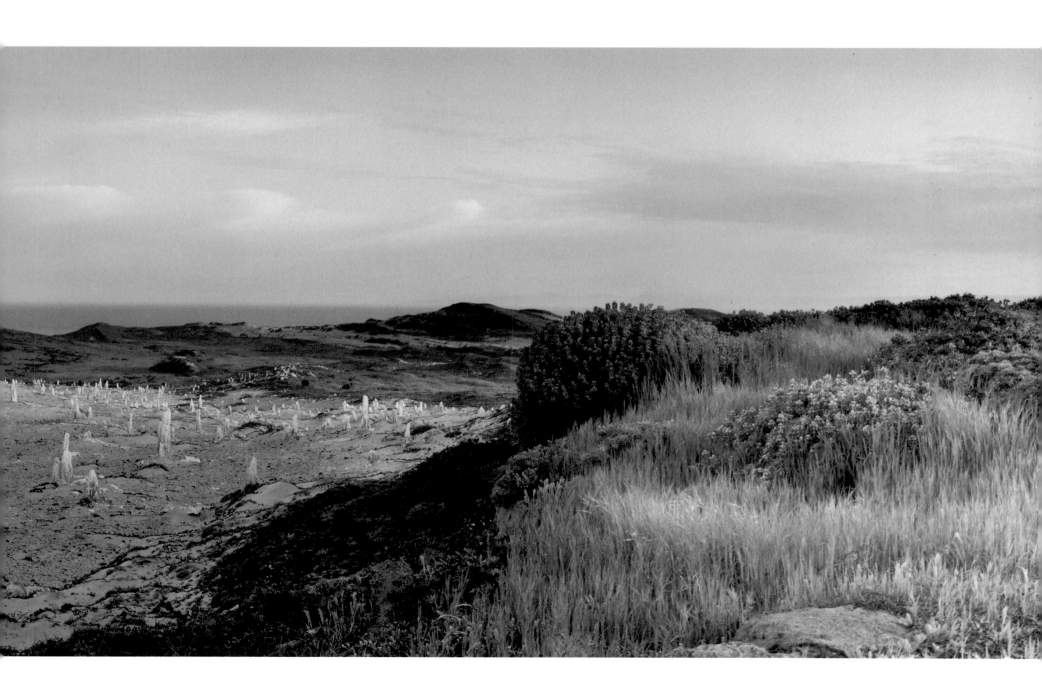

BISCAYNE NATIONAL PARK

Florida, Established 1980

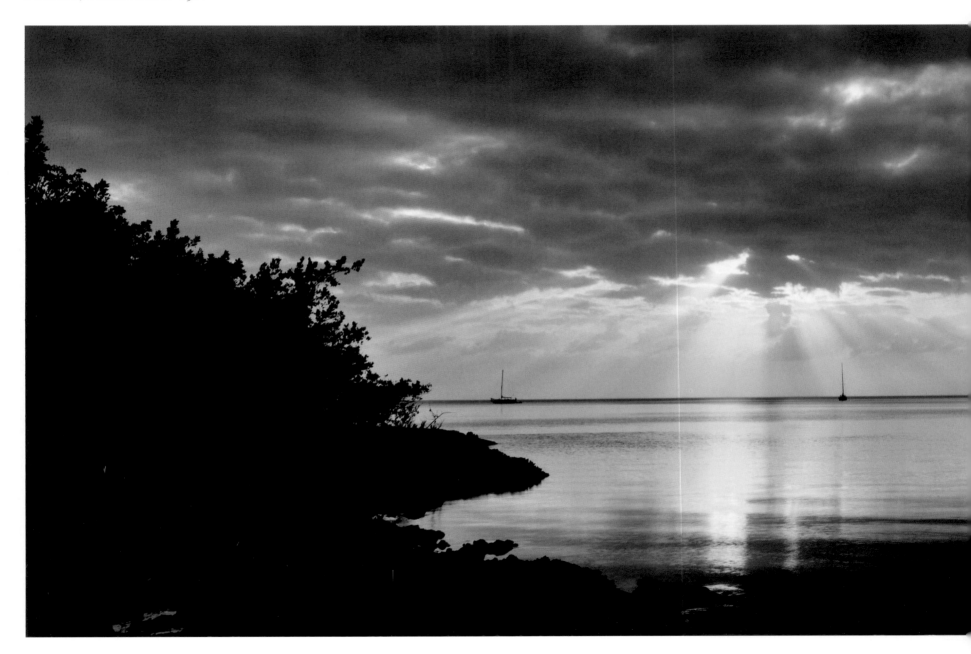

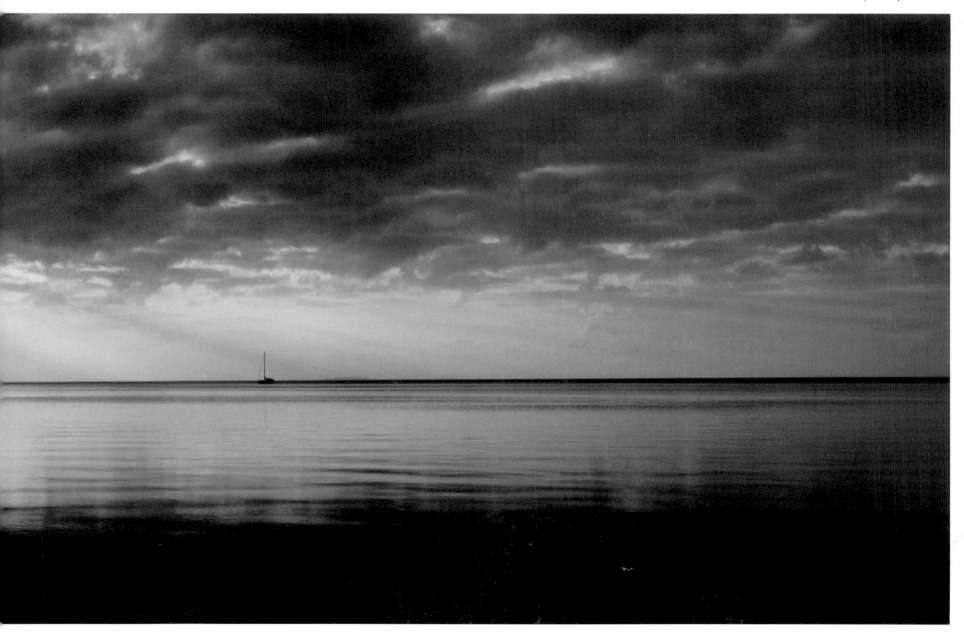

Biscayne Bay at sunset.

GATES OF THE ARCTIC NATIONAL PARK

ALASKA, ESTABLISHED 1980

OPPOSITE: Takahula Lake on the Alatna River.
BELOW: Lichen and reindeer moss.
OVERLEAF: The gentle Arctic valley of Gedeke.

Gates of the Arctic is the most northern of the parks, the wildest, and the most remote. One can fly in or walk in, but not drive in. There are no roads. The Endicott Mountains rise like a row of giant teeth, sharpened canines serrating the horizon. Gates of the Arctic is a rough, almost unfinished place. It can snow there in the summer, and often does, while in winter the temperature can reach seventy below zero. The clear lakes teem with fish, the tundra crawls with a bizarre and miniature wildlife of insects, and the park is crossed by herds of caribou and their predators, the wolf and the bear.

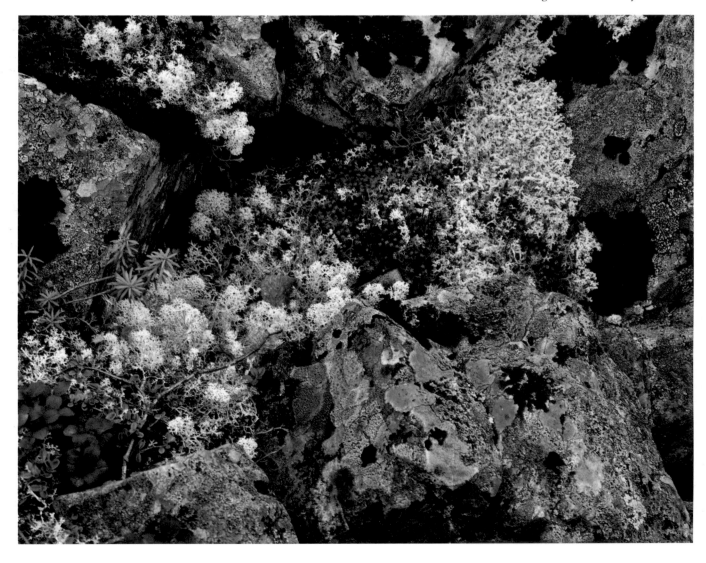

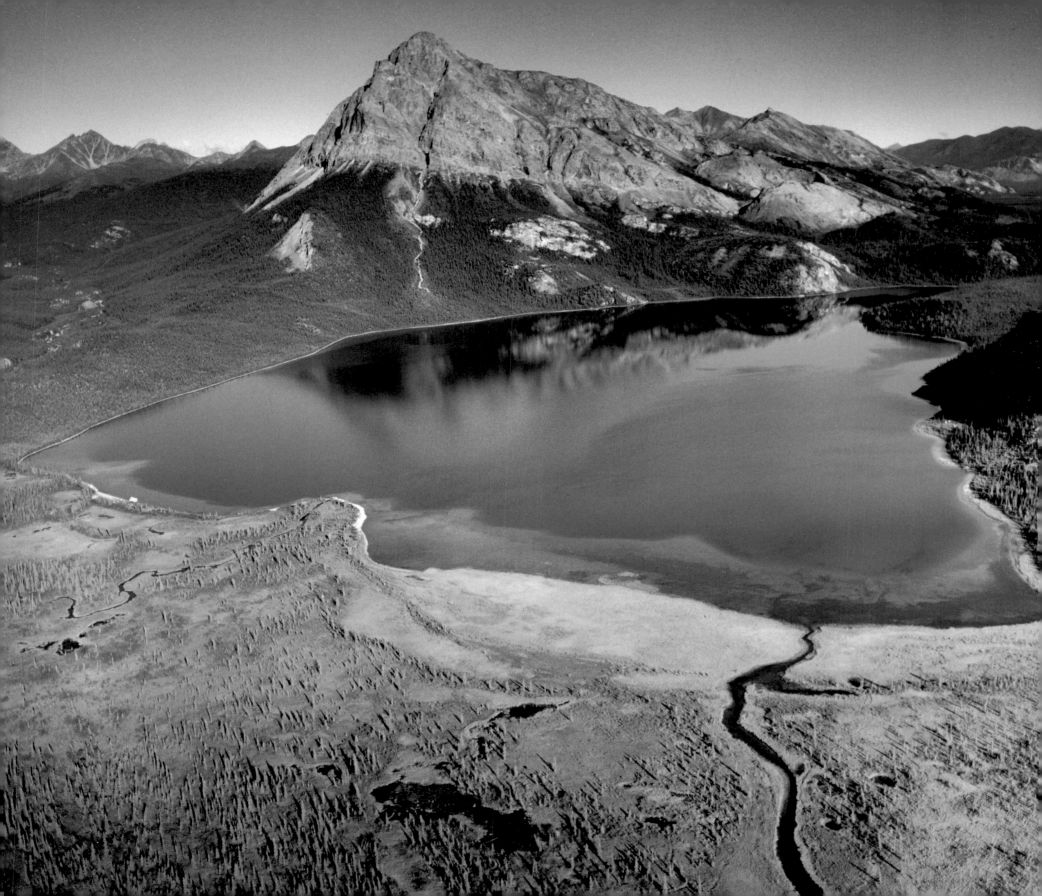

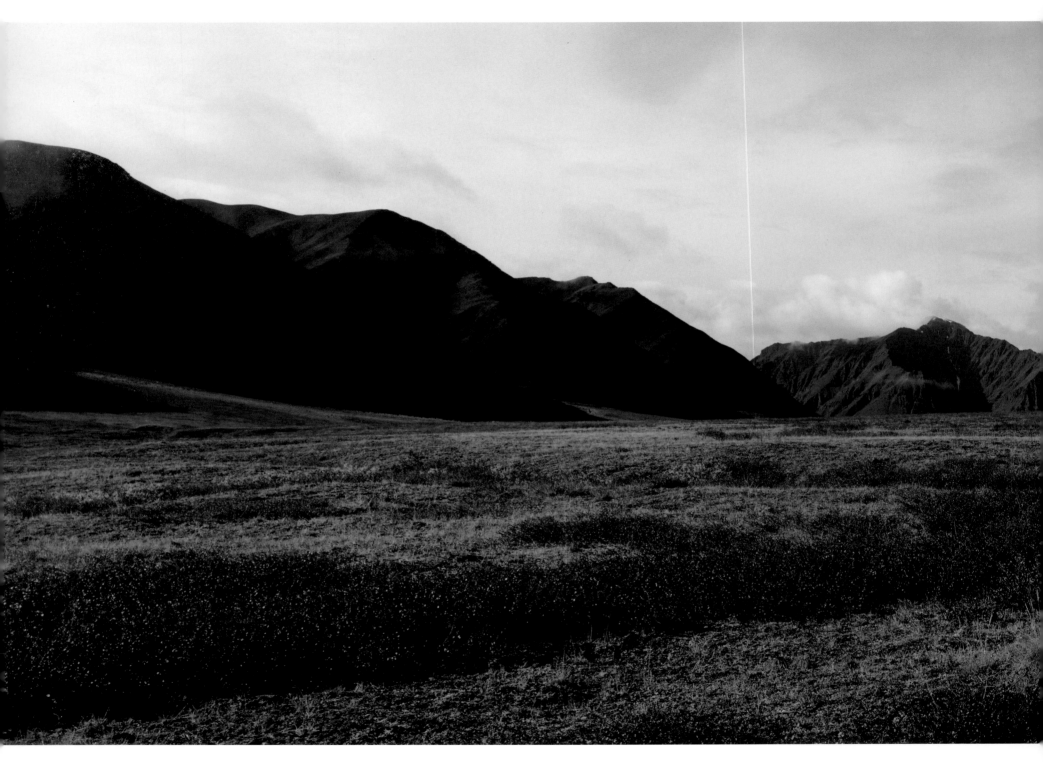

THESE RARE LANDS

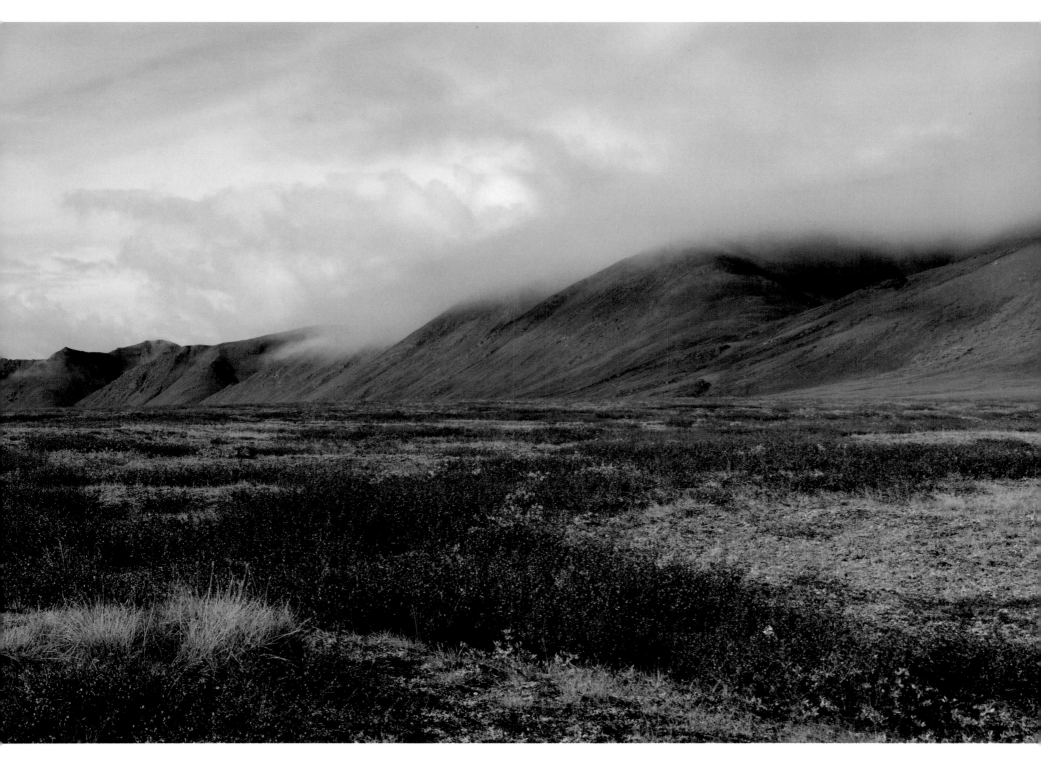

GLACIER BAY NATIONAL PARK

Alaska, Established 1980

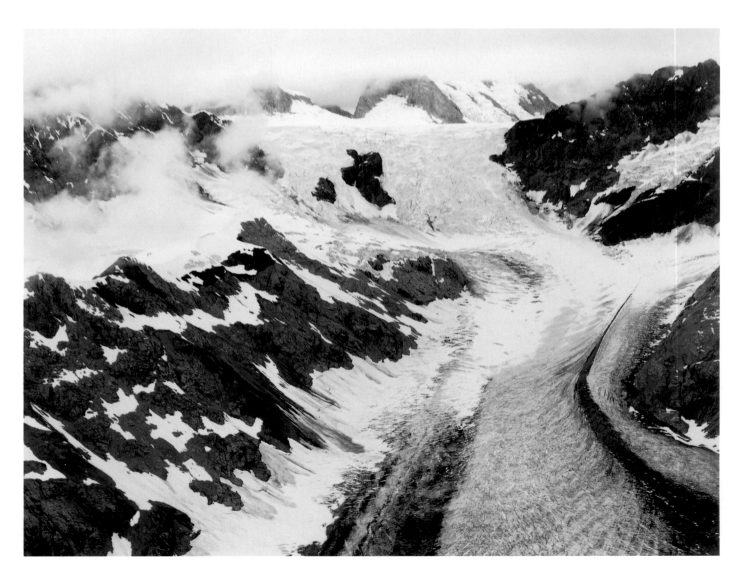

LEFT: Ice once covered this entire park like the glacier that cuts through these peaks.

OPPOSITE: A storm breaks up in Glacier Bay.

OVERLEAF: McBride Glacier.

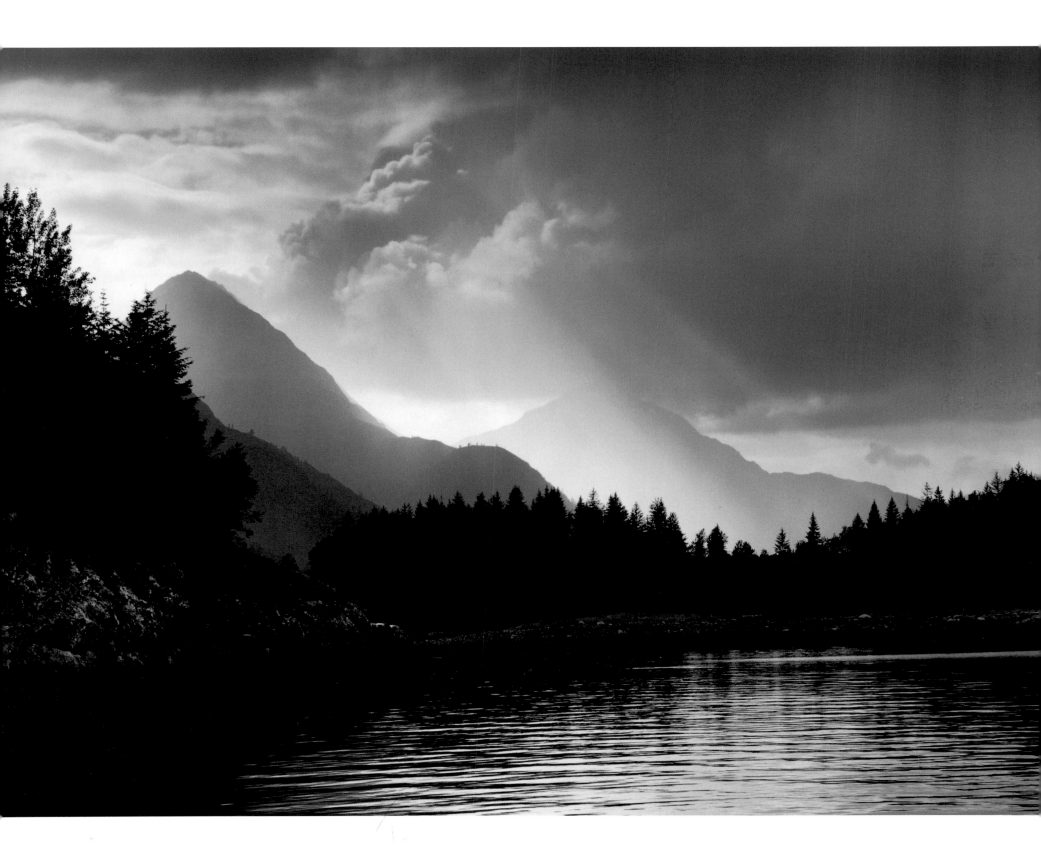

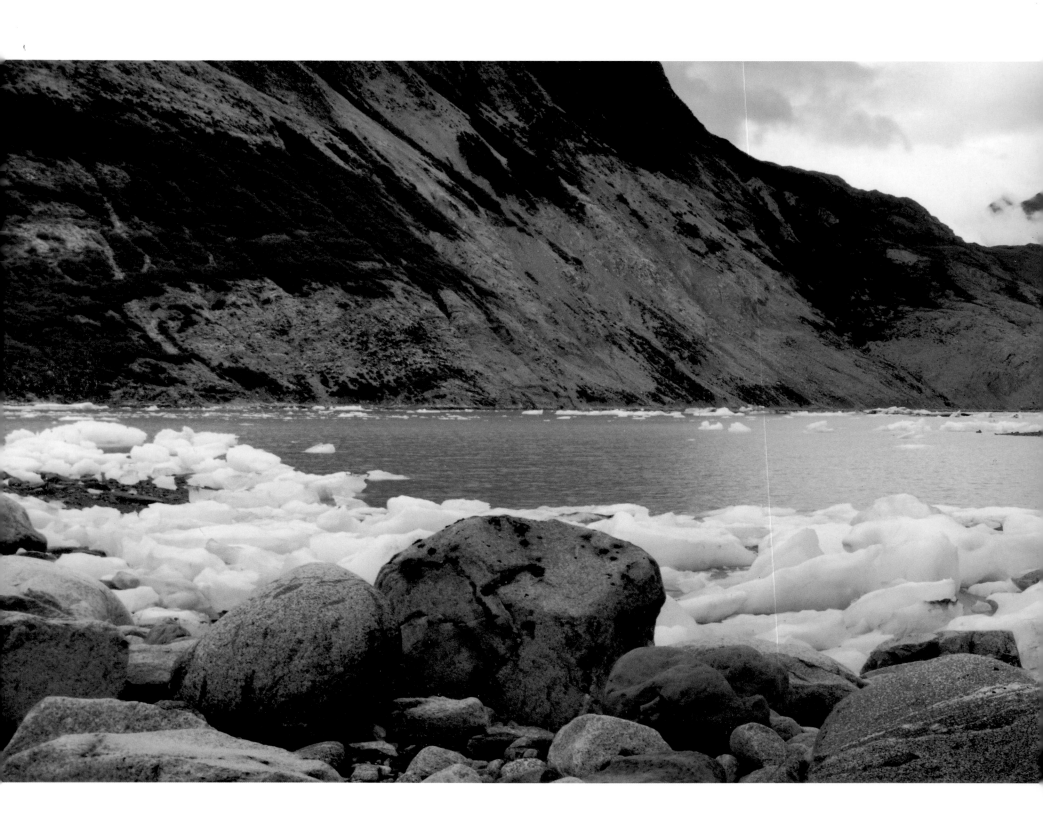

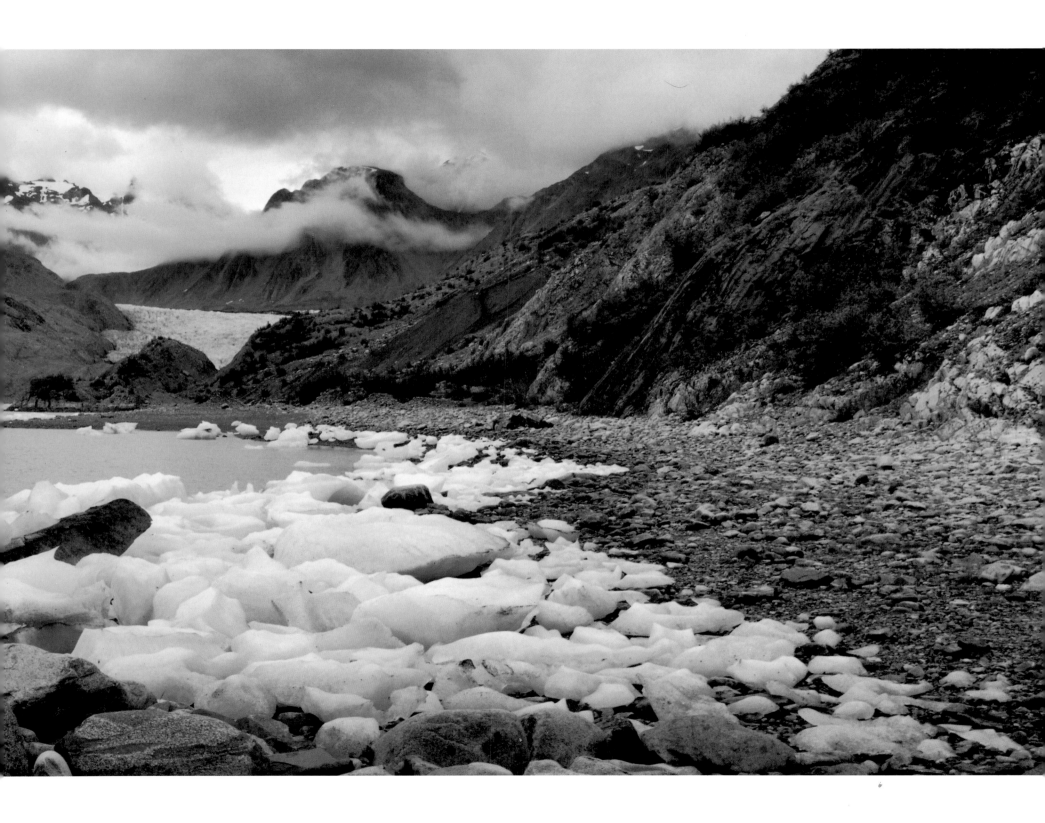

KOBUK VALLEY NATIONAL PARK

Alaska, Established 1980

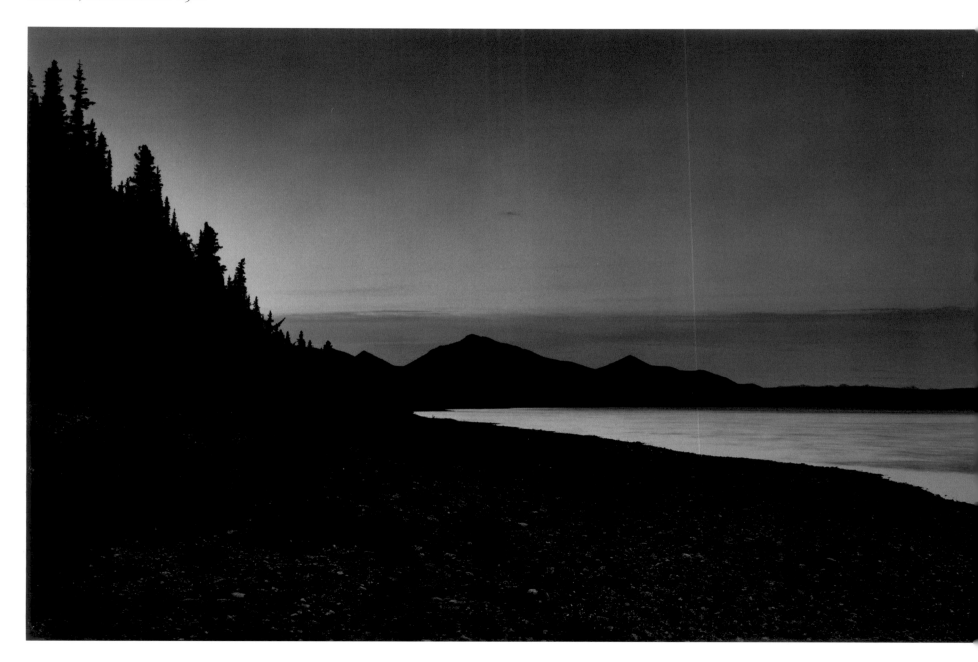

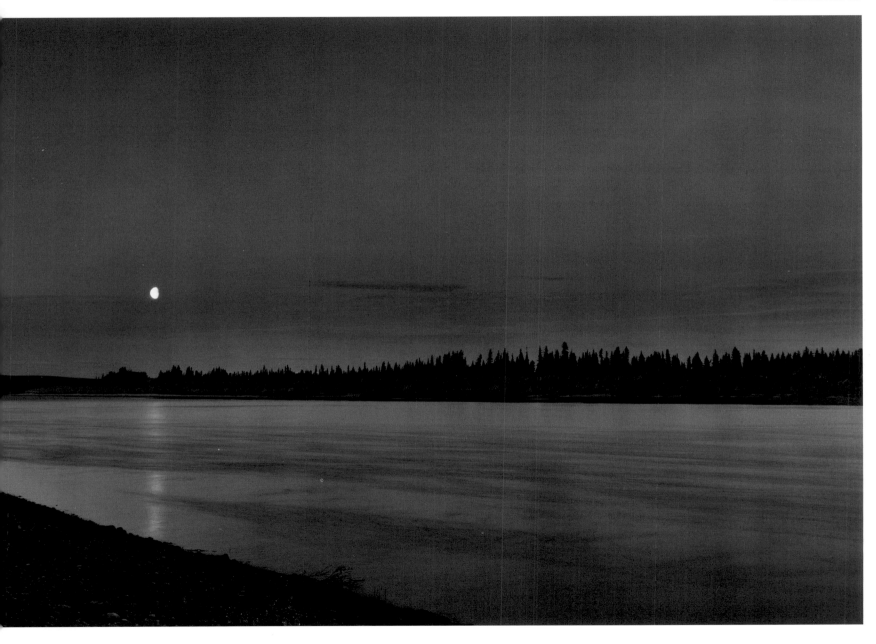

Onion Portage on
the Kobuk River.

LAKE CLARK NATIONAL PARK

Alaska, Established 1980

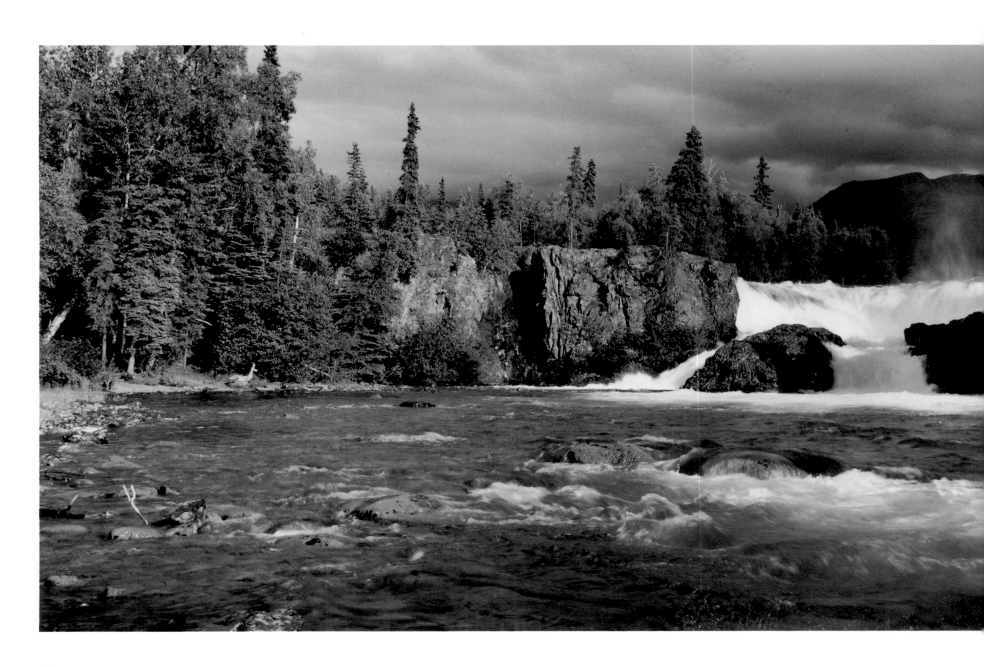

Tanalian Falls.

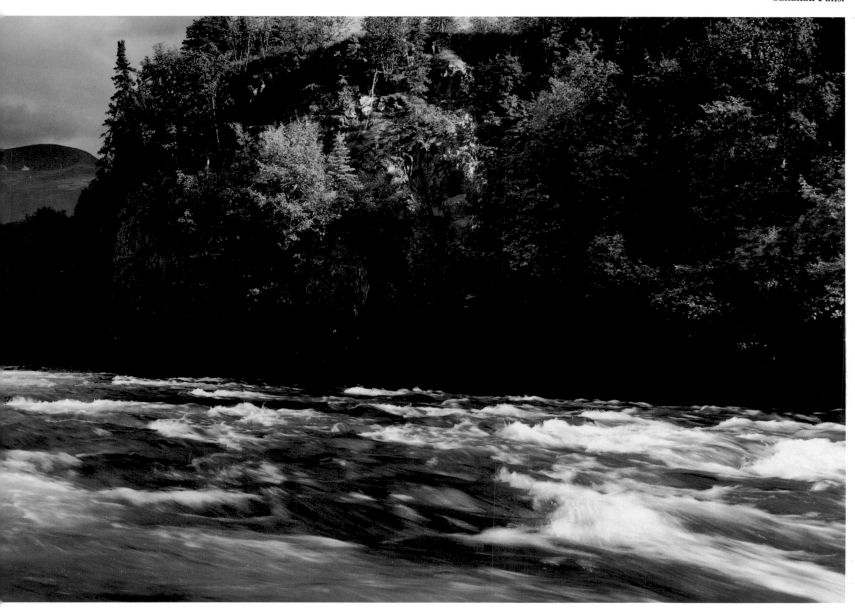

WRANGELL-ST. ELIAS NATIONAL PARK

Alaska, Established 1980

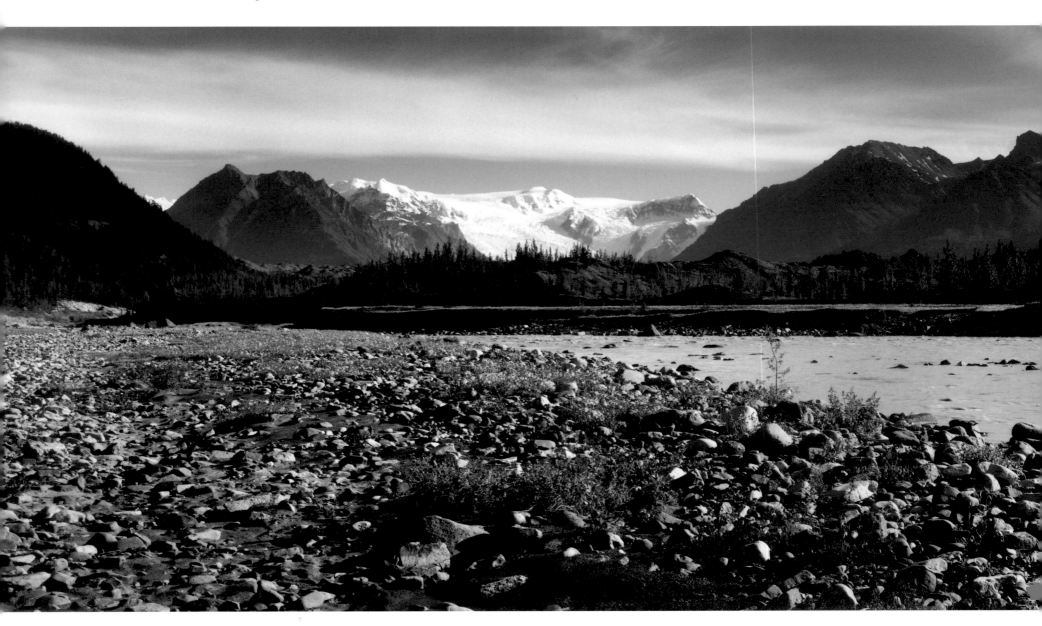

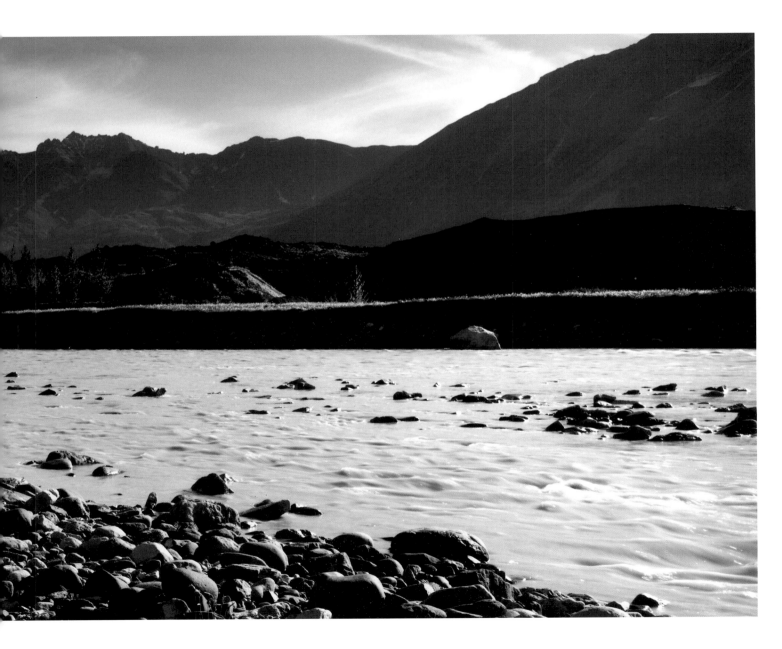

ABOVE: Fireweed.

LEFT: View toward the Wrangell Mountains at the Kennicott River.

GREAT BASIN NATIONAL PARK

Nevada, Established 1986

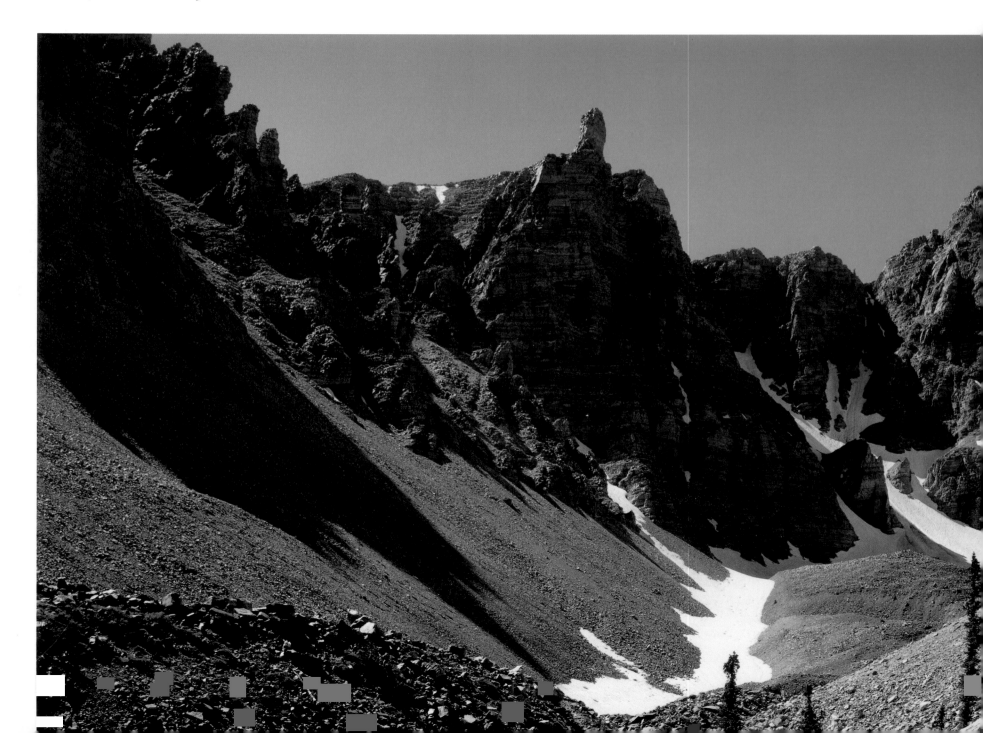

BELOW: Wheeler Peak Basin.

OVERLEAF: Bristlecone pines twisted by time.

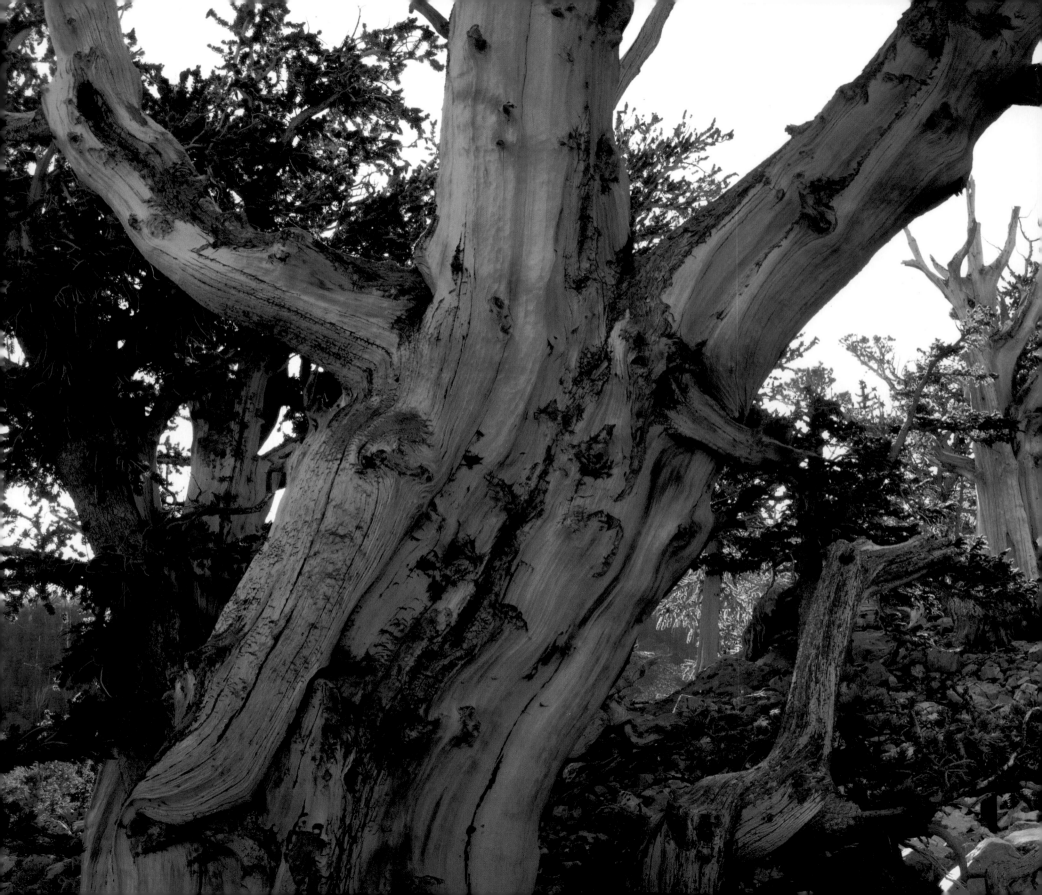

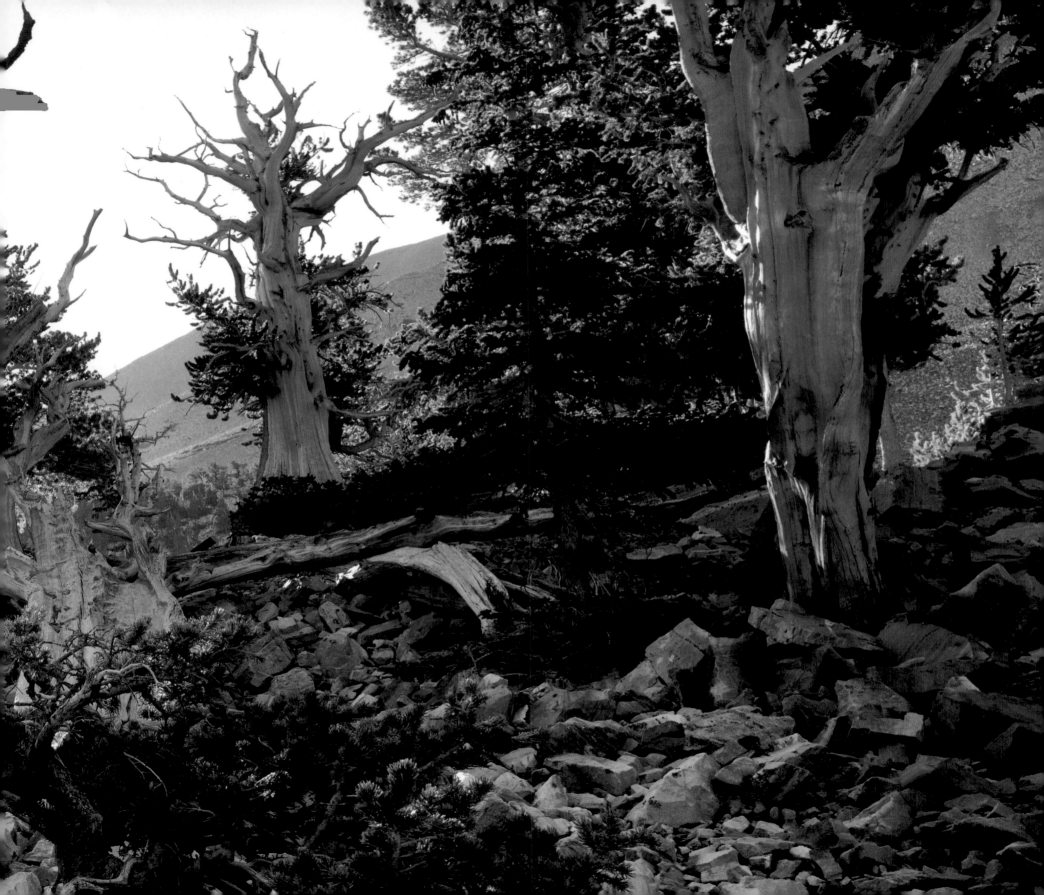

NATIONAL PARK OF AMERICAN SAMOA

American Samoa, Established 1988

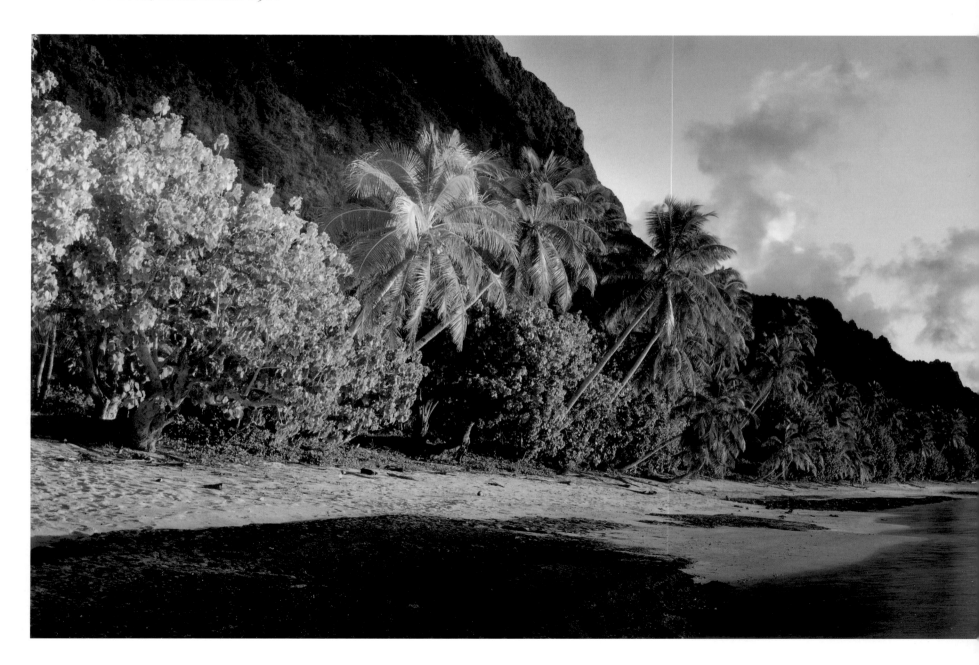

The allure of Ofu Island.

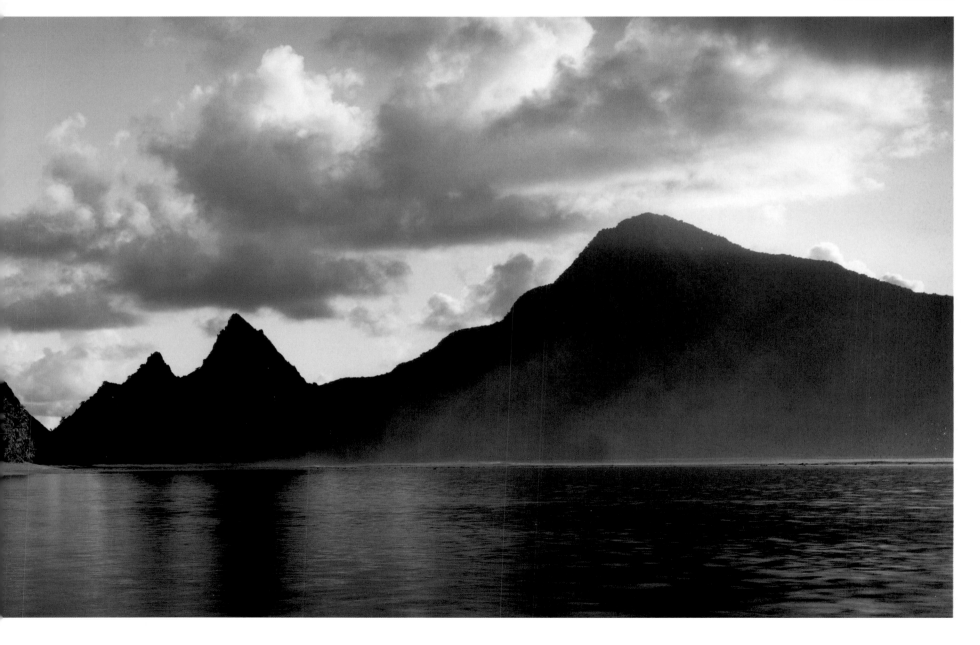

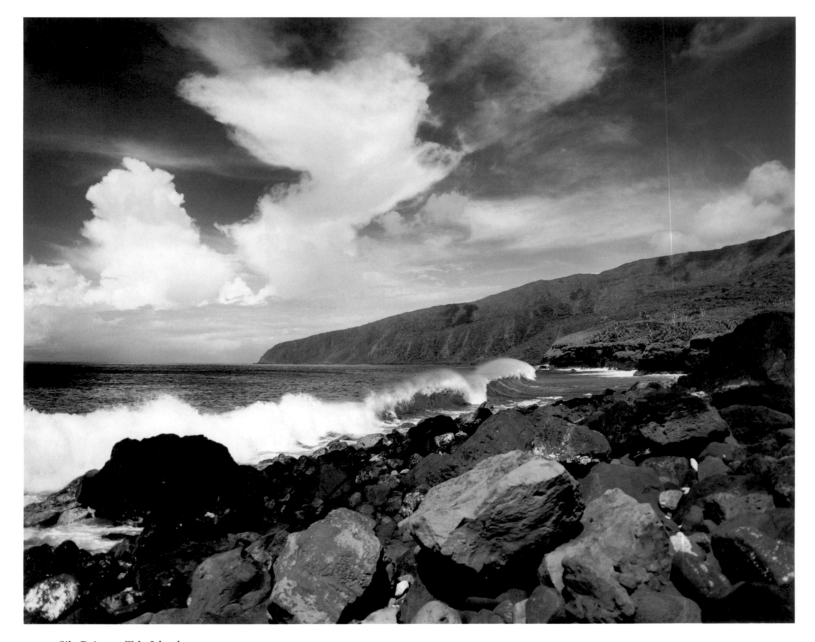

ABOVE: Si'u Point on Ta'u Island.

OPPOSITE: The pola or cockscomb of Tutuila Island.

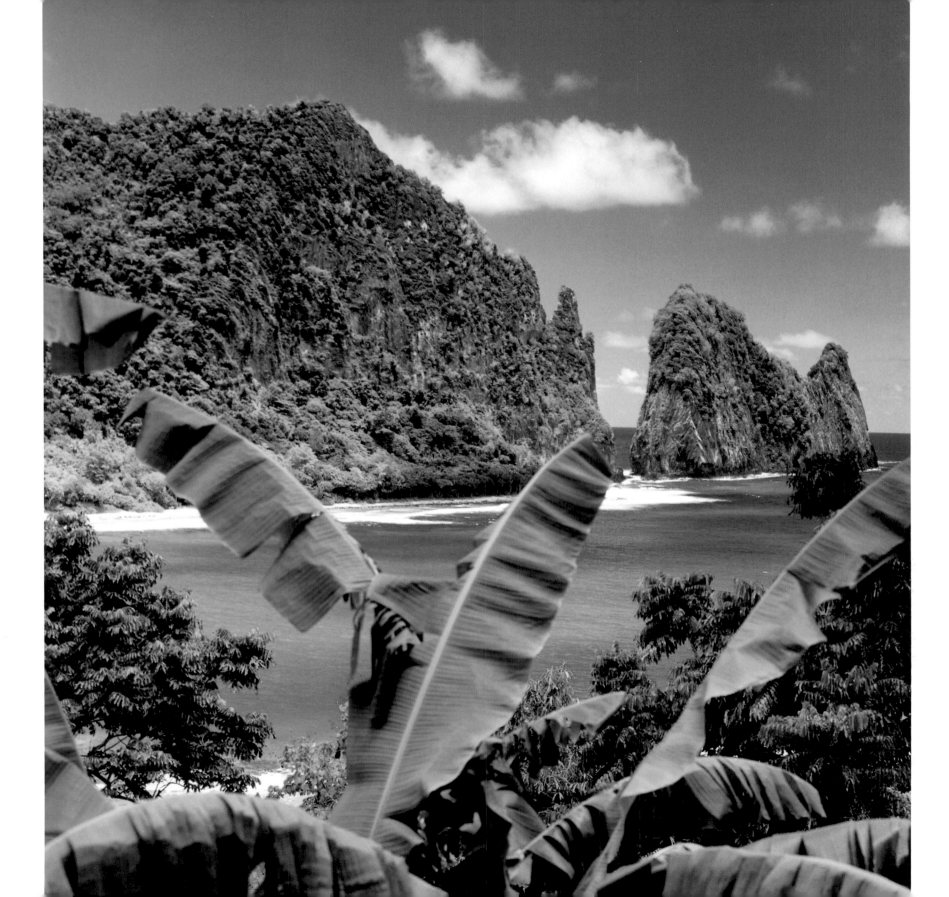

DRY TORTUGAS NATIONAL PARK

Florida, Established 1992

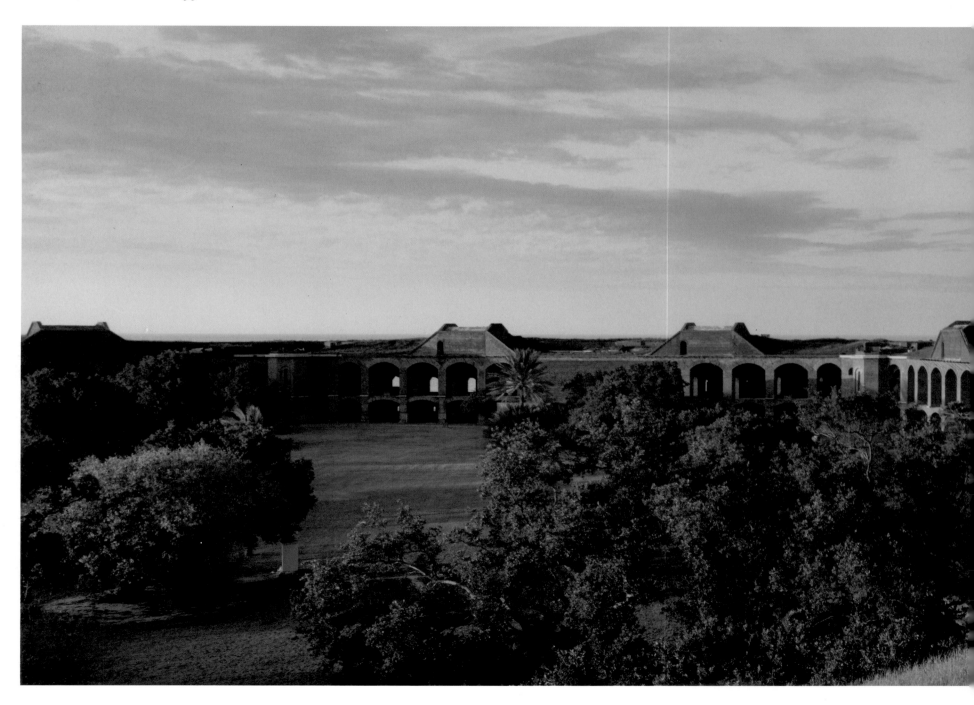

Fort Jefferson, which dates from
the nineteenth century.

SAGUARO NATIONAL PARK

Arizona, Established 1994

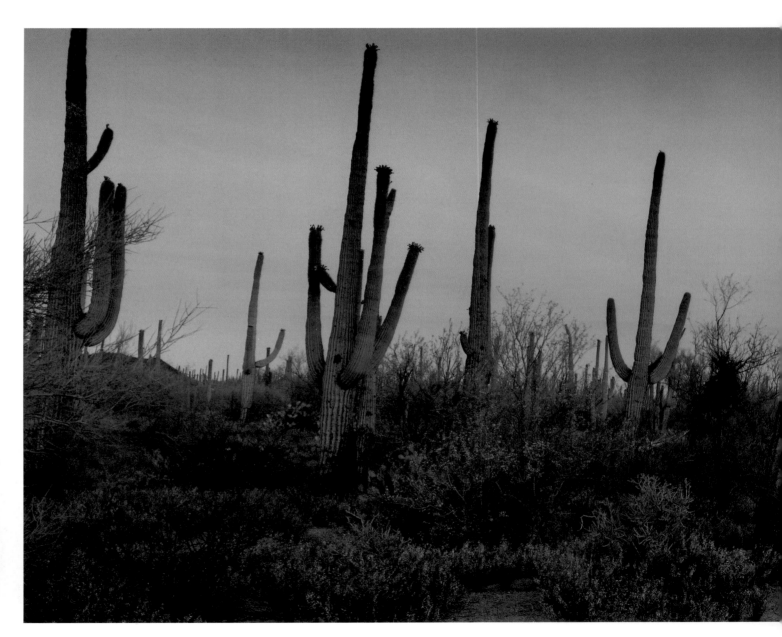

RIGHT: Discovery Trail.

BELOW: A saguaro cactus in bloom.

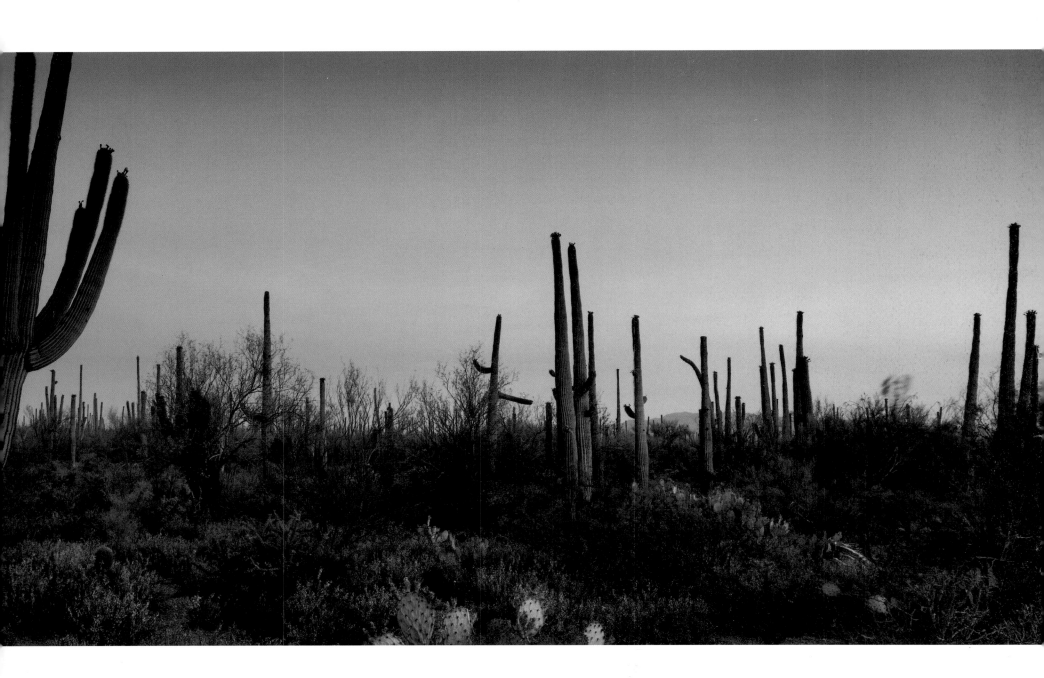

JOSHUA TREE NATIONAL PARK

California, Established 1994

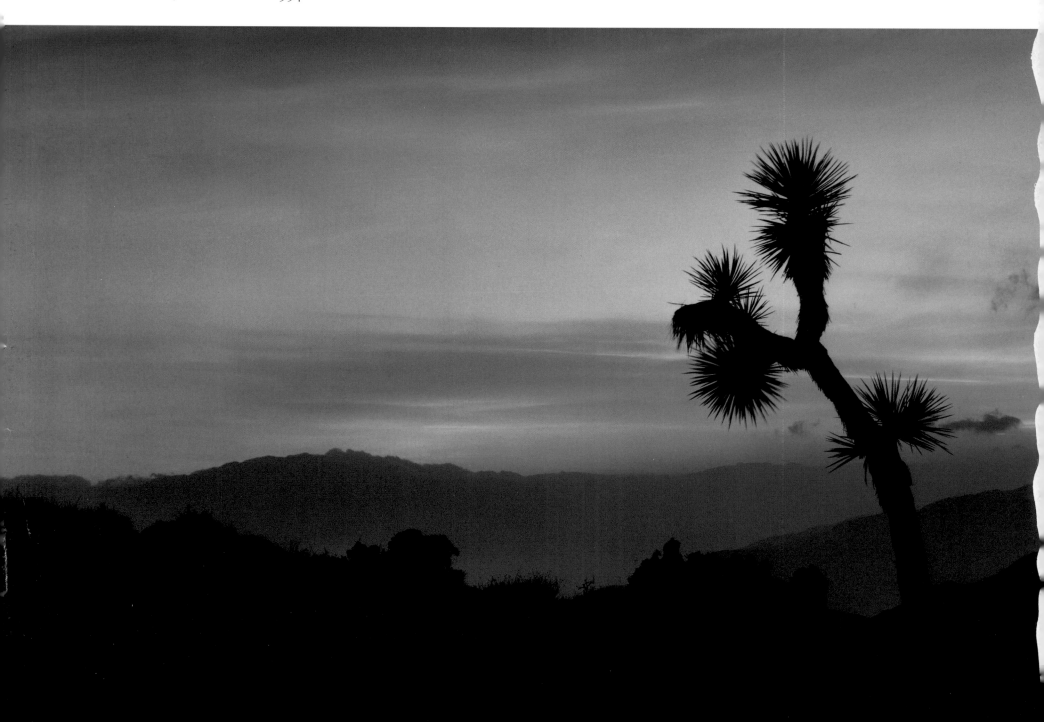

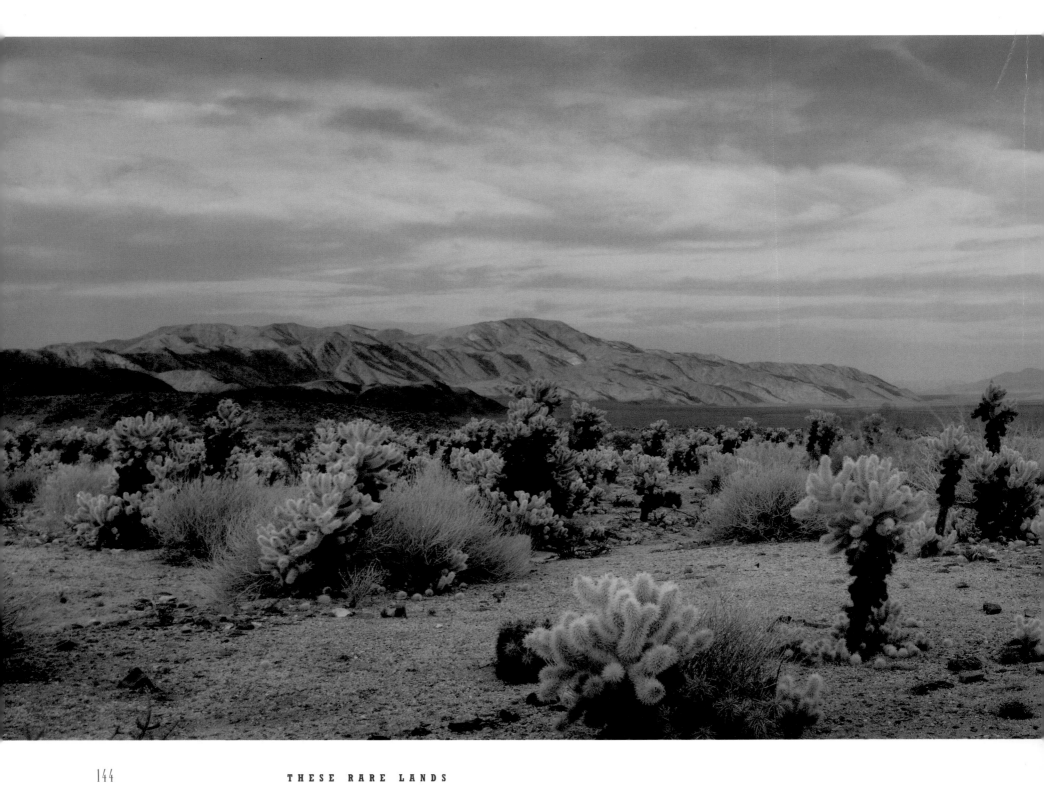

THESE RARE LANDS

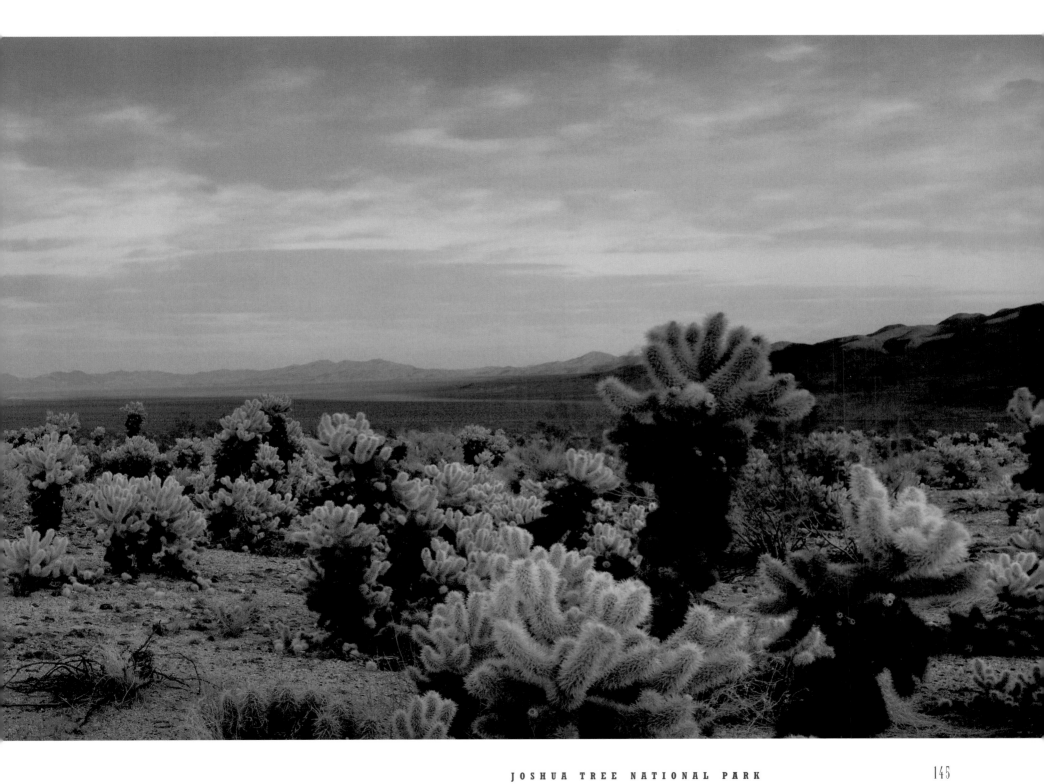

DEATH VALLEY NATIONAL PARK

CALIFORNIA, NEVADA, ESTABLISHED 1994

One of the most oddly exotic of the national parks is Death Valley. Its million-plus acres of yellows, oranges, faint reds, and purple smudges of manganese suggest a Martian landscape, or what we believe the reaches of Mars to be like. And unless one lives in Las Vegas, the drive to get to Death Valley makes it seem as remote as Mars. And that is something in its favor. The air in Death Valley is unusually clear, especially at night, so it appears that there are many more stars in its sky than in any other. And the special dryness of the place lends a delicacy to the breezes that brush against the skin. It is an almost transcendent lightness that touches us.

But if we dare to go in August, Death Valley will be brutal. The temperature can rise above 120 degrees in the shade. The air will seem as heavy as it once seemed light. Each step taken will be ponderously diffi-cult. If one is sitting, the body will be unwilling to stand. If one is standing, the body will be unwilling to take a step.

To say that Death Valley is changeable would be an understatement. Rather, it is moody, aggressively so. And its grandeur cannot be disassociated from the variety in the weather it offers the visitor. Nature seems especially raw here, but the gradual changes in color, the often perplexing passes of silken air, make it seem subtle as well.

This photograph of Death Valley was taken in the evening when the moon was small and low on the horizon, looking as if it were a marble held between two fingers of a cloud. Gazing at the rough, heavily eroded landscape with its tawny violet cast, we can say that what we see is beautiful, that Death Valley has been the subject of a remarkable portrait.

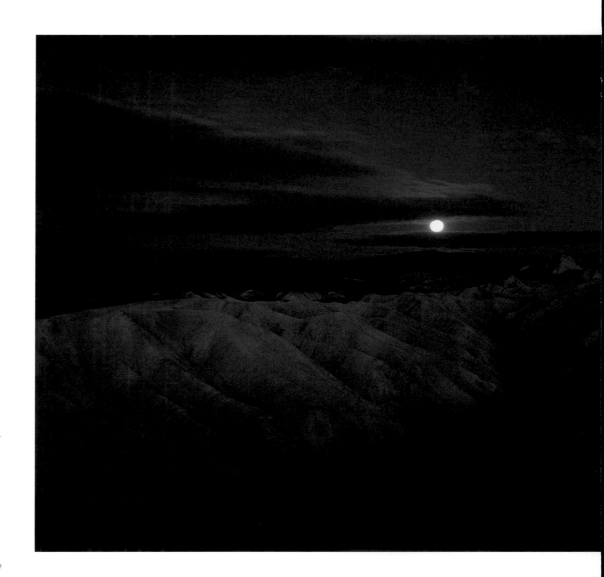

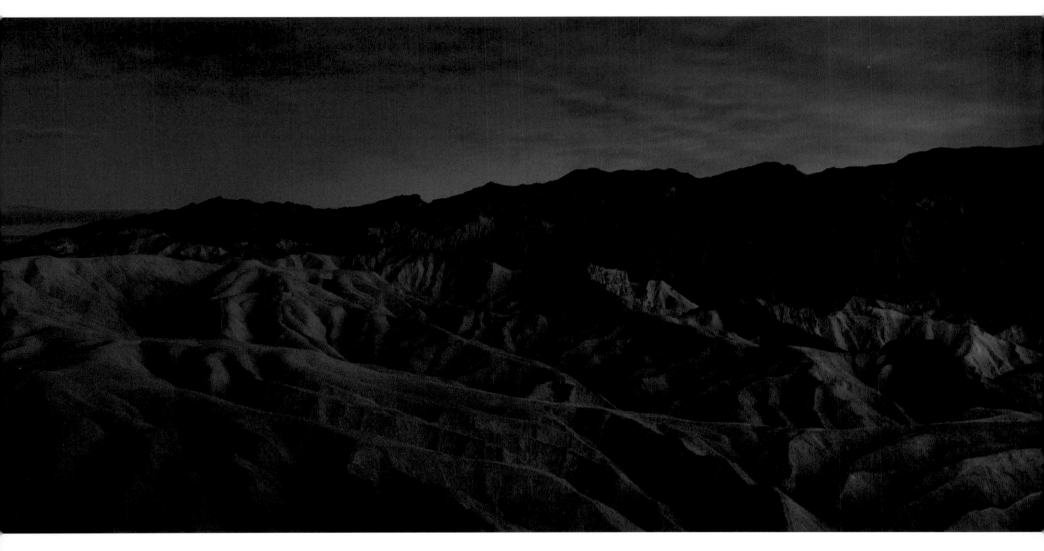

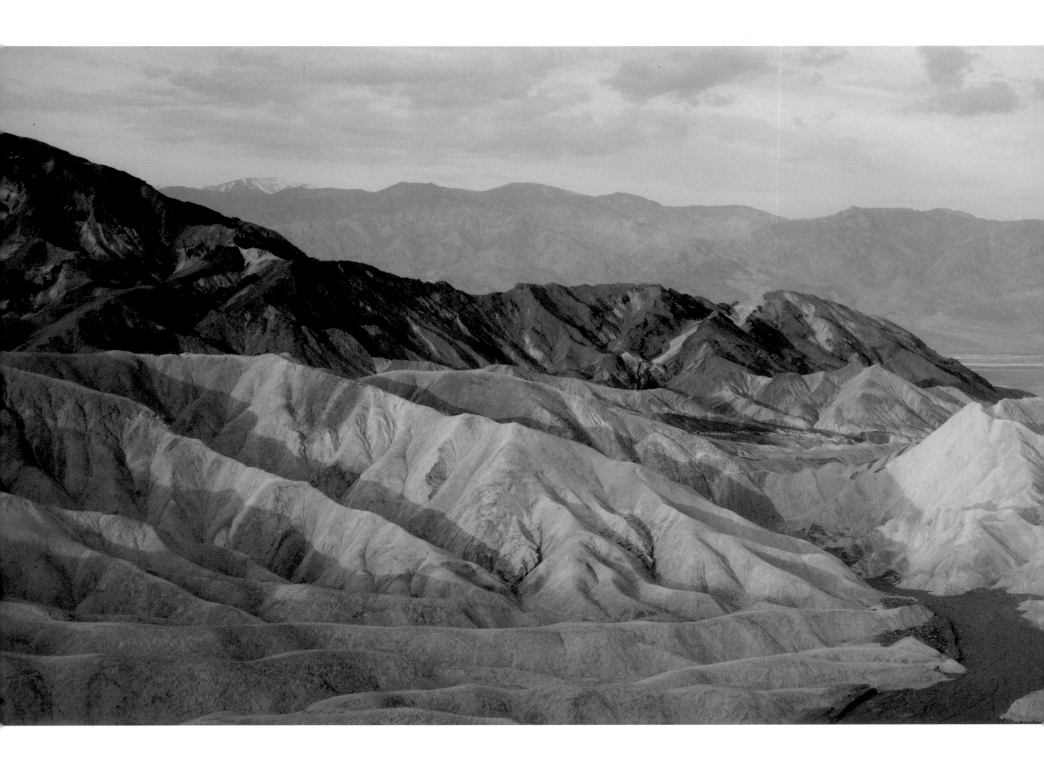

THESE RARE LANDS

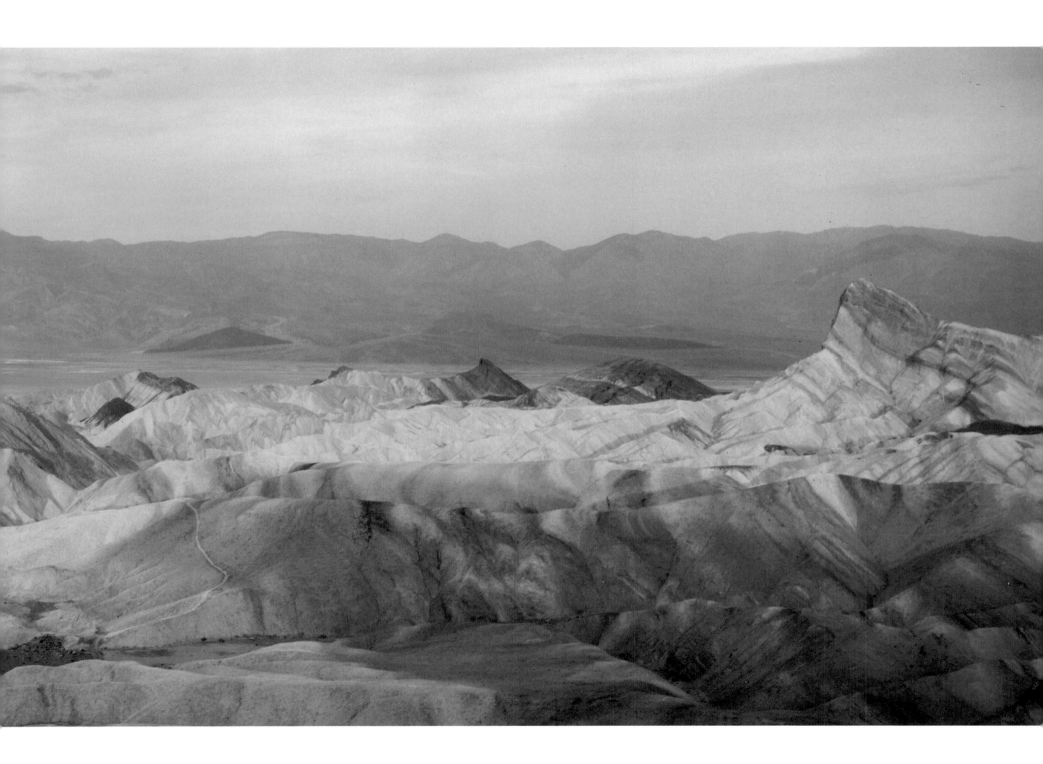

ACADIA NATIONAL PARK

Mount Desert Island, Maine

P.O. Box 177
Bar Harbor, ME 04609
(207) 288-3338

George B. Dorr devoted forty-three years of his life, energy, and family fortune to preserving the Acadian landscape. Today, Acadia preserves about 40,000 acres of Atlantic coast shoreline, mixed hardwood and spruce/fir forest, mountains, and lakes as well as several offshore islands.

The park is open every day throughout the year; some roads are closed in winter.

AMERICAN SAMOA NATIONAL PARK

see National Park of American Samoa

ARCHES NATIONAL PARK

Moab, Utah

P.O. Box 907
Moab, UT 84532
(801) 259-8151

The park contains one of the largest concentrations of natural sandstone arches in the world. The arches and numerous other extraordinary geologic features, such as spires, pinnacles, pedestals, and balanced rocks, are highlighted in striking foreground and background views created by contrasting colors, landforms, and textures.

The park is open every day throughout the year.

BADLANDS NATIONAL PARK

Interior, South Dakota

P.O. Box 6
Interior, SD 57750
(605) 433-5361

This park consists of nearly 244,000 acres of sharply eroded buttes, pinnacles, and spires blended with the largest protected mixed-grass prairie in the United States. Here, the most endangered land mammal in North America, the black-footed ferret, was reintroduced. The Stronghold Unit is comanaged with the Oglala Sioux tribe. Over 11,000 years of human history pales before the eons-old paleontological resources. Badlands contains the world's richest Oligocene epoch fossil beds, dating 23 to 35 million years old. The evolution of mammal species such as the horse, sheep, rhinoceros, and pig can be studied in the formations.

The park is open every day throughout the year. Entrance fees are collected April through November.

BIG BEND NATIONAL PARK

Southern Brewster county, in far west Texas

P.O. Box 129
Big Bend National Park, TX 79834
(915) 477-2251

Big Bend National Park is a land of borders. Situated on the boundary with Mexico along the Rio Grande, it is a place where countries and cultures meet. It is also a place that merges natural environments, from desert to mountains, and where south meets north and east meets west, creating a great diversity of plants and animals. The park covers over 801,000 acres of west Texas where the Rio Grande makes a sharp turn called the Big Bend.

The park is open every day throughout the year.

BISCAYNE NATIONAL PARK

Homestead, Florida

P.O. Box 1369
Homestead, FL 33090
(305) 230-7275

Biscayne National Park protects and preserves a nationally significant marine ecosystem with mangrove shorelines, a shallow bay, undeveloped islands, and living coral reefs. These stunning emerald islands, fringed with mangroves, contain tropical hardwood forests in their interiors. On the Atlantic side of the islands lie the most diverse and beautiful of the underwater communities: coral reefs, which support a kaleidoscope of life. The park is 180,000 acres of which 95 percent is under water.

The park is open every day throughout the year.

BRYCE CANYON NATIONAL PARK

Bryce Canyon, Utah

P.O. Box 170001
Bryce Canyon, UT 84717
(801) 834-5322

Bryce Canyon National Park is named for just one of many canyons that form a series of horseshoe-shaped amphitheaters on the edge of the Paunsaugunt Plateau in southern Utah. Erosion has carved colorful limestones into thousands of spires, fins, arches, and mazes collectively called "hoodoos." Ponderosa pines, high-elevation meadows, and spruce-fir forests border the rim of the plateau, while panoramic views of three states spread beyond the park's boundaries. This area boasts some of the nation's best air quality. This, coupled with the lack of nearby large light sources, creates unparalleled opportunities for stargazing.

The park is open every day throughout the year. There may be some temporary road clo-sures during and shortly after winter snowstorms until plowing is completed and conditions are safe for visitor traffic. Road maintenance may require brief closures of individual areas at other times.

CANYONLANDS NATIONAL PARK

Southeast Utah

2282 S. West Resource Blvd.
Moab, UT 84532
(801) 259-7164

Canyonlands National Park preserves 527 square miles of colorful canyons, mesas, buttes, fins, arches, and spires in the heart of the Colorado Plateau in southeastern Utah. Water and gravity have been the prime architects of this land, carving flat layers of sedimentary rock into the landscape. At center stage are two great canyons carved by the Green and Colorado rivers, which divide the park into four districts: the Island in the Sky to the north, the Maze to the west, the Needles to the south, and the Rivers.

Few people were familiar with these remote lands when the park was established in 1964, and much of Canyonlands remains untrammeled today: its roads mostly unpaved, its trails primitive, and its rivers free flowing.

The park is open every day throughout the year.

CAPITOL REEF NATIONAL PARK

South central Utah

HC 70, Box 15
Torrey, Utah 84775
(801) 425-3791

A giant, sinuous wrinkle in the earth's crust stretches for 100 miles across south central Utah. This impressive buckling of rock, created by the same tremendous forces that built the Colorado Plateau 65 million years

ago, is called the Waterpocket Fold. Capitol Reef National Park preserves the Fold and its spectacular, eroded jumble of colorful cliffs, massive domes, soaring spires, stark monoliths, twisting canyons, and graceful arches.

The park is open every day throughout the year.

CARLSBAD CAVERNS NATIONAL PARK

Southeast New Mexico

3225 National Parks Highway
Carlsbad, NM 88220
(505) 785-2232

This park was established to preserve Carlsbad Cavern and numerous other caves within a Permian-age fossil reef. The park contains eighty-three separate caves, including the nation's deepest limestone cave—1,597 feet—as well as the third longest. Carlsbad Cavern, with one of the world's largest underground chambers and countless formations, is also highly accessible, with a variety of tours offered year-round.

The park is open every day throughout the year except on December 25.

CHANNEL ISLANDS NATIONAL PARK

The islands within the park extend along the Southern California coast from Point Conception near Santa Barbara to just north of Los Angeles.

1901 Spinnaker Drive
Ventura, California 93001
(805) 658-5730

Consisting of five of the eight California Channel Islands, the park is home to a wide variety of internationally significant natural resources. Over 2,000 terrestrial plants and animals can be found within the park, 145 of which can be found nowhere else in the world. Marine life ranges from microscopic plankton to the endangered blue whale, the largest animal to live on earth. The park consists of 249,353 acres,

half of which are under the ocean, as well as a number of islands. Even though the islands seem tantalizingly close to the densely populated Southern California coast, their isolation has left them relatively undeveloped.

The park is open every day throughout the year.

CRATER LAKE NATIONAL PARK

Crater Lake, Oregon

P.O. Box 7
Crater Lake, OR 97604
(541) 594-2211

Crater Lake is world renowned for its deep blue color. It lies within the caldera of Mount Mazama, a volcano of the Cascade Range that erupted about 7,700 years ago. When the mountain collapsed, rain and melting snow gradually filled the caldera, forming the lake. Its greatest depth of 1,932 feet makes it the deepest lake in the United States.

South and west entrances are open every day throughout the year. North entrance open mid-June to mid-October, snow permitting. East side of Rim Drive, from Cleetwood Cove to park headquarters, may remain closed by snow until late July.

DEATH VALLEY NATIONAL PARK

Death Valley, California

P.O. Box 579
Death Valley, CA 92328
(619) 786-2331

Death Valley has more than 3.3 million acres of spectacular desert scenery, interesting and rare desert wildlife, complex geology, undisturbed wilderness, and sites of historical and cultural interest. Bounded on the west by 11,049-foot Telescope Peak and on the east by 5,475-foot Dante's View, Badwater is the lowest point (-282 feet) in the Western hemisphere.

The park is open every day throughout the year.

DENALI NATIONAL PARK

Approximately 240 miles north of Anchorage, 125 miles south of Fairbanks, and twelve miles south of Healy, Alaska

P.O. Box 9
Denali Park, AK 99755
(907) 683-2294

Denali National Park and Preserve features North America's highest mountain, 20,320-foot Mount McKinley. The Alaska Range also includes countless other spectacular mountains and many large glaciers. Denali's more than six million acres also encompass a complete subarctic ecosystem with large mammals such as grizzly bears, wolves, Dall sheep, and moose.

The park is open every day throughout the year.

DRY TORTUGAS NATIONAL PARK

Sixty-eight miles west of Key West, Florida

c/o Everglades National Park
40001 State Road 9336
Homestead, FL 33034
(305) 242-7700

The Dry Tortugas National Park encompasses seven small islands known as the

Dry Tortugas within its 100-square-mile jurisdiction. Central to the area is Fort Jefferson, a masonry fort with half-mile-long perimeter walls fifty feet high and eight feet thick, located on Garden Key.

The park is open every day throughout the year.

EVERGLADES NATIONAL PARK

Southeast Florida

40001 State Road 9336
Homestead, FL 33034
(305) 242-7700

Everglades National Park is the largest remaining subtropical wilderness in the continental United States and has extensive fresh and saltwater areas, open Everglades prairies, and mangrove forests. Abundant wildlife includes rare and colorful birds; this is also the only place in the world where alligators and crocodiles exist side by side. The park, which covers 1,506,539 acres, is a World Heritage Site, a Biosphere Reserve, and a Wetland of International Significance.

The park is open every day throughout the year.

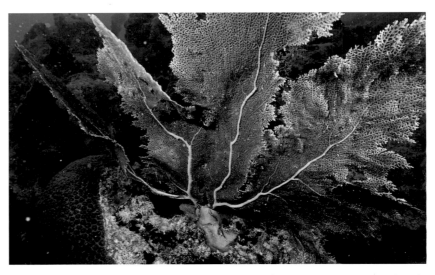

Gorgonian Sea Fan in the Dry Tortugas National Park.

GATES OF THE ARCTIC NATIONAL PARK

North central Alaska, about 200 miles north-west of Fairbanks

P.O. Box 74680
Fairbanks, AK 99707
(907) 456-0281

Lying entirely north of the Arctic Circle, the park and preserve includes a portion of the central Brooks Range, the northern-most extension of the Rocky Mountains. Often referred to as the greatest remaining wilderness in North America, this area, the second-largest unit of the National Park System, is characterized by jagged peaks, gentle arctic valleys, wild rivers, and numerous lakes. The forested southern slopes contrast to the barren northern reaches of the site at the edge of Alaska's "north slope."

The park is open every day throughout the year.

GLACIER BAY NATIONAL PARK

Southeast Alaska, about sixty-five air miles northwest of Juneau

P.O. Box 140
Gustavus, AK 99826
(907) 697-2230

Great tidewater glaciers, a dramatic range of plant communities from rocky terrain recently covered by ice to lush temperate rainforest, and a large variety of animals (brown and black bear, mountain goats, whales, seals, and eagles) can be found within the park. Also included are Mount Fairweather, the highest peak in southeast Alaska, and the U.S. portion of the Alsek River.

The park is open every day throughout the year.

GLACIER NATIONAL PARK

Northwestern Montana on the U.S./Canadian border

P.O. Box 128
West Glacier, MT 59936
(406) 888-7800

Glacier National Park provides over one million acres of habitat and protection for a rich variety of wildlife and wildflowers. The geologic history of Glacier is read in the numerous exposed layers of Precambrian sedimentary formations that date back to over one billion years ago. Subsequent sculpting by massive bodies of ice has transformed this area into a dramatic example of glacial landforms. Today several small alpine glaciers of relatively recent origin dot the mountains. Due to its geographic location and geologic history, Glacier contains a particularly rich biological diversity of plant and animal species. This combination of spectacular scenery, diverse flora and fauna, and relative isolation from major population centers has combined to make Glacier one of the largest and most intact ecosystems in North America.

The park is open every day throughout the year.

GRAND CANYON NATIONAL PARK

Grand Canyon, Arizona

P.O. Box 129
Grand Canyon, AZ 86023
(520) 638-7888

Located entirely in northern Arizona, the park encompasses 277 miles of the Colorado River and adjacent uplands. One of the most spectacular examples of erosion anywhere in the world, Grand Canyon is unmatched in the incomparable vistas it offers to visitors on the rim. Grand Canyon National Park is a World Heritage Site.

The South Rim is open every day throughout the year; the North Rim is closed from late October to mid-May.

GRAND TETON NATIONAL PARK

Teton County, northwestern Wyoming, south of Yellowstone National Park and north of Jackson, Wyoming

P.O. Drawer 170
Moose, WY 83012
(307) 739-3300

Towering more than a mile above the valley known as Jackson Hole, the Grand Teton rises to 13,770 feet above sea level. Twelve of the Teton's peaks reach above 12,000 feet, high enough to support a dozen mountain glaciers. In contrast to the abrupt eastern face, the west side of the range slopes gently. Youngest of the mountains in the Rocky Mountain system, the Teton Range displays some of the North America's oldest rocks. The rise of the Teton Range as well as the erosion caused by eons of glaciation have created the conditions that allow several plant communities to thrive, from ribbons of green riparian plants bordering rivers and streams to sagebrush flats, Lodgepole pine and spruce forests, subalpine meadows, and alpine stone fields. The wide range of plant communities create habitats for a wide variety of animals.

The park is open every day throughout the year.

GREAT BASIN NATIONAL PARK

Eastern Nevada, five hours north of Las Vegas

Baker, NV 89311
(702) 234-7331

The park includes much of the South Snake Range, a superb example of a desert mountain island. From the sagebrush at its alluvial base to the 13,063-foot summit of Wheeler Peak, the park includes streams, lakes, alpine plants, abundant wildlife, a variety of forest types, including groves of ancient bristlecone pines, and numerous limestone caverns, among them the beautiful Lehman Caves.

The park is open every day throughout the year, except Thanksgiving, December 25, and January 1.

GREAT SMOKY MOUNTAINS NATIONAL PARK

Western North Carolina and eastern Tennessee

107 Park Headquarters Road
Gatlinburg, TN 37738
(423) 436-1200

Situated on the border between North Carolina and Tennessee, this park, which draws more visitors than any in the park system, encompasses 800 square miles of which ninety-five percent is forested. World renowned for the diversity of its plant and animal resources, the beauty of its ancient mountains, the quality of its remnants of American pioneer culture, and the depth and integrity of the wilderness sanctuary within its boundaries, it is one of the largest protected areas in the East.

The park is open every day throughout the year.

GUADALUPE MOUNTAINS NATIONAL PARK

Pine Springs, Texas. Located 110 miles east of El Paso, Texas, fifty-five miles southwest of Carlsbad, New Mexico, and sixty-five miles north of Van Horn, Texas.

HC 60 Box 400
Salt Flat, TX 79847
(915) 828-3251

Rising from the desert, this mountain mass contains portions of the world's most extensive and significant Permian limestone fossil reef. Also featured are a tremendous earth fault, lofty peaks, unusual flora and fauna, and a colorful record of the past. Guadalupe Peak, highest point in Texas at 8,749 feet; El Capitan, a massive limestone formation; McKittrick Canyon, with its unique flora and fauna; and the "bowl," located in a high-country conifer forest, are

unique flora and fauna; and the "bowl," located in a high-country conifer forest, are significant park features.

The park is open every day throughout the year.

HALEAKALA NATIONAL PARK
Maui, Hawaii

P.O. Box 369
Makawao, HI 96768
(808) 572-9306

The park preserves the outstanding features of Haleakala Crater on the island of Maui and protects the unique and fragile ecosystems of Kipahulu Valley, the scenic pools along 'Ohe'o Gulch, and many rare and endangered species.

The park is open every day throughout the year, but call ahead for information on weather and roads.

HAWAII VOLCANOES NATIONAL PARK
On the Island of Hawaii, ninety-six miles from Kailua-Kona and thirty miles from Hilo

P.O. Box 52
Hawaii National Park, HI 96718
(808) 985-6000

Hawaii Volcanoes National Park displays the results of 70 million years of volcanism, migration, and evolution—processes that thrust a bare land from the sea and clothed it with complex and unique ecosystems and a distinct human culture. The park encompasses 230,000 acres and ranges from sea level to the summit of the earth's most massive volcano, Mauna Loa, at 13,677 feet. Kilauea, the world's most active volcano, offers scientists insights on the birth of the Hawaiian Islands and visitors views of dramatic volcanic landscapes. Over half of the park is designated wilderness and provides unusual hiking and camping opportunities.

The park is open every day throughout the year.

HOT SPRINGS NATIONAL PARK
Hot Springs, Arkansas

P.O. Box 1860
Hot Springs, AR 71902
(501) 624-3383

Hot Springs Reservation was set aside in 1832 by the federal government to protect for future generations the forty-seven hot springs flowing from the southwestern slope of Hot Springs Mountain at a temperature of 143 degrees Fahrenheit. The main attraction has always been the hot spring water and the baths, given at the eight magnificent bathhouses on Bathhouse Row. In the past, the baths were taken as a therapeutic treatment for rheumatism and other ailments. Visitors may also enjoy mountain drives, hiking trails, the Grand Promenade, and Gulpha Gorge Campground. The park contains 5,839 acres.

The park is open every day throughout the year, except Thanksgiving, December 25, and January 1.

ISLE ROYALE NATIONAL PARK
Upper Peninsula of Michigan

800 East Lakeshore Drive
Houghton, MI 49931
(906) 482-0984

Wild animals, pristine forests, crystal clear lakes, and rugged shorelines are a few of this park's fine features. This island archipelago is forty-five miles long and nine miles wide at its widest point. The park encompasses a total area of 850 square miles, including submerged lands, which extends four and a half miles out into Lake Superior. Isle Royale has 165 miles of scenic hiking trails and thirty-six campgrounds for backpackers and recreational boaters. There is excellent Lake Superior fishing, historic lighthouses, shipwrecks, and plenty of spots to observe wildlife. Accessible only by boat or floatplane, Isle Royale is rela-

tively untouched by direct outside influences and serves as a living laboratory and International Biosphere Reserve.

The park is only open in the summer, from April 16 to October 31, with full transportation services mid-June to Labor Day.

JOSHUA TREE NATIONAL PARK
Southern California

74485 National Park Drive
Twentynine Palms, CA 92277
(619) 367-7511

Two deserts, two large ecosystems primarily determined by elevation, come together at Joshua Tree. Few areas more vividly illustrate the contrast between high and low desert. Below 3,000 feet, the Colorado Desert, occupying the eastern half of the park, is dominated by the abundant creosote bush. Adding interest to this arid land are small stands of spidery ocotillo and cholla cactus. The higher, slightly cooler and wetter Mojave Desert is the special habitat of the undisciplined Joshua tree, extensive stands of which occur throughout the western half of the park.

The park encompasses some of the most interesting geologic displays in California's deserts. Rugged mountains of twisted rock and exposed granite monoliths testify to the tremendous earth forces that shaped and formed this land. Arroyos, playas, alluvial fans, bajadas, pediments, desert varnish, granites, aplite, and gneiss interact to form a giant desert mosaic of immense beauty and complexity.

The park is open every day throughout the year.

KATMAI NATIONAL PARK
About 290 miles southwest of Anchorage on the Alaska Peninsula, just west of King Salmon. Kodiak Island lies just off the Katmai Coast to the east.

P.O. Box 7
King Salmon, AK 99613
(907) 246-3305

Variety marks this vast land: lakes, forests, mountains, and marshlands all abound in wildlife. The Alaska brown bear, the world's largest carnivore, thrives here, feeding upon red salmon that spawn in the many lakes and streams. Wild rivers and

Valley of 10,000 Smokes, Katmai National Park.

renowned sport fishing add to the attractions of this subarctic environment. Here, in 1912, Novarupta Volcano erupted violently, forming the ash-filled "Valley of Ten Thousand Smokes" where steam rose from countless fumaroles. Today only a few active vents remain. The park-preserve contains part of the Alagnak River.

The park is open every day throughout the year.

KENAI FJORDS NATIONAL PARK
Seward, Alaska

P.O. Box 1727
Seward, AK 99664
(907) 224-3175

Contained within the Kenai Fjords is the 300-square-mile Harding Icefield, which is one of the four major ice caps in the United States. Elsewhere in the park, a rich, varied rain forest is home to tens of thousands of breeding birds, and adjoining marine waters support a multitude of sea lions, sea otters, and seals.

The park is open every day throughout the year, but from about mid-October to May the road to Exit Glacier may be closed by snow. Call ahead for information on weather and roads.

KINGS CANYON NATIONAL PARK
Fresno and Tulare counties, California

Three Rivers, CA 93271
(209) 565-3341

Kings Canyon includes 443,637 acres of backcountry wilderness and the south fork of the Kings River, which, at one point, is the deepest canyon in North America. In the Grant Grove, the General Grant tree is the world's third-largest living thing.

The park is open every day throughout the year. The road to Cedar Grove is closed in the winter.

KOBUK VALLEY NATIONAL PARK
Kotzebue, Alaska

Northwest Alaska Areas
P.O. Box 1029
Kotzebue, AK 99752
(907) 442-8300

Kobuk Valley National Park is located entirely north of the Arctic Circle. Here, in the northmost extent of the boreal forest, a rich array of arctic wildlife can be found, including caribou, grizzly and black bear, wolf, and fox. Archeological sites revealing more than 10,000 years of human occupation are among the most significant known in the arctic.

The park is open all year long, except for most federal holidays.

LAKE CLARK NATIONAL PARK
150 miles southwest of Anchorage, on the west side of the Cook Inlet, at the north end of the Alaska Peninsula

4230 University Drive, Suite 311
Anchorage, AK 99508
(907) 271-3751

The wilderness that comprises Lake Clark National Park and Preserve is a composite of ecosystems representative of many diverse regions throughout Alaska. Covering four million acres, the spectacular scenery stretches from the shores of Cook Inlet, across the Chigmit Mountains, to the tundra-covered hills of the western interior. The Chigmits, where the Alaska and Aleutian ranges meet, are an awesome, jagged array of mountains and glaciers, which include two active volcanoes, Mount Redoubt and Mount Iliamna. Lake Clark, fifty miles long, and many other lakes and rivers within the park are critical salmon habitat to the Bristol Bay salmon fishery, one of the largest sockeye salmon fishing grounds in the world. Numerous lake and river systems in the park and preserve offer excellent fishing and wildlife viewing.

The park is open every day throughout the year.

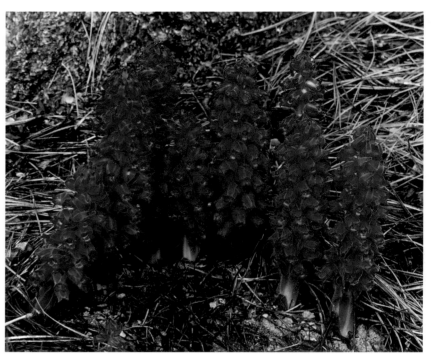

The red blossoms of snow plant in Lassen Volcanic National Park.

LASSEN VOLCANIC NATIONAL PARK
Mineral, California

P.O. Box 100
Mineral, CA 96063
(916) 595-4444

Lassen Volcanic became a national park because of its significance as an active volcanic landscape. Lassen Peak began erupting in 1914, had its most significant activity in 1915, and had minor activity until 1921. The four types of volcanoes in the world are found in Lassen's 106,000 acres.

The park is open every day throughout the year.

MAMMOTH CAVE NATIONAL PARK
Edmonson, Hart, and Barren counties, Kentucky

Mammoth Cave, KY 42259
(502) 758-2328

The park was established to preserve the cave system, including Mammoth Cave, the scenic river valleys of the Green and Nolin rivers, and a section of south central Kentucky. This is the longest recorded cave system in the world, with more than 336 miles explored and mapped.

The park is open every day throughout the year. In order to view the caves, visitors must join one of the tours that are given all year except on December 25.

MESA VERDE NATIONAL PARK

Southwest Colorado, eight miles east of Cortez

P.O. Box 8
Mesa Verde, CO 81330
(970) 529-4465

Mesa Verde is the first national park set aside to preserve the works of people. It was also designated as a World Heritage Cultural Site by UNESCO. Mesa Verde, Spanish for "Green Table," offers an unparalleled opportunity to see and experience the life of the Anasazi. During the summer months, visitors can walk through cliff dwellings and numerous mesa-top villages built by the ancestral Pueblo people between A.D. 600 and 1300.

The park is open every day throughout the year.

MOUNT RAINIER NATIONAL PARK

West central Washington State

Tahoma Woods, Star Route
Ashford, WA 98304
(360) 569-2211

Mount Rainier has the greatest single-peak glacial system in the country, radiating from the summit and slopes of the 14,411-foot dormant volcano. The park contains vast expanses of pristine old-growth forests, subalpine flower meadows, spectacular alpine scenery, and stimulating outdoor activities. While Mount Rainier as a volcano is dormant, it is not believed to be extinct.

The park is open from July 1 to Labor Day. Access to certain locations is limited by snow at other times.

NATIONAL PARK OF AMERICAN SAMOA

American Samoa

c/o Pacific Area Office
Box 50165
300 Ala Moana Blvd.
Honolulu, HI 96850
(808) 541-2693

Two rain forest preserves and a coral reef are home to unique tropical animals, including the flying fox, Pacific boa, tortoises, and an array of birds and fish. The park contains paleotropical rain forests, pristine coral reefs, and magnificent white sand beaches. Flights from Honolulu to Pago Pago take five and a half hours. Total time from California is fourteen hours, including layover.

The park is open every day throughout the year. Visitors need permission to enter the park. Write or call American Samoa Office of Tourism, P.O. Box 1147, Pago Pago, American Samoa, 96799, (684) 699-9280. Or write National Park of American Samoa, Pago Pago, American Samoa, 96799.

NORTH CASCADES NATIONAL PARK

Northwest Washington State

2105 State Route 20
Sedro-Woolley, WA 98284
(360) 856-5700

North Cascades contains some of America's most breathtakingly beautiful scenery—high jagged peaks, steep ridges, deep valleys, countless cascading waterfalls, and about 318 glaciers. The park itself is part of a National Park Service Complex that also includes Ross Lake National Recreation Area and Lake Chelan National Recreation Area, both of which provide scenic roads and recreation opportunities.

The park is open every day throughout the year, but access may be limited by snow in winter.

Horsetail and ferns at Lost Man Creek, Redwood National Park.

OLYMPIC NATIONAL PARK

Northwest Washington State

600 East Park Avenue
Port Angeles, WA 98362
(360) 452-4501

Often described as "three parks in one," Olympic National Park encompasses three distinctly different ecosystems—rugged glacier-capped mountains, over sixty miles of wild Pacific coast, and magnificent stands of old-growth and temperate rain forest. These diverse ecosystems are still largely pristine in character—about 95 percent of the park is designated wilderness. Olympic is also known for its biological diversity. Isolated for eons by glacial ice, the waters of Puget Sound, and the Strait of Juan de Fuca, the Olympic Peninsula has developed its own distinct array of plants and animals.

The park is open every day throughout the year, but access to some areas may be limited in winter.

PETRIFIED FOREST NATIONAL PARK

East central Arizona, twenty miles east of Holbrook

P.O. Box 2217
Petrified Forest, AZ 86028
(520) 524-6228

Trees that have petrified, or changed to multicolored stone, Indian ruins and petroglyphs, and portions of the colorful Painted Desert are features of the park.

The park is open every day throughout the year, except December 25.

REDWOOD NATIONAL PARK

Northern California

1111 Second Street
Crescent City, CA 95531
(707) 464-6101

Redwood National Park protects old-growth coast redwoods, some of the world's tallest trees, although less well-known prairies, oak woodlands, and the coastal and marine ecosystems are also important features of the park. Together the

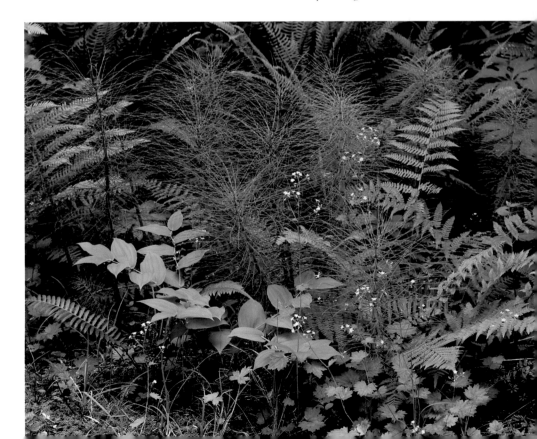

Redwood national and state parks are a World Heritage Site and an International Biosphere Reserve.

The park is open every day throughout the year except for Thanksgiving, December 25, and January 1.

ROCKY MOUNTAIN NATIONAL PARK

Estes Park, Colorado

Estes Park, CO 80517
(970) 586-1206

The massive grandeur of the Rocky Mountains is showcased in this park's rich scenery. Trail Ridge Road crosses the Continental Divide and looks out over peaks that tower more than 14,000 feet high.

The park is open every day throughout the year.

SAGUARO NATIONAL PARK

Tucson, Arizona

3693 South Old Spanish Trail
Tucson, AZ 85730
(520) 733-5153

The saguaro has been described variously as the monarch of the Sonoran Desert, a prickly horror, and the supreme symbol of the American Southwest. It is renowned for the variety of odd, all-too-human shapes it assumes. Giant saguaro cacti, unique to the Sonoran Desert, sometimes reach a height of fifty feet in this cactus forest, which covers the valley floor, rising into the Rincon and West Tucson mountains. In lushness and variety of life the Sonoran Desert far surpasses all other North American deserts.

The park is open every day throughout the year except for December 25.

SEQUOIA NATIONAL PARK

Tulare County, California

Three Rivers, CA 93271
(209) 565-3341

Sequoia is the second-oldest national park in the United States. It was established in 1890 to protect the big trees in Giant Forest, including the General Sherman Tree, the world's largest living thing, Sequoia also contains the Mineral King Valley and Mount Whitney, the highest mountain in the United States outside of Alaska.

The park is open every day throughout the year. The road to Mineral King is closed in the winter.

SHENANDOAH NATIONAL PARK

Northern Virginia twenty-five miles west of Charlottesville

3655 U.S. Hwy. 211 E
Luray, VA 22835
(540) 999-3500

Shenandoah National Park lies astride a beautiful section of the Blue Ridge, which forms the eastern rampart of the Appalachian Mountains between Pennsylvania and Georgia. In the valley to the west is the Shenandoah River and to the east is the rolling Piedmont country. Skyline Drive, a winding road that runs along the crest of this portion of the Blue Ridge Mountains through the length of the Park, provides extraordinary vistas of the spectacular landscape.

The park is open every day throughout the year, but some portions of Skyline Drive are closed at night during hunting season.

THEODORE ROOSEVELT NATIONAL PARK

Western North Dakota, 130 miles west of Bismark

P.O. Box 7
Medora, ND 58645
(701) 623-4466

The park includes scenic badlands along the Little Missouri River and part of Theodore Roosevelt's Elkhorn Ranch. It preserves both extraordinary landscape and the memory of an extraordinary U.S. president.

The park is open every day throughout the year, but access may be limited during winter months.

VIRGIN ISLANDS NATIONAL PARK

St. John, U.S. Virgin Islands

6310 Estate Nazareth
St. Thomas, VI 00802
(809) 775-6238

Covering about one-half of St. John and Hassel islands in St. Thomas harbor, this spectacular park includes quiet coves, blue-green waters, and white sandy beaches fringed by lush green hills, as well as early Carib Indian relics and the remains of Danish colonial sugar plantations.

The park is open every day throughout the year except for December 25.

VOYAGEURS NATIONAL PARK

Northern Minnesota, along the Canadian border

3131 Highway 53
International Falls, MN 56649
(218) 283-9821

Water dominates the landscape of Voyageurs National Park. Within its boundaries, more than thirty lakes fill glacier-carved rock basins, including four large lakes—Rainy, Kabetogama, Namakan, and Sand Point—that cover almost 40 percent of the 219,000 acres of the park. In the midst of all this water lies the Kabetogama

Peninsula whose rugged topography matches much of the rest of the park with rolling hills interspersed between bogs, beaver ponds, swamps, and smaller lakes.

The park lies in the southern part of the Canadian Shield, representing some of the oldest exposed rock formations in the world—bedrock that has been shaped and carved by at least four periods of glaciation. In the years since the last period of glaciation, a thin layer of soil has been created that supports the boreal forest ecosystem, the "North Woods."

The park is open every day throughout the year.

WIND CAVE NATIONAL PARK

Seven miles north of Hot Springs, South Dakota

RR 1, Box 190-WCNP
Hot Springs, SD 57747
(605) 745-4600

One of the world's longest and most complex caves and 28,295 acres of mixed-grass prairie, ponderosa pine forest, and associated wildlife are main features of this park. The cave is well known for its outstanding display of boxwork, an unusual cave formation composed of thin calcite fins resembling honeycombs. The mixed-grass prairie is one of the few remaining and is home to native wildlife such as bison, elk, pronghorn, mule deer, coyotes, and prairie dogs.

The park is open every day throughout the year.

WRANGELL–ST. ELIAS NATIONAL PARK

Eastern Alaska, 200 miles east of Anchorage

Mile 105.5 Old Richardson Highway
P.O. Box 439
Copper Center, AK 99573
(907) 822-5234

The Chugach, Wrangell, and St. Elias mountain ranges converge here in what is often referred to as the "mountain king-

dom of North America." The largest unit of the National Park System, the park-preserve includes the continent's largest assemblage of glaciers and the greatest collection of peaks above 16,000 feet. Mount St. Elias, at 18,008 feet, is the second-highest peak in the United States. Adjacent to Canada's Kluane National Park, the site is characterized by remote mountains, valleys, wild rivers, and a variety of wildlife.

The park is open every day throughout the year except for December 25.

YELLOWSTONE NATIONAL PARK

Northwestern corner of Wyoming, with portions extending into southwestern Montana and southeastern Idaho

P.O. Box 168
Yellowstone National Park, WY 82190
(307) 344-7381

Yellowstone is the first and oldest national park in the world. The commanding features that initially attracted interest and led to the preservation of Yellowstone as a national park were geological: geothermal phenomena (there are more geysers and hot springs here than in the rest of the world combined), the colorful Grand Canyon of the Yellowstone River, fossil forests, and the size and elevation of Yellowstone Lake. The human history of the park is evidenced by cultural sites dating back 12,000 years.

Ninety-nine percent of the park's 3,400 square miles (2.2 million acres) remains undeveloped, providing a wide range of habitat types that support one of the continent's largest and most varied large mammal populations. Yellowstone is a true wilderness, one of the few large, natural areas remaining in the lower forty-eight states of the United States.

The park is open every day throughout the year.

YOSEMITE NATIONAL PARK

Yosemite, California

P.O. Box 577
Yosemite, CA 95389
(209) 372-0200

Yosemite National Park embraces almost 1,200 square miles of scenic wild lands set aside in 1890 to preserve a portion of the central Sierra Nevada that stretches along California's eastern flank. The park ranges from 2,000 feet above sea level to more than 13,000 feet. Its major attractions are alpine wilderness, three groves of giant sequoias, and the glacially carved Yosemite Valley with impressive waterfalls, cliffs, and unusual rock formations.

The park is open every day throughout the year.

ZION NATIONAL PARK

Southern tip of Utah

Springdale, UT 84767
(801) 772-3256

Protected within Zion National Park's 229 square miles is a spectacular cliff-and-canyon landscape and wilderness full of the unexpected, including the world's largest arch—Kolob Arch—with a span that measures 310 feet. Wildlife such as mule deer, golden eagles, and mountain lions also inhabit the park.

The park is open every day throughout the year, but higher hiking trails are closed by snow in winter.

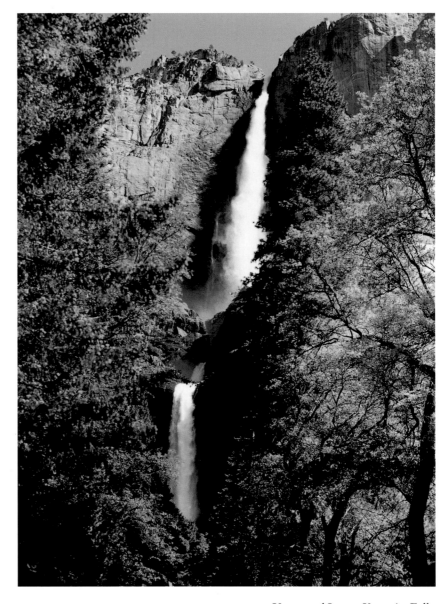

Upper and Lower Yosemite Falls.

INDEX